RECOLLECTIONS

RECOLLECTIONS

TEN WOMEN OF PHOTOGRAPHY

BERENICE ABBOTT
RUTH BERNHARD
CARLOTTA M. CORPRON
LOUISE DAHL-WOLFE
NELL DORR
TONI FRISSELL
LAURA GILPIN
LOTTE JACOBI
CONSUELO KANAGA
BARBARA MORGAN

BY MARGARETTA K. MITCHELL

A STUDIO BOOK · THE VIKING PRESS · NEW YORK

CONTENTS

This book is dedicated to:

Berenice Abbott
Ruth Bernhard
Carlotta M. Corpron
Louise Dahl-Wolfe
Nell Dorr
Toni Frissell
Laura Gilpin
Lotte Jacobi
Consuelo Kanaga
Barbara Morgan

and the energy,
courage, and spirit
of camerawomen everywhere

". . . endeavouring to clothe my little
history with light, as with a garment, I feel
confident that the truthful account of
indefatigable work, with the anecodote of
human interest attached to that work, will
add in some measure to its value."

JULIA MARGARET CAMERON,
from her manuscript,
Annals of My Glass House,
written in 1874

FOREWORD

As the only male voice in this book, as a fellow photographer, and as Executive Director of the institution that enthusiastically embraced the exhibition concept suggested by Margaretta Mitchell, I feel privileged to write this introduction. But these are only the obvious and surface reasons; the true privilege is in having personally known six of the photographers, having lived in their time, and having followed their careers.

The past decade will be noted in the history of photography as the beginning of a revolutionary era for the medium. The process began in the United States, and its effect is now felt globally. The recognition of photography is all-pervading, on museum and gallery walls, in living rooms, on the pages of topical magazines and in books of illustrations, and now in monographs on outstanding work. This has all become a welcome reality, especially for one who remembers when it was impossible to sell a print or to find museum space to hang an exhibit.

Recollections: Ten Women of Photography takes the concept a few steps further. The work of these photographers illuminates our century from the vantage point of these exceptional women. Their individual careers, their areas of interest, their artistic sensibilities, their lives—shown through their work and revealed through their words—take us to worlds never explored before in quite this way.

A word to those not familiar with this century's great women photographers. Because this collection concentrates on the work of living and active photographers, it could not include the work of Dorothea Lange and Margaret Bourke-White, who died in 1965 and 1971, respectively. I miss their area of interest, their passion and commitment to social justice, and the coverage of historical events which are outside the scope of those represented in this volume. Thanks and appreciation are due to Margaretta Mitchell, who has quietly, painstakingly, and modestly assembled the words and photographs that make up *Recollections.*

CORNELL CAPA
Executive Director
International Center of Photography

May 15, 1979

INTRODUCTION

The history of American photography in the twentieth century includes a generation of remarkably creative and able photographers whose place in that history is still to be adequately understood.

The publication and presentation of *Recollections: Ten Women of Photography*, both this book and the traveling exhibition of the same title, will begin to redress the balance by reviewing the lives and work of women whose contribution to the history of photography has not yet been fully recognized. Aside from gender, their only tie to one another is that of age: all these photographers were born around the turn of the century. Their work reflects a panorama of life experience and more than seventy-five years of photographic history. Their generation lived through drastic social change and observed extremes in social mores, ethical values, and the definition of good taste in art as well as life. The world they knew as children was abruptly upended by World War I and their adult lives were disrupted by World War II. Seen as a group, their photographs form a bridge of perceptions moving through these shifts in style. Today they are among the distinguished elders of their profession. Their subject matter ranges from fashion to still life to poetry, from portraits to landscapes, from scientific documents to painterly abstractions. The majority of their photographs have not been shown recently and some of them have never been exhibited at all. I hope that these small retrospectives will serve to introduce these women's work to younger generations of photographers.

Recollections is not a historical survey; rather, each section presents a selection of words and photographs mutually agreed upon by the editor and photographer. The text material illuminates their lives, reveals their use of the craft, and explores their relationship as photographers and as women to the history of the medium. Thus the book contributes to both the literature of photography and the literature of women. This presentation has both cultural significance and timeliness. The individual sensitivity of each woman draws attention to the possibilities open to those with the courage to rise above the stereotypical concepts of women's lives in twentieth-century American society.

I know that to categorize photographers as women photographers or men photographers is to create an artificial division of labor. After all, as Imogen Cunningham retorted when asked about her work as a woman photographer, photography has no sex. I have chosen to focus on women in this book not because I want to preach for a segregated sensitivity but because I want our society to recognize more fully the creative work of its women now. I am a photographer and I was drawn to study the women conspicuously absent from photographic history.* I have sought the oldest photographers, because in their lives is the true capacity for accumulated wisdom.

During the different stages of the research and the interviews for *Recollections* I felt drawn back to my own beginnings in photography during the late fifties. The best known accessible work of the day was by men. The technical wizardry of those photographers (who were also fascinating personalities) was unquestioned, yet I was strangely untouched by it. I could admire the work and learn from it, but since I could not follow the male role model, I often could not understand how their life and work blended. I began to sense uneasily that there was no relationship between their path as men who practiced photography and mine as a woman who wanted to do the same. I turned to the bookshelves and galleries for work by women.

A lonely search, but fortunately I found a biography of Julia Margaret Cameron, an extraordinary nineteenth-century Englishwoman who found herself as an artist through the practice of photography. Her portraits of the great writers and thinkers of Victorian England have become virtual icons of the era. She took up the camera in her forty-eighth year and zealously worked from a canon of beauty derived directly from European painting. For the most part the men she photographed were portrayed

as Great Men; the women posed for her camera as symbols of great ideals. Her work was great theater, and so was her life. Mrs. Cameron ran a large household of family and servants who all posed for her camera. She was free from all convention; she was impulsive and demanding, "a very picturesque and eccentric personality who lived her life according to her own will, yet who was deeply devoted to her family and friends, though both were subordinated when she found a higher purpose in life—Photography."[1] She had to take considerable public criticism for her eccentricities. The Photographic Society of London criticized her work (they disapproved of her lack of proper technique) even though they acknowledged its greatness. They commented, "We are sorry to have to speak thus severely on the work of a lady but we feel compelled to do so in the interest of art."[2] But they did not prevent her from photographing in her own way. For "she was a woman who feared no man."[3]

In further study of the history of photography I came across issues of *Camera Work*, the journal edited by Alfred Stieglitz. During the first two decades of the twentieth century he led the crusade in America for the acceptance of photography as fine art. Stieglitz published the work of Gertrude Käsebier and Anne Brigman, two women whose work was well received. Mrs. Käsebier, like Mrs. Cameron, was a successful portrait photographer who took up the medium in midlife and developed her own pictorial style. The photographer and poet Anne Brigman made pictures of nudes that dramatized the feminine spirit in nature.

For encouragement and energy, I was able to draw on more contemporary photography from Barbara Morgan's dance photographs to Berenice Abbott's New York scenes. I found myself strongly drawn to Margaret Bourke-White's work for *Life* and Dorothea Lange's view of the Depression and its dust-bowl refugees. One day I was privileged to discover *Mother and Child*, a small book by a photographer named Nell Dorr. I was captured instantly by its idealized and romantic imagery. I had noted

* Two recent books that present the work of women photographers are: Margery Mann and Ann Noggle, *Women of Photography: An Historical Survey*, San Francisco: San Francisco Museum of Art, catalogue for exhibition, 1975; and Anne Tucker, *The Woman's Eye* (New York: Knopf, 1973).

[1] Helmut Gernsheim, *Julia Margaret Cameron, Her Life and Photographic Work* (London: The Fountain Press, 1948), p. 11.
[2] *Ibid.,* p. 41.
[3] *Ibid.,* p. 42.

her prints in the "Family of Man" exhibit at the Museum of Modern Art in 1955, when I was still a devoted student of painting and engraving. Something in Nell's vision fitted my own.

Nell Dorr was the first photographer whom I actually sought out. I met her in 1958 and found her as magical in person as I could have hoped. And her words, too, were right for me: about following the light, about love, about living my dream. She was a wife and mother, a perfect role model since I was on the threshold of marriage. It was natural for me to make portraiture my own photographic specialty, first at home with my family and later as a full-time career.

In my recent portraiture and writing I have focused on the work of older photographers, some of whom have not been published for many years but who have fine work to show and many important things to say. I became more and more absorbed in the question of old age itself, seeing in some of the people I studied a creativity maintained well into the late years. This was particularly true in my research on the lives of Imogen Cunningham and Dorothea Lange.

All of us, young and old, need more vital examples of courageous old people. Other cultures and other ages can teach us, but best of all are the voices of our own oldest generation. We cannot know ourselves unless we revisit the past, return to the source, reconnect with our cultural tradition through the survivors—in this case, the older women.

It is a challenge to our iconographic memory to summon up images of great older women, to discover a positive, powerful image from our Western culture: a vision of the older woman whose strength of character, intellectual energy, and artistic (or other) achievements in the world give white hair and wrinkles an unambiguous beauty. There are virtually no useful prototypes. Except as Mother or Grandmother, old women in our culture are even less respected than old men. Women must stay young and selflessly giving to be deemed beautiful and good. Old and "selfish" is ugly. Every old crone in fairy tales becomes a witch. Powerful older women are

perceived as negative, or at least unfeminine, especially if they reach for their own greatness. Their power appears masculine because achievement is still associated with acting as men do. There seems to be no image at the source of our cultural memory that is not based on biology. For that reason, and because women today so often outlive their years of motherhood, it benefits us to study the lives and work of older creative women. Eventually, from studies in different fields, enough of the positive power of older women will be evident and we as a culture will develop a new perception of women.

In this study it is not difficult to perceive the effect on women's lives of the idea that achievement is male. In these biographies the father was always thought of as the contributing member of society. The mother might be present and a positive influence, but it was difficult to imagine her personality outside her role as mother. On the other hand, I received vivid accounts of fathers, not all lovable but always worth an anecdote. In our society at the turn of the century mother was a "place to be," father a person doing something. The issue is not who or what he was, but the power invested in his position as titular head of the family. The women in this book were all unusual in their sensitive awareness of themselves as artists, but only a few consciously felt a double standard as women early in life and took a stand.

The photographers in this book are true pioneers. Each one began her life work during a period in which the cultural atmosphere was still subtly antipathetic to women. Photography was becoming "big business," and it was largely male territory. The professional photographer began to face increasing competition as the craft became a useful advertising tool for industry. It sometimes required mobility and demanding hours, which were difficult for women with family obligations. It is evident from the choices of subject matter and life styles described here how each photographer reacted to this necessity. Some tried the commercial field and fit into a niche that suited them; others fled

from the cultural mainstream; still others supported themselves by teaching or doing portraits. Some of the women married and hired domestic help. Others waited until their children had grown up to pursue their own careers.

The 1930s and 1940s were the decades in which these photographers became established. The war years set the stage for women to take men's jobs. Because there were so few professional women in the field of photography, those who worked were readily accepted, provided their work met the standards of the profession. Margaret Bourke-White and Dorothea Lange were fortunate to be able to use their photographic talent and at the same time produce imagery that met the needs of the government. This was also true of Berenice Abbott for periods during her career. Toni Frissell and Louise Dahl-Wolfe understood how to satisfy their magazine editors and maintain their own standards at the same time. Several of the women worked privately so that they did not have to conform to any hierarchy of taste and style; they deliberately chose to stay out of reach of critic or curator.

Although all these photographers have received some recognition, only a few have seen their work widely appreciated. Each has used photography in her own way, to express ideas or convey an experience, to sell a product, to document her own life, to experiment with form, to record a place, a landscape. But only two of these photographers, Berenice Abbott and Barbara Morgan, are mentioned in Beaumont Newhall's *History of Photography*. The others are little known outside their own coteries.

Berenice Abbott's own photographic contribution was initially obscured in this country by her monumental task of preserving and publishing the work of the French photographer Eugene Atget, in itself an admirable achievement. Her American reputation has rested largely on the extensive documentation she made of the changing city of New York during the 1930s. However, Berenice Abbott is also a sensitive portrait photographer who understands intuitively how to bring out strength in women and gentleness in men. Her portraits are remarkable character studies, especially those from the Paris years.

Treating all her subjects with respect, she is never content with stereotypes.

If I found Berenice Abbott fearlessly proud, even bitter, it is because she has stood by her convictions, pursuing her work for years alone, at greater risk than most women of her generation. Always insistent on the unflinching observation of life as it is, she has consistently spoken out with a passionate intensity for documentary photography. Berenice Abbott is spirited and serious not only as a photographer, but also as a thinker and as a woman.

Barbara Morgan, for many years a painter, became a photographer with the encouragement of her husband, Willard Morgan, himself a publisher and photographer. The photographic community immediately recognized Barbara's talent. Fortunately, her work was visible from the beginning not only because she had that support but also because her ideas were large. Hers is a mental kind of vision composed of readable visual metaphors, like symbols in language. Hers is a cosmic view of life in motion. She is a thinker, a seeker, eager to learn from whatever life presents to her, a philosopher who seems at once air-borne and earthbound. A convert to the medium, Barbara Morgan has become a missionary for photography, lecturing and writing as well as photographing.

Few women who have practiced photography have achieved recognition as great landscape photographers. In this especially male-dominated field Laura Gilpin has established a solid standard. Although she has done many kinds of photography, Laura Gilpin is mainly considered a landscape photographer of the Southwest. What fascinates me about her is her matter-of-factness. In her presence everything is possible; difficulties are problems to solve or facts to live with. She has traversed the landscape for seventy-five years, using all formats from standard to 35 mm., and most of the processes possible since the early days from autochrome to silver to platinum. She has continued to work in platinum, mixing it herself since the preparation was taken off the market almost forty years ago.

Laura has the dignified reserve of a person who has kept to herself—shy but absolutely direct, respectful of others, modest but

with a chuckle. Not a trace of artistic temperament. She is, in her own words, "a worker doing what I do best, photography." Another photographer who sees herself as a worker is Louise Dahl-Wolfe, who photographed for *Harper's Bazaar* for almost forty years. As a fashion and still-life photographer she is especially admired for her masterly work with the early 8-by-10 color transparencies as well as for her painterly use of studio lighting, solving pictorial design problems with concepts derived from her lifelong studies in the history of art. She was a member of the team that worked under Carmel Snow to create a classic concept of beauty that is now thought of as the *Harper's Bazaar* look. Her portraits are a photographic witness to the literary, artistic, and theatrical discoveries of the era.

For Toni Frissell, also a magazine photographer, the camera was an extension of the eye, leading her on adventures all over the world, but especially in England and America. Largely self-taught, she claims that she really never did more than shoot, shoot, shoot. Her camera was a passport to a world of action, of sports, of glamour, of travel to other countries or into a romantic storybook of her own making. In her early days on the *Vogue* staff she was one of the first fashion photographers to take her models out of doors to project the liberated, scrubbed, sporty look that she herself made chic.

Her wish to chronicle her times came true: her photographic collection stands as a remarkable record of a stratum of society: the people, the fashions, the celebrations and events. Most of the time she herself was as much a participant as a spectator. The photographer Nell Dorr has simply expressed her inner life as it has been lived. She speaks in words and pictures as a mother and poet, openly and subjectively responding to life. While she has photographed many subjects—nudes, flowers, people, and places—always her underlying theme is mother and child, the title of the best known of her books. She retains a childlike capacity to live in the present and savor the simple pleasures of everyday life. She does not confront her subject with the

camera; she reveals it. As a result, her pictures are like clear glass windows into another world, often a dream world. Nell's books form an intimate journal of a woman's inner journey, of her many aspects and archetypes: child, maiden, bride, wife, mother, matriarch, and muse.

She describes herself as "drawn to light." Like Lotte Jacobi and Carlotta Corpron, Nell has had a fascination for the camera-less print, many of which appear in her books, adding to the dreamlike quality of the sequences. Out of her own need, she has sought universal meaning through living, using the camera to record the moments that to her were magical. And she makes it all seem so simple.

Like Nell Dorr, Lotte Jacobi followed her father in a career as a successful professional photographer. The firstborn, she was predestined to her profession, a fourth-generation photographer in a family of photographers. German by birth, she made portraits full time for the Jacobi studio in Berlin until she came to this country in 1935. From an early desire to be an actress she was drawn to make theater portraits. Consequently her early work is a composite portrait of the German cultural scene. She claims no special approach to portraiture beyond being highly intuitive and keeping her own personality out of her portraits. As the actress knows how to disappear into the role she plays, the photographer becomes a medium for her subject. In her own words: "I only photograph what I see. My style is the style of the people I photograph. In my portraits I refuse to photograph *myself,* as do so many photographers."

The life work of Lotte Jacobi includes a series of light inventions called "photogenics," distinct from photograms because they are made not just without a camera but also without any recognizable objects. She describes the technique as simply drawing on photosensitized paper by moving the light source, glass, or cellophane to allow subtle nuances in the play of light. Never is the intuition of an artist more challenged than in a technique developed from such minimal materials.

A humanitarian with the camera, Consuelo Kanaga was a confessed perfectionist in her work, always pulled in too many different

directions to be single-minded and ambitious for herself as a photographer. She would just as soon make a bowl of chili as a print. Her concepts about making photographs were closely patterned upon those of Stieglitz, whose *Camera Work* she admired, but her own direction was more compassionate than aesthetic. She exhibited with the f/64 group in the early 1930s; she photographed black people before the days of civil rights and poor people before the Depression. Humble personal moments, objects, and places were her subjects. She watched for beauty in unlikely places, and her photographs, while few in number, were made with care, one by one.

A universal poetry extracted from particular form speaks in the photographs of Ruth Bernhard, whose vision is drawn to the inner designs of nature where she finds the essence of the subject: a face, a nude, a shell. Philosophically androgynous, she deliberately chose to emphasize the female nude because "woman has been the target of much that is sordid and cheap, especially in photography. To raise, to elevate, to endorse with timeless reverence the image of woman, has been my vision. . . ." Her best photographs of nudes bring to mind the carefully composed harmony sought by the sculptors of ancient Greece. In a sense her photographic work is a visual extension of a devoted meditation on the beauty of matter itself, on the life force universally present in form. As a teacher she is a catalyst for perceptive intuitions that rise in her students from the example of her meticulous attention to the act of seeing.

Like Ruth Bernhard and Berenice Abbott, Carlotta M. Corpron has been a fine teacher as well as a photographer, but for her, teaching was the full-time profession and photography the avocation. Her work with the camera evolved side by side with her teaching of design, art history, and creative photography, in which she emphasized the making of photograms. Out of that experience with students she developed an experimental approach toward the medium that enabled her to design freely with light, taking her guidance from her association with Georgy Kepes. For a period of ten years she worked at those compositions with intense concentration. Using glass bricks or venetian blinds as reflecting surfaces and transmitting substances, she let her work literally follow light, which she describes as "entering the experience itself." She was led to explore the full potential of light, to use its subtle variations much as a painter uses a color palette. Her example moved her students to a concept of art as an activity that truly creates something new out of material.

In the course of researching this book, I listened to each photographer draw the pattern of her life's design, and in each I found common motifs. Each woman remembers her young self as independent, rebelling against convention, or encouraged by parents to become self-reliant. After a lifetime, all of them are satisfied to stand for what they say in their work, for what they are today, with neither apology nor overdeveloped ego. They have followed their own authentic natures in ideas as well as technique. Even those women whose work demanded that they become successful in the male-dominated business world were at home with themselves. There was agreement that it took extra amounts of energy, risk taking, and ambition to work in that world. Any normal self-doubt had to be more than counteracted by confidence solidly supported by others: a sympathetic art director, manager, husband, or working partner.

The making of this book has been a transforming experience. I discovered with a jolt that the choices made by these women of an older generation were the same choices I and other working photographers have to make today. I had hoped to discover a way to resolve the conflict in our society between one's life and one's work. After the interviews were over and the texts completed, I realized that if there is any resolution, it is in the individual reward gained through a lifetime of effort.

The women entrusted me with the stories of their lives and work. Each statement was revised by each photographer and then reshaped to her satisfaction. My place was at the edge, focusing light on them through brief retrospectives that present their words and work for an ever-widening audience of future photographers, many of whom will be women.

Under the avalanche of words and pictures from the past I had a recurring vision of the Sunday afternoon visits I made as a young child to my great-grandmother, then in her eighties. She received me in her room where I would sit on a footstool in front of her high-backed chair, looking at picture postcards from a dusty Chinese papier-mâché box, painted with now-faded chrysanthemums and latched with a brass oblong lock. "There I am on a camel in Egypt; that is Marienbad; those are Swiss wild flowers. You can have them, take them home and start a collection." Each carried a story, a memory, an enthusiasm. I traveled into the past with her; she gave me her memories and inspired my dreams. In some sense I have always been preparing to make this present journey, hearing life stories, moving from world to world, studying pictures and faces and gestures for clues to personality. The journey has been convoluted, visionary, and at the same time humble and practical. As if in a myth, the journey moved back in time, through the living memory of others who have been there and who, were they not asked to tell their story, might remain silent: another unwritten chapter in the history of women's lives.

As a daughter, making this book has been for me like a journey home, home to where the spirit lies. As though I were on a drive in the curve of a bare hill in late November on a road winding down to a village nestled in its arched side, I have been traveling in the variegated human landscape I love, that of relationships across the generations. In that landscape all the hills have bare trees now, some still hung with dry leaves, most like magnified feathers against the sky that darkens toward evening. The fireball of a sun in the western sky turns the tree branches to charcoal. Light lingers along the meadow and washes the tips of the trees a sharp metallic golden yellow. The turn taken here is decisive: toward a weathered landscape where time drops away and only the light is left. What a clear bright light it is that radiates from the energy in these recollections from ten great women of photography!

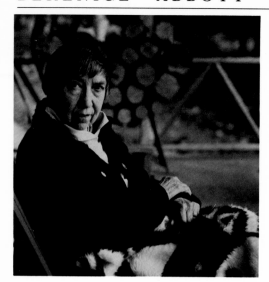

For the last decade the home of Berenice Abbott has been a sturdy white house with green trim and a fire-engine-red tin roof far up north in the lake country of Maine. Knowing her exclusively through published work, I carry with me only a partial impression of the person I am about to meet. At first, there is a wariness in her eyes and in her squarely-planted stance that spells resistance to this interruption of her day. But Berenice Abbott is accustomed to questions about her career in photography and it is not long before she takes command of the conversation. She talks decisively and to the point on everything from portraiture to physics. Always affirming the documentary approach, she speaks in measured prose with plain (and witty) practicality. Her ideas have a kind of clarity that is appropriate to the air of the northern woods. She is as down to earth as her red L. L. Bean shirt, khaki corduroy trousers, blue socks, and red sneakers. She has projects in mind but these days Berenice Abbott finds little time to photograph; there is too much demand for prints from her earlier negatives. When she can, she relaxes at her cabin on a nearby lake where Butch, the huge marmalade cat, is in charge. Central Maine is a great distance, in every way, from the Paris and New York of half a century ago. And her long study of science through photography may seem unrelated to the mist rising on the lake in Maine on a July morning, but Berenice Abbott knows the best place at the right time for herself and her photography.

I was born in Springfield, Ohio, in 1898. I was unhappy as a child, had a fragmented family, but it taught me self-reliance. I was forced to be a very independent kid. At one point I wanted to be a farmer, at another an astronomer, and then a journalist. I also wanted to fly, but women were not permitted to learn.

I went to Columbia University to study journalism and it seemed like a hell of a sausage factory to me. But I had grown up in a haphazard way without any help from the outside, so I found my way. Next I tried sculpture. I grew interested in art, but of course I had to work and earn a living. I worked in an office for a while and hated it. I came up the hard way—knocks and knockdown again.

I didn't decide to be a photographer; I just happened to fall into it. I saved money to buy a one-way ticket to Europe. I thought I may as well be poor there as poor here. I worked as an apprentice and then as an assitant to Man Ray in Paris in 1924. It was a good way to learn. Man Ray never showed me how to take pictures but how to do the darkroom, the finishing up, all the general work involved. I developed and printed for him. Man Ray took magnificent portraits of men, but nearly all of his women were beautiful objects, beautiful still lifes. I learned mostly by trial and error after getting a bit of technical know-how. I think my work in sculpture helped. Any work in different media helps.

I opened a portrait studio in Paris but it was not for financial reasons exactly; it just evolved. These things you don't decide, you learn in the process. You apprentice yourself. You learn in some way and you work whichever it may be, hit or miss. At that time I took about six shots as a rule.

When I first came to New York I lived at the Hotel des Artistes. The studio had good northern light, and that helped with portraits. During the Depression I had to move to a less expensive apartment downtown. There I had to use artificial lights entirely, and it was death to portraits. It is no way to photograph people. You need a good skylight. You need illumination, maybe an accent or two; but you must keep it very simple as far as I'm concerned.

Portraits are very interesting to do but the photographer has to have a flair for it. It is difficult because during the taking there has to be a kind of exchange. I only tried to let people be themselves. You can't pose them. Friends used to say to me, "You could make better money if you would charge less and do more." I just could not do it. I would take one person a day and that was enough.

Not all of my portraits were done with studio lighting. I had one place with good light in Paris—where I did James Joyce. His eyes were bad and I couldn't have had

a single light on him. That is when he wore his hat to shade his eyes. The one with the patch was taken at a different time, in his apartment. He had serious problems with his eyes. I liked Joyce very much. I thought he was a very elegant person.

After I had lived in New York about five years I taught one evening a week. I tell students that you have to learn the way a flower evolves. It is a seed, a nothing in the ground, it germinates and grows a little bit and—boom!—the whole plant. You grow gradually and maybe you learn something as you evolve. But by being forced and trying to pick it up from someone else, you cannot grow naturally, for yourself. There are many teachers who could ruin you. Before you know it you could be a pale copy of this teacher or that teacher. You have to evolve on your own.

My portraits have not been recognized in this country. They were all recognized in France, but that was in the 1920s. After a decade abroad I became nostalgic for my own roots and decided to return. I came back at the height of a considerable success in Paris, which I've never known here.

When I returned to this country I fell in love with New York. It was overwhelming after so many years away. But I had to earn my living. I was a professional photographer and that's how I paid my rent. That meant doing commercial work, anything that came up. There's nothing wrong with good, honest commercial work. It's good technical experience. The money situation determines what you do—but I knew

that I wanted to photograph New York primarily, so I decided to take at least one day a week, without any interference, for New York alone. When you undertake a project you can make mistakes, but you have to learn. If you expect somebody to show you how, you'll never do it because you learn most by doing it yourself. Talking about it alone doesn't get it done.

My American reputation was really made on the New York work. Even in those days when I sold prints I tried to keep my values high and I would never sell a picture cheaply.

My work was known by word of mouth. It takes time, maybe a lifetime. But I had too much respect for my profession to photograph for nothing. Supplies cost too much, as does good equipment. I just paid over six thousand dollars for an enlarger. Lately I have had a renewed interest in taking portraits.

I think the important decision for a photographer is to choose a subject that intensely interests him or her. While I loved more than anything to photograph New York and I could have worked all my life on it, it was lost to me because of overwhelming financial difficulties.

I decided to change my subject. It was an age of science and I decided to know more about the subject myself. I wanted to learn by photographing it. We sorely needed it—we live in a scientific age and are generally very ignorant. We have a handful of short-sighted, myopic scientists just sending us straight to hell as fast as they can. All of us little squirrels are down on the ground with our little nuts and sunflower seeds. Most of us don't even know what makes the light go on. I decided to photograph electricity as a starter. What was it, anyway? I'd seen men who were experts in the field and I'd ask them to collaborate on such a project. The general feeling was that it couldn't be done. So I had to decide to try it without them. I had to study it, to understand it. The result was mixed but I did get valuable experience and a few good pictures. I had to actually build photogenic apparatus.

I was going broke doing that because it was really time-consuming and very unrewarding and discouraging. I made trips to try to stir up interest—to Washington and Pittsburgh—and nothing came of it. I went to a Bronx high school where they have a considerable reputation in science. I got the same old-fashioned answer. "Well, we've got these diagrams. We're satisfied with them. We don't really need photographs." Physicists all seem to think they're photographers, just as doctors do. Finally, I got in touch with Robert C. Cook in Washington, D.C., who learned of my efforts in that direction after I met him in Pittsburgh quite a few years back. At the time of Sputnik, I said to him, "Maybe the interest in the physics project might come to life." He knew of a group doing a new book on high school physics, a group called the Physical Science Study Committee, started at MIT. This resulted in a job to photograph what I most wanted to. It was a success for me and very interesting. I loved what I was doing and worked hard at it. I have always wanted to understand why artists don't understand scientists and scientists don't understand artists. They really need to work together, even though they are so unlike in many ways.

When the science project ended and the book was finished, I moved to Maine where I had bought a home. I agreed to do a book on Maine, which resulted in *A Portrait of Maine*. In that book I tried to express the essential properties of the place. I am working today as I always have, doing all sorts of things that interest me, but I never talk about work while I'm doing it.

You asked me to sum up my photography. I think my work is very American. In the first place, I am American and deeply so. I lived away from this country for a while, which gave me a perspective, then I came back with a kind of nostalgic boom. In broad terms the work I have done here is really the American scene, which I think is very important to photograph because the United States is such a changing country and is still young. Photography can only represent the present. Once photographed, the subject becomes part of the past.

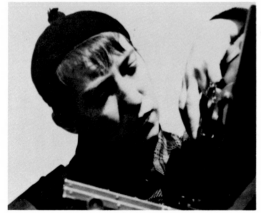

Berenice Abbott, c. 1935. Photograph by Consuelo Kanaga, courtesy Marlborough Gallery.

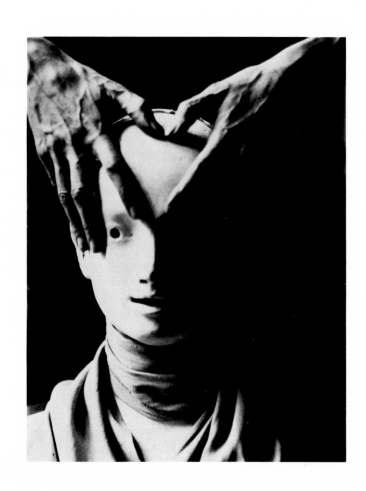

Cocteau's Hands, 1927

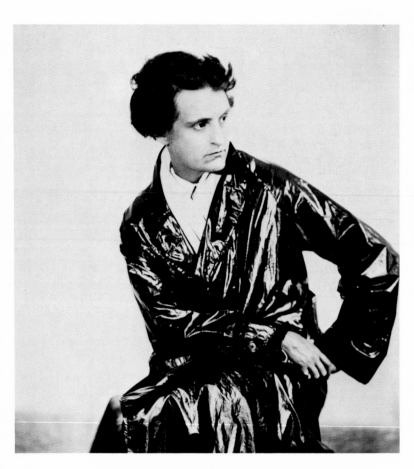
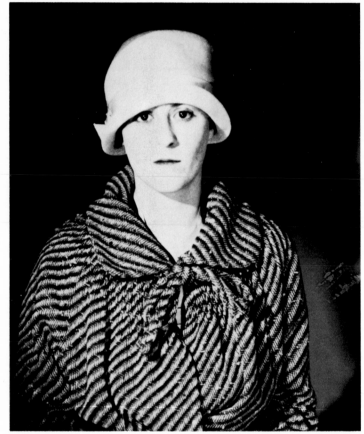

Sylvia Beach, 1927

Sophie Victor, 1927

16

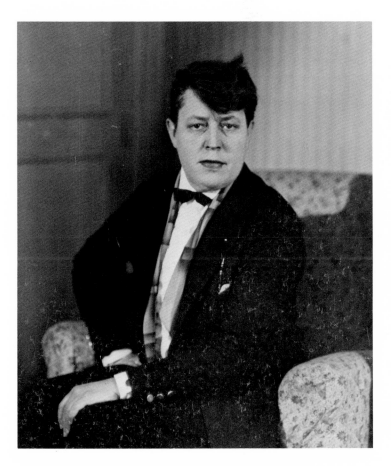

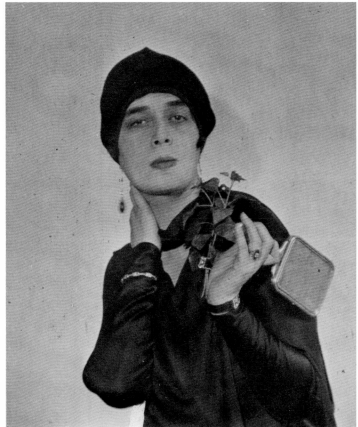

Princesse Marthe Bibesco, 1927

Jane Heap, 1927

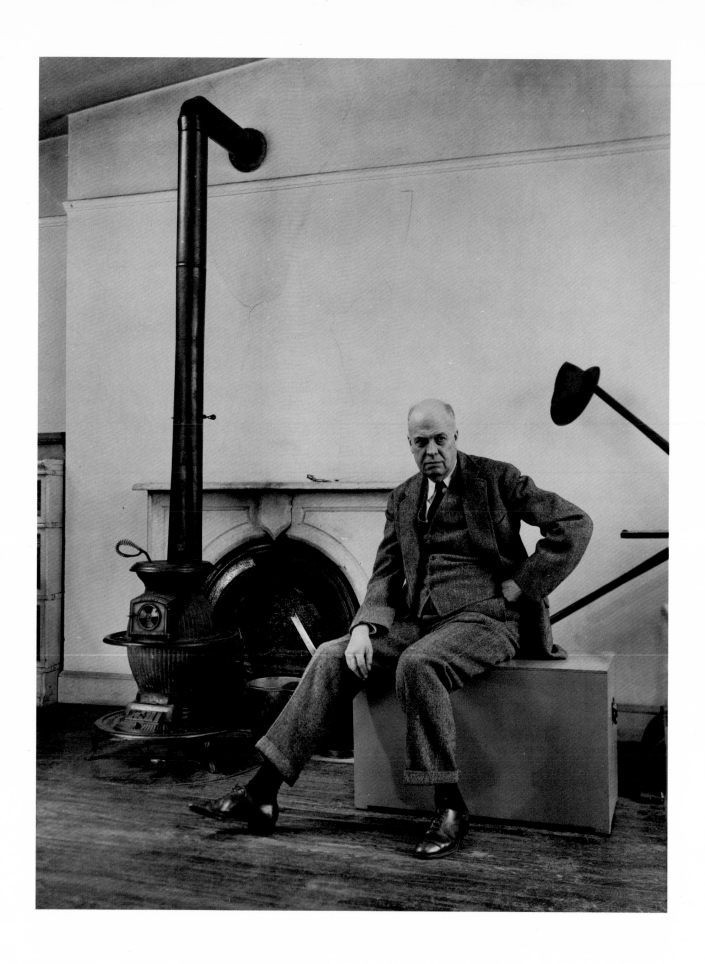

Edward Hopper, 1949

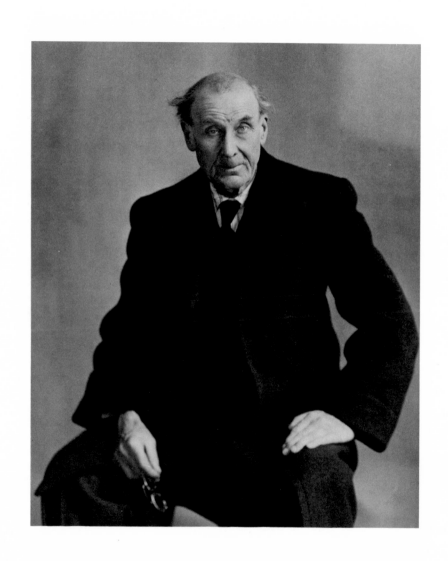

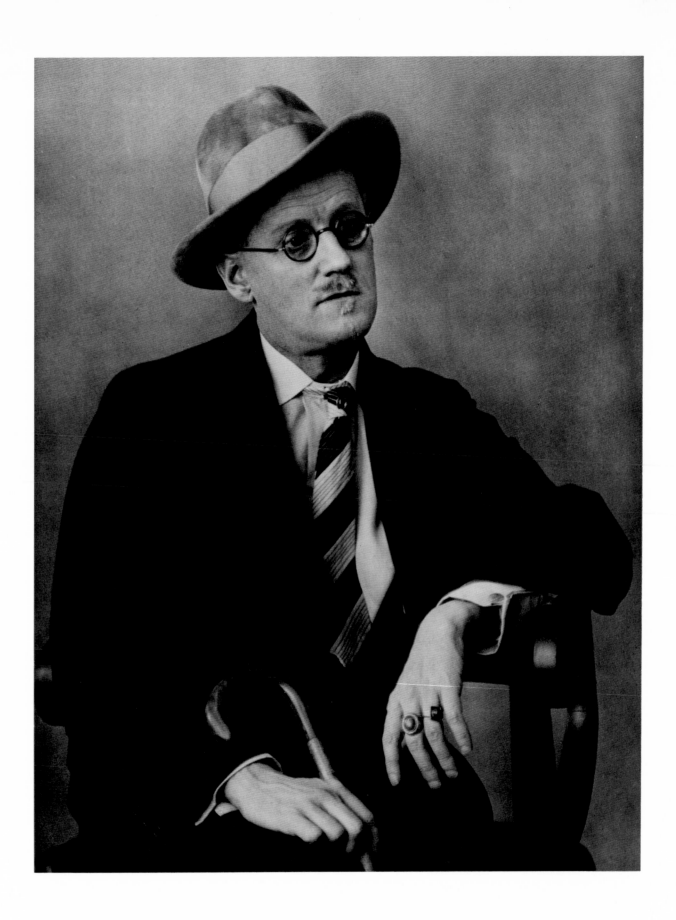

James Joyce, 1928

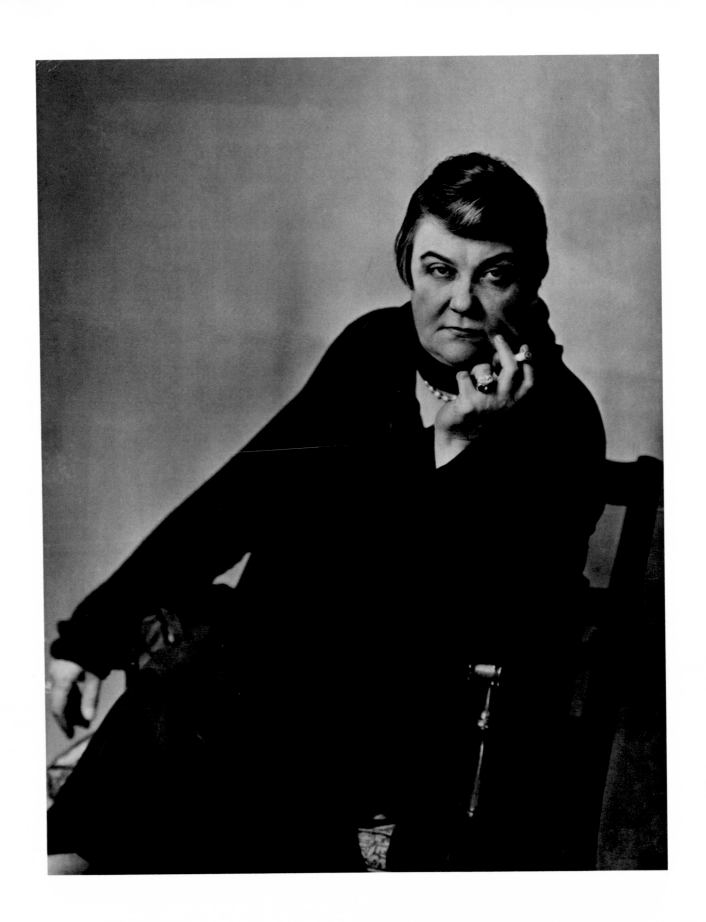

Princess Eugène Murat, 1929

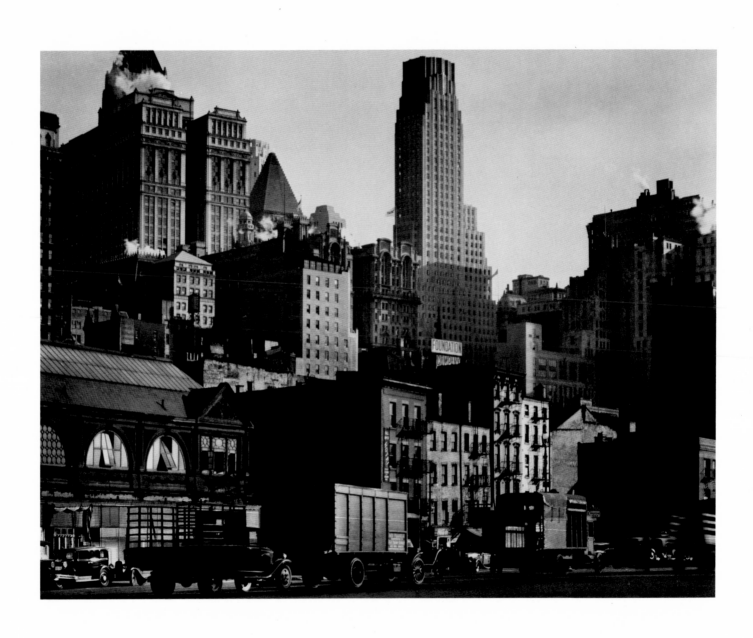

West Street, New York, 1932–33

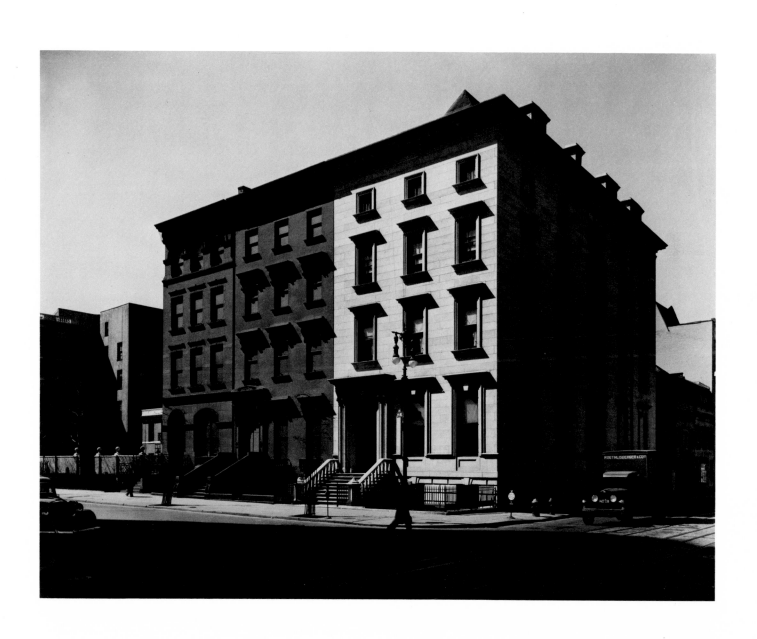

Fifth Avenue and 8th Street, New York, 1937

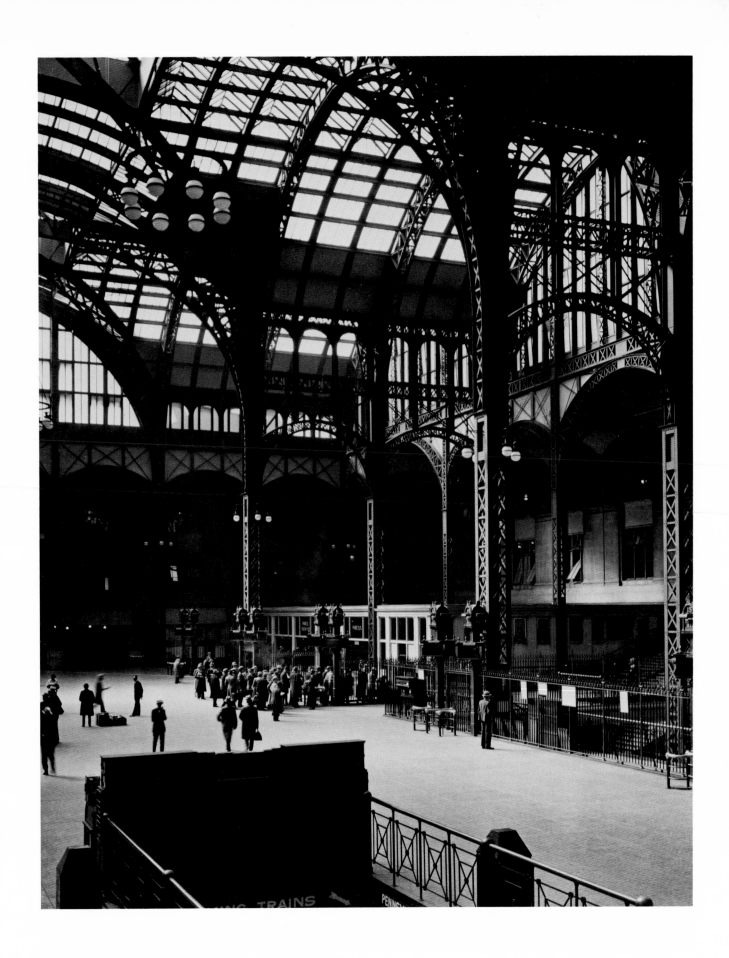

Pennsylvania Station, New York, 1937

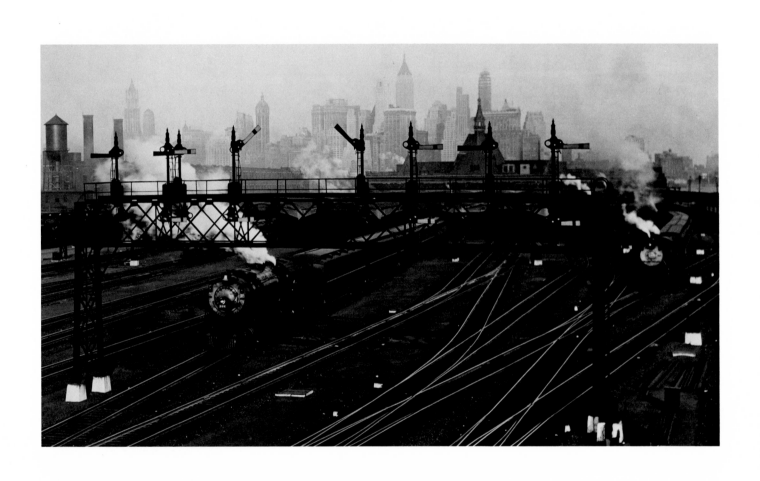

Jersey Railroad Yard, 1932

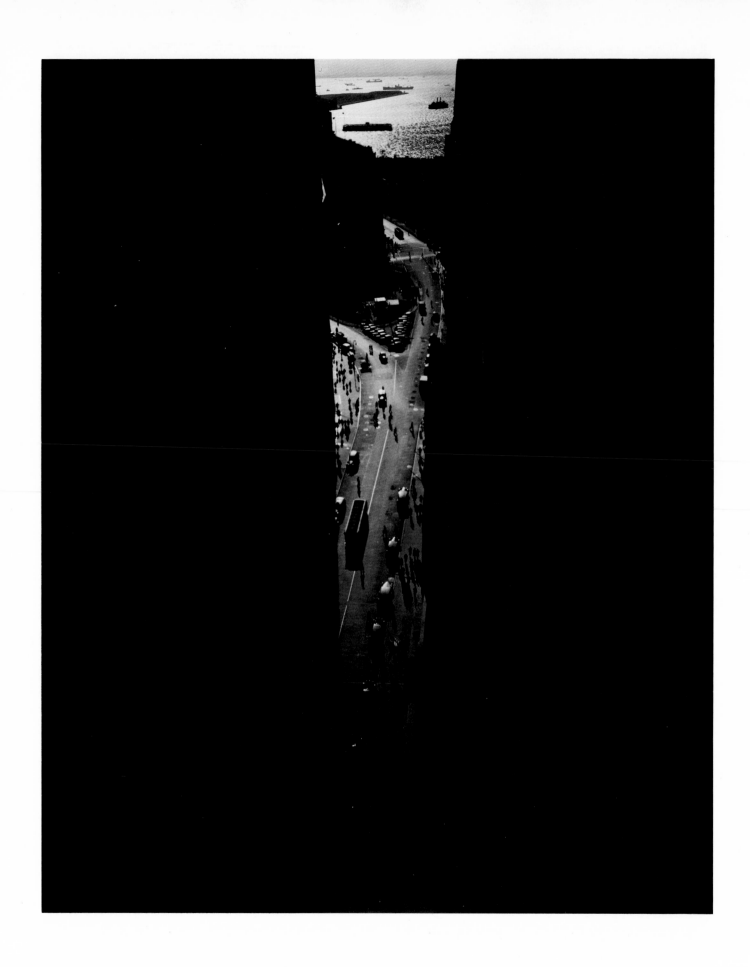

Canyon, Broadway and Exchange Place, New York, 1933

26

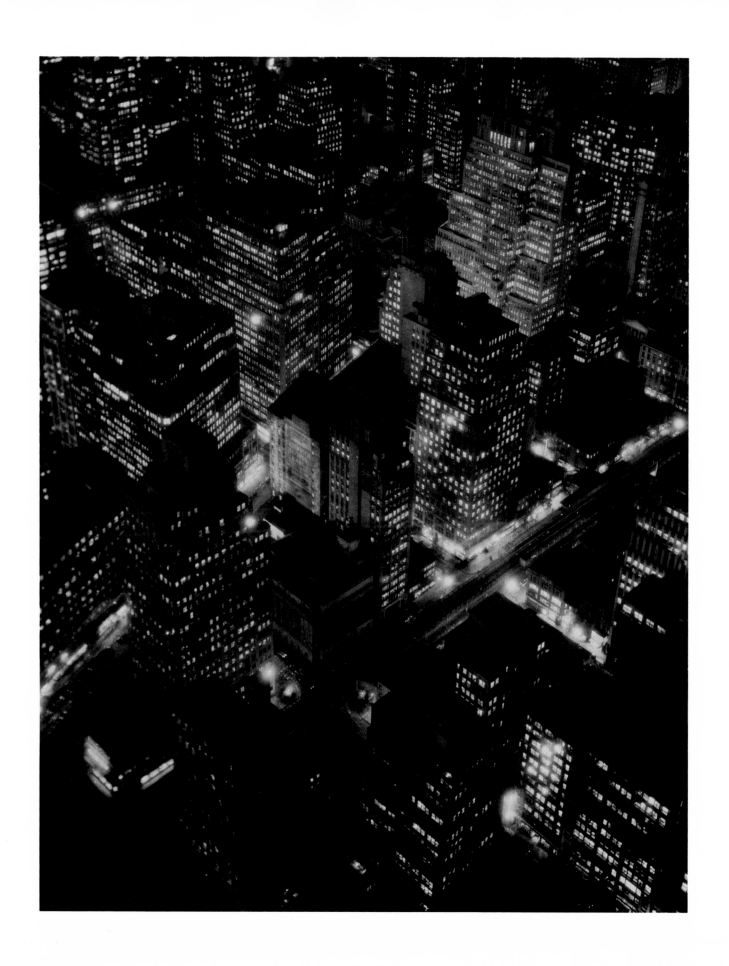

New York at Night, c. 1932

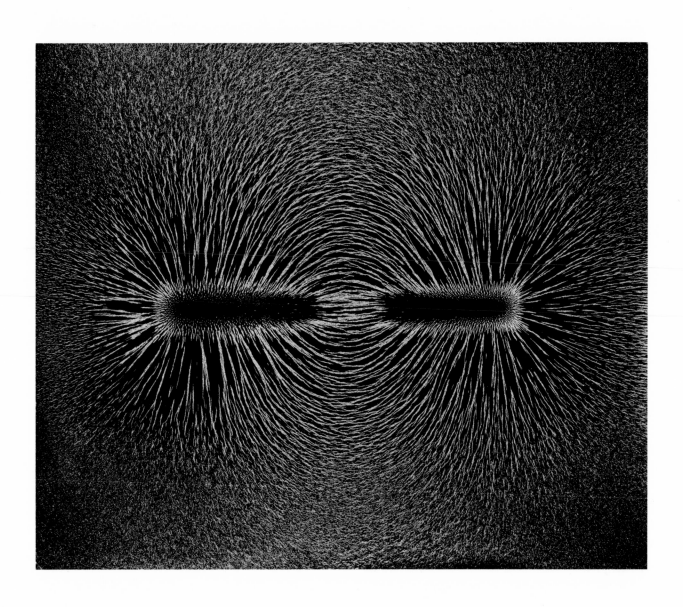

Magnetic Field, 1959

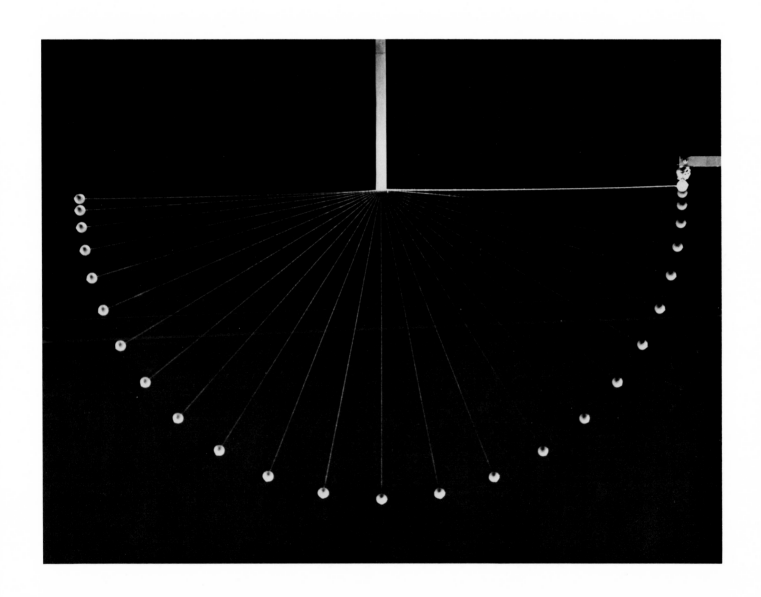

Pendulum Swing, 1960

RUTH BERNHARD

Ruth Bernhard lives in the upstairs flat of a narrow white Victorian house in San Francisco. The staircase runs straight to the top, where both long walls are hung with photographs. Ruth Bernhard is a wiry woman with short curly hair, her alert eyes parenthesized by elegant facial lines. Our conversation takes place near the bay window in the front living room. Everything seems to be white-on-white, floor to ceiling, except for one gray wall. Against all this whiteness countless natural and handmade objects demand my attention: hanging ferns, a feather, a bone, a fossil, a small bronze nude, a geometric shape in brass and others in glass, a curved gunsight lens. All are arranged on stretches of bright-colored felt for the pleasure of seeing and touching (all, that is, except for the miniature dachshund who insists on keeping a safe distance from visitors). Once settled in a chair with a fresh cup of coffee, Ruth Bernhard talks with great ease. Perennially curious about life, Ruth enthusiastically shares her well-formed concepts about making and viewing photographs, about teaching, about her own unfolding as an artist. In her present philosophy of vision and perception she retains the curiosity of childhood. Because of this, our exchange is a cooperative and energetic sharing of ideas and experiences.

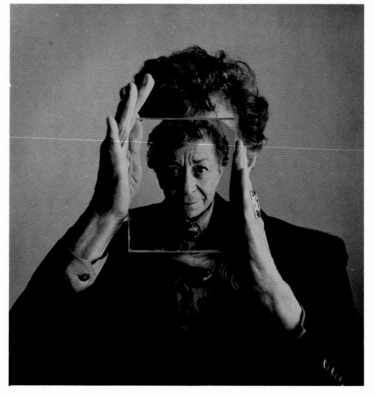

Living is a matter of passion. I feel intensely about every single day. Here I am, seventy-three years old, and still possessed with the curiosity of my childhood. Perhaps I feel even more intensely now because I'm so much more aware of what is important to me. I feel close to nature's basic rhythm, and things seem to fall harmoniously into place.

The art world is my primary interest. It disturbs and saddens me to see that the world of art and, indeed, the world as a whole seem to have changed drastically. I'm afraid I'm pessimistic about the future of the human race. All of the arts, naturally, are responding to our cultural degradation, so we find an abundance of empty and meaningless work around. The trend today is to imitate those who are successful; to work from the outside in, rather than from the inside out. To be a creative person carries with it a responsibility that many contemporary artists find difficult to live up to.

At this time in my life people ask if I ever think of death. My response is that death is a part of life—a normal transition—and it holds no fears for me. I shall die young—at whatever age that experience occurs.

When I look back on my childhood, I must say my life has turned out far better than I ever dreamed. My parents were mere youngsters when they married—seventeen and twenty-one—and were divorced by the time I was two. My mother left for the United States to remarry, leaving my young father to carry on as best he could. I have never learned how or when my father became acquainted with the Lotze sisters, Helene and Katarina. When I came to live with them at the age of two, they were in their forties and both unmarried. I remember them vividly and with affection. Their mother served as my made-to-order grandmother. All three were highly cultured schoolteachers and among other things taught me to read by the time I was four. Living with the Lotzes had a most profound effect upon me, which I feel even to this day.

Can you imagine a household consisting of thirty-six canaries, two guinea pigs, two rabbits, one salamander, and, just coincidentally, four human females? As a part of my training in responsibility, the care and feeding of the animals were relegated to me. Often we would go on nature walks to the meadows, and occasionally we'd take a trip to the seashore. These little jaunts gave birth to my "career" as a collector—of everything! Once in a while we met other children on these outings with whom I played, but mostly I was an only child among adults, though never unhappy about it. Actually, I've always felt lucky indeed to have spent my early years in such a loving atmosphere.

When I was eight my father remarried and eventually I had a sister and three brothers with whom I have always had a very close relationship.

During these years I saw my mother only twice, when I was nine and again when I was seventeen. If she possessed any special talents, I was unaware of them, but she was certainly a beautiful woman with a fantastic sense of style.

I was enrolled in boarding school when I was eleven. It offered an outlet for all my interests, especially music. In 1925, despite my great love of music, I decided to study at the Academy of Art in Berlin, taking

history and calligraphy, no doubt to please my father.

I decided at the age of seventeen that marriage and motherhood would not be a part of my life's plan. Even at this early age I was very much aware that I would need the freedom to do whatever the future held in store for me.

My father came to New York City in 1923 at the invitation of Pynson Printers and made it his permanent home. He asked me to come live with him, and in 1927 I accepted. My unexpected photographic career was launched with a job in 1929 as assistant to the assistant to Ralph Steiner, who at that time was head of the photography section of the magazine called *The Delineator*. I had barely learned to set up an 8-by-10 camera on a tripod and to develop film when I was dismissed for showing less than a burning interest in my work. With the ninety dollars severance pay I bought most of a friend's darkroom equipment, including an 8-by-10 view camera and (presto!) I owned everything I needed to get started in photography!

I had to prove to myself that photography was more of a challenge than I had experienced on this job. I started photographing and to my great surprise I enjoyed it enormously. My father's friends, mostly industrial designers, sculptors, potters, weavers, became aware of my work. They needed photographs. This gave me the opportunity to practice my new skill and to earn my living as well. I worked for Henry Dreyfuss, Russell Wright, Frederic Kiesler, and many others who were influential at that time. Eventually, I worked for Macy's and Sloane's advertising departments, and drifted into fashion photography.

I was determined not to become an "artist." In fact, if I had thought of photography as one of the arts, I wouldn't have gone near it. I suppose my attitude at the time was influenced by my fear of being second best to my famous father, whom I idolized. He was a great advertising artist, illustrator, and designer of type faces. He was most demanding of himself and others and he expected me always to do more than I was capable of.

To this day, I never feel that anything I do is good enough. I have a great desire for perfection, which, as we know, is impossible to achieve.

Berenice's studio was not far from mine in the Village, and we saw each other often. I had great respect for her and her work. One day I was at her studio and she was washing a tubful of prints. Looking down at the prints with a woeful expression on her face, she said solemnly, "It's really discouraging. No matter what I do, these prints won't last more than a hundred years!"

In 1931, by chance, Dr. M. F. Agha, a very influential person in the field of advertising, saw some of my work and was ultimately responsible for one of my early photographs being published in *Advertising Age* magazine.

I was a neighbor of Jan von Ruhtenberg, then staff designer in the art department of the Museum of Modern Art, who saw my work. I became photographer for the museum's book, *Machine Age,* a project perfectly suited to my particular talents.

Another lucky break came as a result of my friendship with Bobby Lewis, a member of the cast of a theatrical company called The Group Theater. Bobby took me to meet Alfred Stieglitz in 1942. Naturally, I had heard of Stieglitz and his ways. I was in awe of him so he could easily have discouraged me, but happily he really liked what he saw and compared me to Georgia O'Keeffe, saying we had a lot in common—skulls and bones!

I continued supporting myself in New York through photography for a number of years. Though I felt this was a pleasant way to make a living, I really didn't take photography seriously until 1935, when my attitude and life changed completely. Quite by chance I met Edward Weston while vacationing in California. Upon learning that I was a photographer, he invited me to see his work. His photographs were the first to move me deeply and bring me to the realization that photography was indeed another medium of art. In January 1936 I packed everything and left for Santa Monica to study with Weston, unaware that in the meantime he had moved to Carmel!

After looking over my situation, I concluded that my livelihood had to be made from photography, and I knew the kind of work I was looking for could not be easily found in Carmel. So I settled instead in a delightful studio across the street from the Hollywood Bowl. Acquaintances took me in hand and introduced me to their friends. Imagine my surprise one day to find an exhibition of Edward Weston's work in a bookstore gallery. Naturally, I made friends with the owner, Jake Zeitlin, with whom I am still in contact. I am especially grateful to Jake for my first show in 1936.

One day while strolling on Hollywood Boulevard, I spied a beautiful doll's head in the window of a doll hospital and I decided I must have it. The owner was curious, of course, as to what I was going to do with a bodyless head. When I explained that I was a photographer with strange ideas, he came up with what he called a "proposition." He had a small room suitable for a portrait studio. Would I take photographs of his customers' children—those who spent at least ten dollars on doll repair? I was to give them one "free" portrait and sell the rest of the sittings to them—that is, if I could. I accepted, and it turned out that the children and I were quite successful in supporting me adequately.

My passion for seashells began in my childhood. This ultimately led me in 1941 to Sanibel Island in Florida, a serious collectors' paradise. There I became friends with Jean Schwengel, a conchologist connected with the Academy of Natural Sciences of Philadelphia. Eventually I spent the better part of a year photographing her outstanding collection.

After the war I returned to southern California and remained there until 1953, when I moved to San Francisco. It was an excellent decision. It offered me the opportunity to become acquainted with some of my much admired colleagues: Dorothea Lange, Ansel Adams, Minor White, and later, Wynn Bullock. Each has contributed greatly to my life and my work. And San Francisco still remains an exciting atmosphere for me.

Teaching is at once provocative and fulfilling, and I take it very seriously. I look upon the teacher as gardener—one who prepares the soil, drops the seed, does the necessary weeding and fertilizing, and waits to see how the crop will grow. My aim is to help each student toward clearer vision and intensified experiences. I have discovered many ways to accomplish this. I ask them to write about their interest in photography. This helps to clarify their own motivations and forces them to face their photographs as mirrors of themselves. I ask them to go no farther than thirty feet from their homes, to photograph the commonplace, the ordinary things that surround them. They soon discover the excitement in their own environments. If we are aware that everything around us is constantly changing, then we can't ever become bored or lose our zest for living.

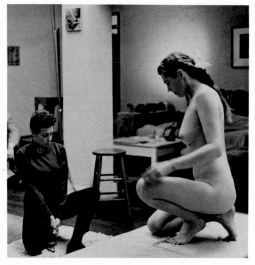

Ruth Bernhard, 1964.

We philosophize about the relationship of poetry and music to photography. I may, for example, suggest they photograph the feeling of the wind, or perhaps loneliness without including a person in the image. I want to see an image with depth. A fine photograph must go beyond the subject, must be a transformation that includes the intense feelings aroused by the experience that caused the exposure to be made. And that takes mastery!

I am quite concerned about the future of those students today who wish to make photography their means of livelihood. Teachers, of course, support themselves by teaching and seem blissfully unaware of the struggles involved in carving out a career in the commercial world. The emphasis is mostly on Art. As a result, students graduate with a portfolio that does not qualify them for careers in the profession. Photography cannot possibly support the thousands of students who hope to earn a living from it.

My own creative work comes to me like a gift, pushing itself into my consciousness. A powerful feeling comes over me. It's hard to explain, but in a way the image creates itself—with a little help from me. It is a timeless experience, almost like being in a trance. Often I have struggled for days to get the image of the photograph to overlap the spirit I seek. It is an awesome responsibility, and a lonely one.

I seem to be best known for my nudes. This is probably due to my unique approach. I think of our bodies as seed pods, and just as universal. The face, however, is personal. That's why I usually compose in such a way that the entire head, not the face, becomes a part of the whole rather than drawing attention to facial expression. I am eagerly looking forward to making my next exposure. The image is clearly visible in my mind. Unfortunately right now I seem to be occupied with many other responsibilities—most of them in the darkroom. How often I wish I had tossed out *all* my old negatives a long time ago instead of only some of them. Now I spend many hours reprinting "old favorites" for collectors and galleries—and last but not least, to keep the wolf from the door! Often foolishly I agree to future exhibitions, always forgetting the work and time it involves. Instead I should be working in my studio where such wonderful things are awaiting me.

To be a creative person is a significant privilege as well as a great responsibility. To be allowed to—in fact, to be commanded to—attain ultimate fulfillment I consider life's most vital gift.

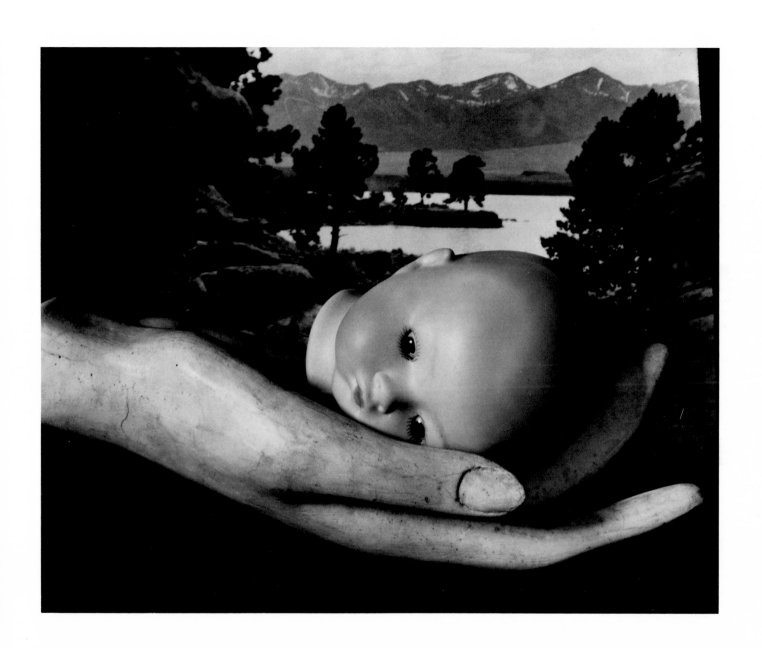

Doll's Head, 1936

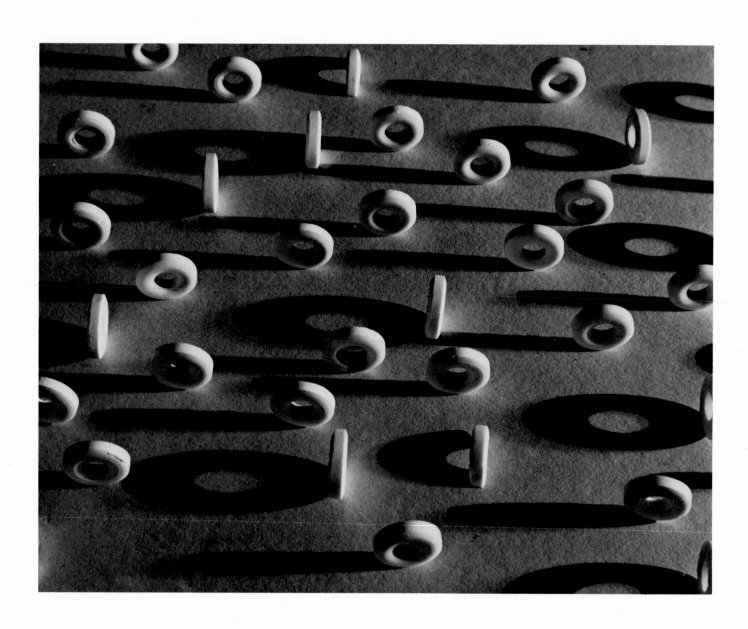

Lifesavers, 1930

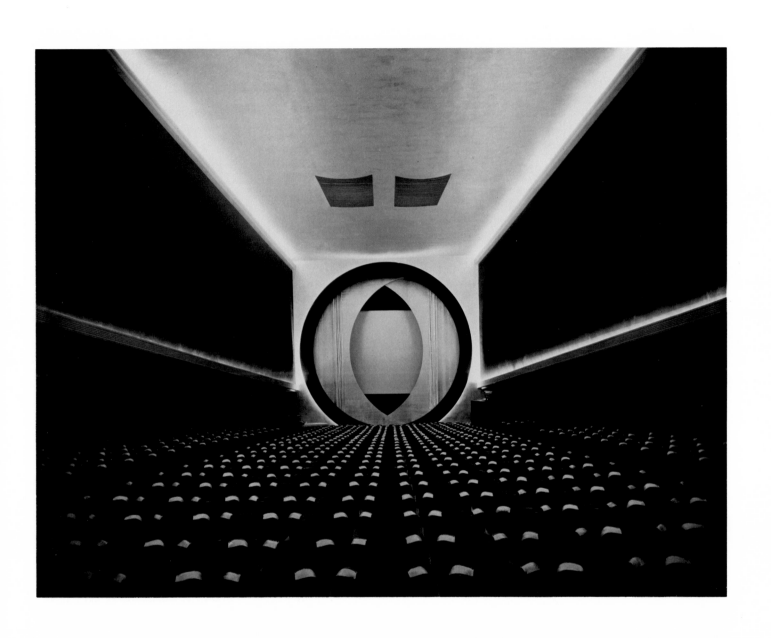

Frederick Kiesler, 8th Street Theater, New York, c. 1945

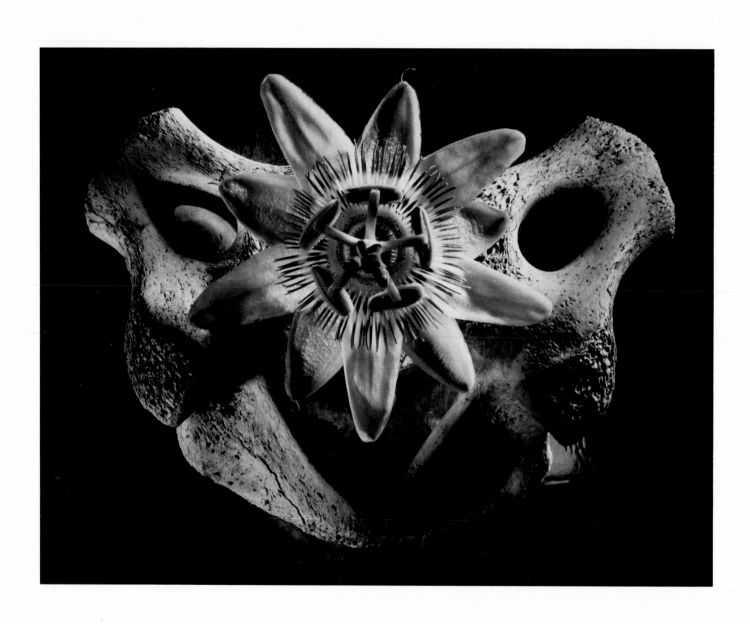

Bone and Passion Flower, n.d.

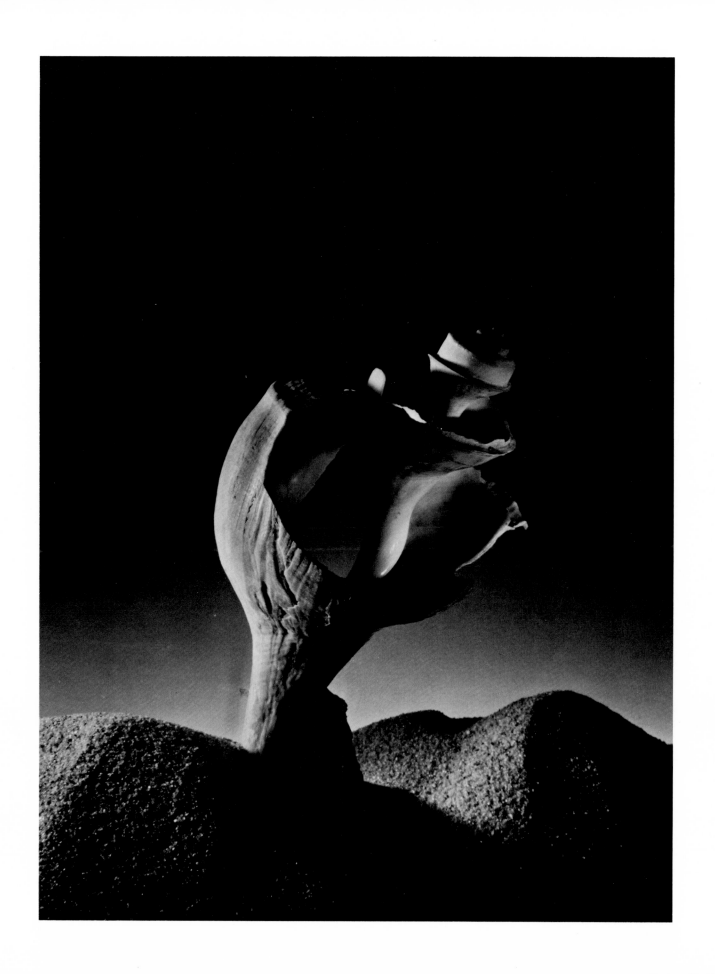

Broken Shell, c. 1934

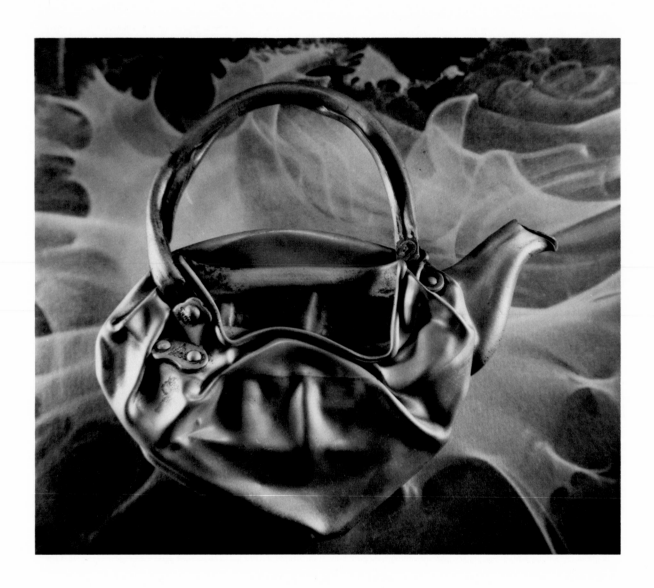

Teapot, 1976

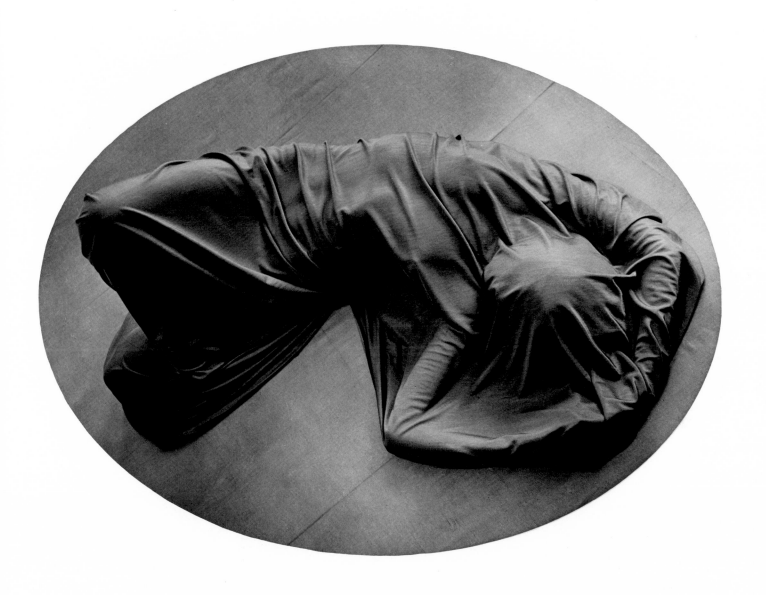

Enigma, c. 1975

Two Leaves, 1952

Two Forms, c. 1963

Candy II, 1942

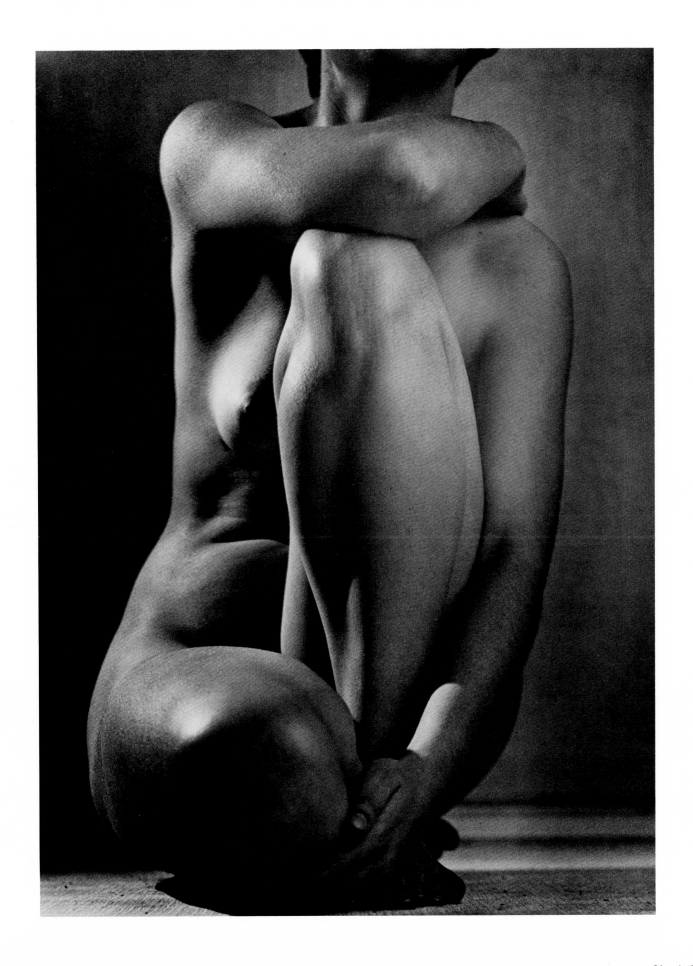

Classic Torso, 1952

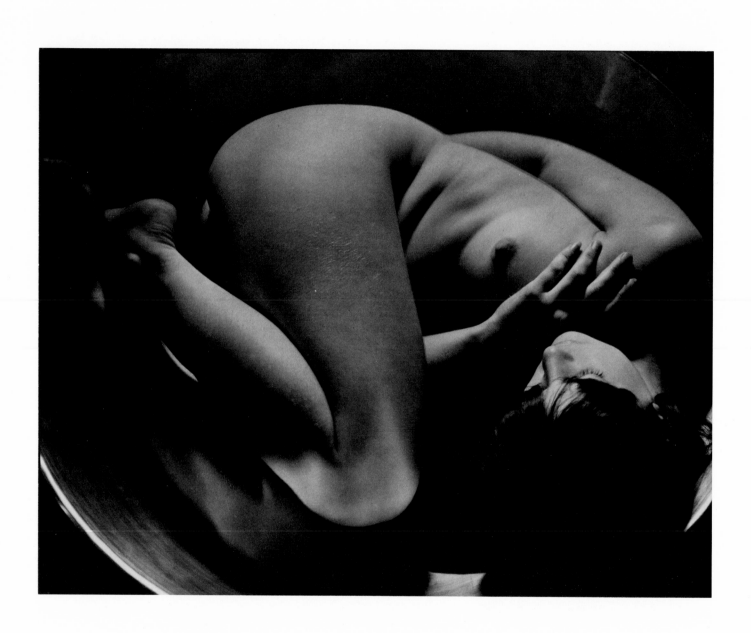

"Embryo," 1934

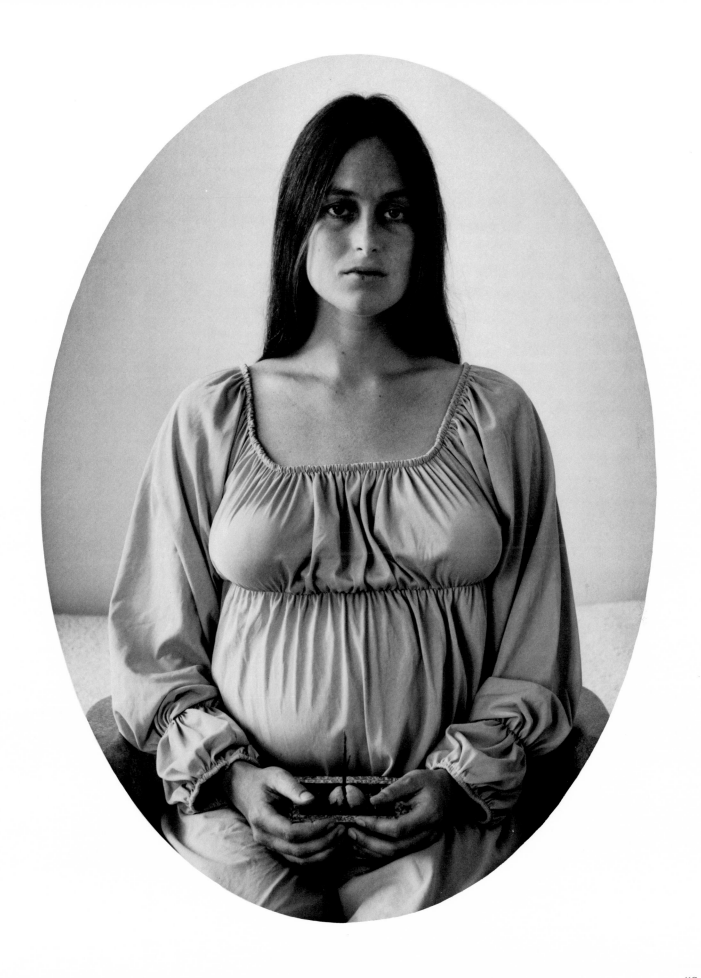

"Seed," 1970

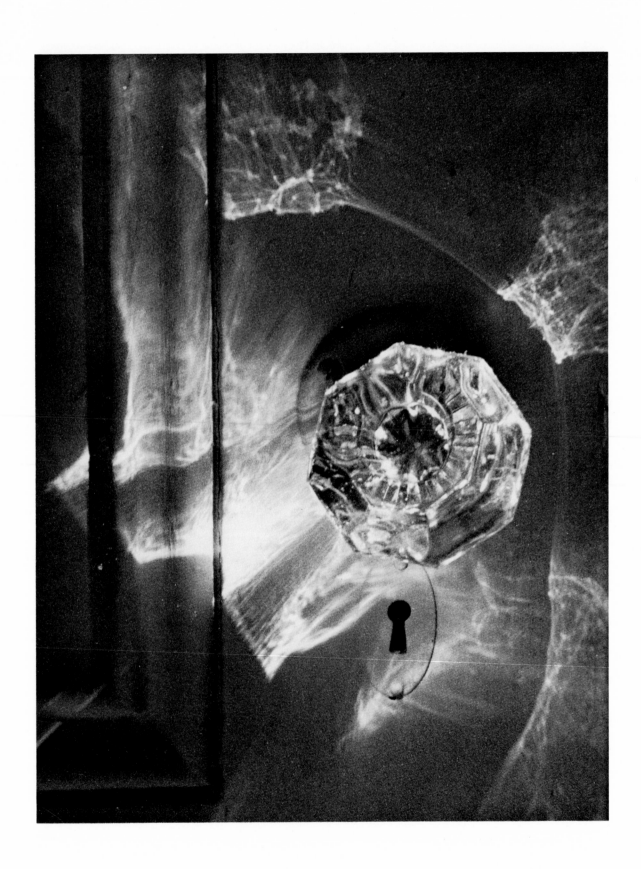

Doorknob, 1970

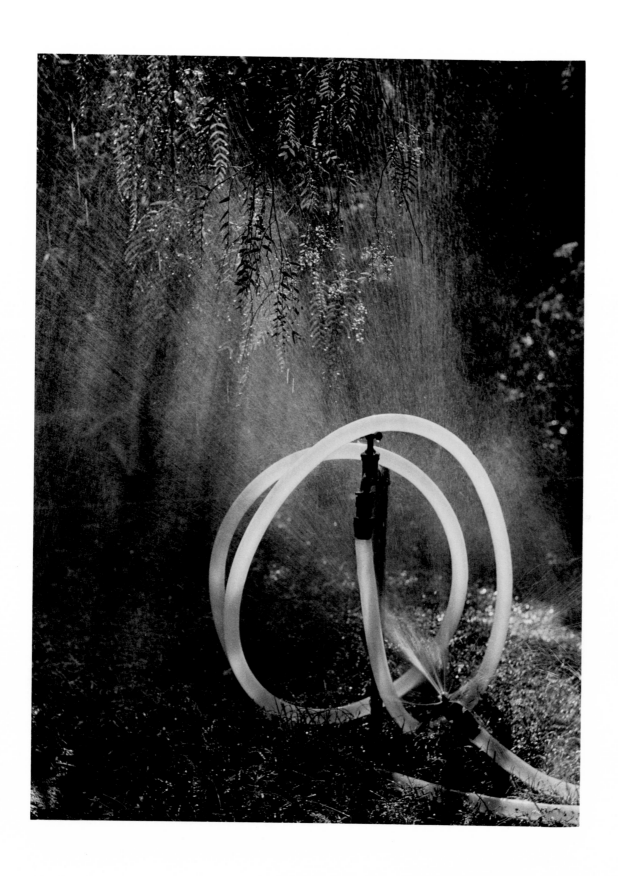

Garden Hose, c. 1969

CARLOTTA M. CORPRON

The ultramodern Dallas–Fort Worth Airport is an appropriate place to meet Carlotta Corpron, a photographer whose work was ultramodern in its time. She is a tall pale woman with kind blue eyes behind glasses; she walks with an elegant silver-handled cane and is dressed in a black and white staccato print dress. She is amused that the rhythm of the print is reminiscent of the design of one of her photographs. It is a hot, flat drive to Denton, which has been her home for over forty years. There on a quiet tree-shaded street she lives in a single-story clapboard house, where two Siamese cats wait on the front porch. Over a long weekend our dialogue ranges from her childhood in India to the power of light as a creative force. She often speaks of students with whom she became friends and whose careers and families are a part of her own. Her collection of antique Indian brass and small tapestries and a small selection of her own photographs are placed carefully in the room for enjoyment. It is such a restful environment for talk that the time of day is easily forgotten as she traces the story of her life and work.

When people think of me, they always associate three things with me. One is my background in India, the second is my interest in photography, and the third is my love of Siamese cats.

I was born in 1901 in Minnesota, but I spent fifteen years of my childhood in India where my father was a missionary surgeon. I attended a boarding school in the beautiful Himalaya Mountains, far away from my parents. Winter months were spent at home in the plains where the hospital was located. From the early days my mother encouraged me to think in terms of a career instead of marrying. Being alone and away from my family, I had to develop self-reliance. I was tall and dignified and gave the impression of being more self-sufficient than I was. I always felt more English than American, in a way, having gone to a British school.

While I was teaching at the University of Cincinnati, I became interested in learning more about Oriental art. I went to the University of Chicago for a summer session to study the religions of India. I had some knowledge of Buddhism, Hinduism, and Mohammedanism, having lived in India, but I was interested in studying the architecture and sculpture of the country.

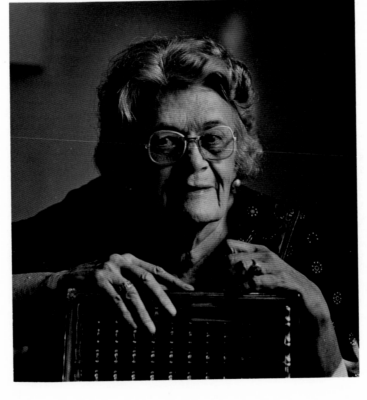

I started photographing flowers and leaves and other natural forms when I was teaching a course in textile design at the University of Cincinnati in the thirties. To interest students in the designs in nature, I bought a camera for close-up photographs of flowers and leaves. I also wanted to have a record of students' original designs. Once they were gone, they were gone forever. When I had a camera in my hands, I was at home. I did not think of it as a mechanical thing. I did not have a darkroom to work in, so I had to join a camera club in order to learn something about enlarging negatives.

When I came here to Denton, Texas, I was asked if I would like to teach photography in the art department. I replied that I knew very little about the technique of photography. The next summer I went to an art school that taught photography. With a good technique, I felt secure about developing a course of my own.

A painter works with color as the medium, a photographer works with light. I began looking around for a teacher who could help me most, because I wanted to be sure I was on the right track. In the early forties everything in art was geometric and abstract. I decided that experimental photography appealed to me most. I had seen the beautiful photograms of Gyorgy Kepes, and knew that he was the one person in the world who could direct my work.

I decided to take a year off from teaching to go to the School of Design in Chicago to study with Mr. Kepes. I received a letter from the school informing me that he had resigned to work on his book *The Language of Vision.* The next thing I knew, Mr. Kepes came to Denton to teach for a year, while writing the book. This was an extraordinary break for me. When I asked him if he would give me lessons, he said, at first, that he was too busy. After seeing my photographs he suggested that we meet once a week, at his house or mine, and talk about photography. His wife, Juliet, is an Englishwoman. He had seen her on a street in London, and asked if he could photograph her. They were dear people, so kind and generous, and we developed a lovely warm friendship. Good fortune had smiled upon me when Mr. Kepes came to Denton, instead of my having to go to him.

I am not sure that I could have taught photography in a school where technique was the important thing. I needed to teach in a college that stressed fine arts and the growth of the individual, and I found that at Texas Woman's University in Denton. I think in all of my teaching I tried to get away from mediocrity and to develop standards of quality and originality. I used to tell my students that I wanted their photographs to "sing." They gave me something all the time; it was not a case of my just giving to them.

When I began to teach photography, I did not want to be the kind of person of whom people would say, "Those who can do; those who can't, teach." Before I concentrated on my own creative work, seven years after coming to Denton, my students were creating wonderful photograms and light-and-shadow patterns. Mary Marshall, an exceptional woman who was the head of the art department, said that everyone should have a course in photography in order to learn to see that the world is an exciting place. Every year we were able to put up an exhibit of student work that was entirely different from that of the year before.

When Miss Marshall went to Chicago to study, she asked Moholy-Nagy if he would come to Denton and give a workshop in the summer. He suggested two problems for the Light Workshop. One was the photogram, a design made without a camera of light and shadow on sensitized paper; the other was what he called a "light modulator." The students worked with white paper, folding, curving, and lighting it so that certain planes or surfaces would be distinct in the light, and others would retreat into shadow. Then they learned to use a view camera to photograph their light modulators, and I had to introduce them to a simple darkroom technique. At the end of the three-week workshop we were able to put up an exhibit of about fifty photograms and light modulators. Moholy-Nagy remarked that he had never known such empathy between teacher and students.

At the Texas Woman's University I taught freshman design, which covered general concepts, advertising design, lettering, and history of art, as well as the course in creative photography. Having to teach so many different art courses made it difficult for me to find time and energy for my own work.

The first year I taught in Denton I was asked to photograph the department heads of the college, and that was to me a task. I just could not be a general portrait photographer trying to please everybody. It would not work. It is my way to like just a few people, and not to reach out to the whole world.

For years I photographed landscapes, old houses, flowers, children, light reflections on water—the things that interest most people. With my Rolleiflex I captured moving lights in amusement parks and created abstract light drawings. This was the beginning of my fascination with light. Then I observed the way light transformed simple objects into exciting things of beauty by literally following the contours and penetrating the shadows. This resulted in the "Light Follows Form" photographs. I loved the beauty of seashells and the exquisitely simple form of an egg. I explored them with light, with a reflecting surface in the background. I was delighted with the illusion of deep space and the amazing distortions in the background. I also had the joy of discovering I could photograph fluid light on plastic, with ever-changing, ever-new designs. I consider the compositions with eggs and shells and the fluid light designs my most original work.

One Sunday I decided to photograph eggs, and the six eggs multiplied into thirty or more, due to my visual experiments. I was intoxicated with excitement; I then knew what autointoxication meant. Most of the egg photographs are one-minute and sometimes two-minute exposures, with only a forty-watt bulb in the darkroom. I had a curved reflector at the back of the eggs. I really felt I could not use light from any sources close by, so the film, with that one light up there in the corner, required a long exposure.

Creative work involves a number of things. First of all, artists have to work alone. I took over thirty photographs of eggs that Sunday, every one different. I was really working with reflection and distortion. The images were so exciting that I nearly jumped out of my skin. I could hardly stop; I hated to stop to eat. It was a wonderful experience.

When Mr. Kepes suggested that I work with white paper for a while, I was, at first, too interested in creating forms, often architectural in appearance. Suddenly, however, I was working with a light modulator, something that reflected light and created shadows. I gradually made light work for me, until I was photographing light instead of paper. I found out that I should never have a preconceived idea of what a photograph should look like, if I hoped to be original. Most of my photographs have been developed entirely through exploration. I might spend an hour just exploring with light before I took one photograph. My students also learned to explore with light, and photographing became an exciting adventure. That is why teaching was never boring to me.

The year before Stieglitz died I went to his gallery in New York. Stieglitz was a little man and was at that time eighty-two years old. I am an unusually tall woman but I was apprehensive because I had heard of his reputation. Stieglitz looked at me with his very piercing eyes, and asked, "Who are you?" I answered, "I am Carlotta Corpron from Texas." I told him I was anxious to see more of his photographs. Someone else came in, and he glowered at me, and told me to go and sit down, pointing to a little office with only a chair, a desk, and a cot. I sat down in the chair. After a while Stieglitz came into the little room. He did not look at me but lay down on the cot, and I just sat there. Finally I glanced up and saw him looking at me, sizing me up. I smiled and he asked me to tell him about myself. I told him about my childhood in India, how long I had been teaching, and when I became interested in photography. I had a portfolio of about ten

photographs with me, and after looking at them, he said, "This opens up a new world for me." He patted them and added softly, "Put your children to bed." He told me my photographs were very feminine and beautiful, but also strong.

I had a lovely letter from Stieglitz after I returned to Texas. He hoped I would send him contact prints of anything I photographed that I thought was interesting. When I finally sent contact prints of my fluid light designs, I received a letter from Georgia O'Keeffe, whom I have never met, saying that they had come too late. I sometimes wonder if I could have handled the fame had Stieglitz lived to exhibit my photographs. Now that I am in my seventies, I am grateful for the recognition my work is receiving.

I photographed on weekends and during the holidays. Once I worked in the darkroom all night, not realizing I had done so. (I only wondered why I had to change chemicals so often.) I did not feel tired until I went home in the early morning light. Unfortunately, I have never been able to afford a darkroom of my own.

When I was young, I was told by a doctor that if I wanted to live a full life I had to live a very controlled life. I had to avoid nervous habits and getting upset. As a result I can sit for hours, quietly thinking. Perhaps my years in India influenced my philosophy of life. If you have the kind of acceptance of what comes as you get older, you can adjust to whatever the limitations might be. I expect life to continue to be good, if I hold my health. I have never resented the fact that I have had to earn my own living.

I am happy and contented with my life. I wake up about seven every morning and sometimes I want to go into the backyard and sing. It is kind of the joy of living and it is within myself mostly, the kind of happiness that counts. I was not that way when I was young. It is something that

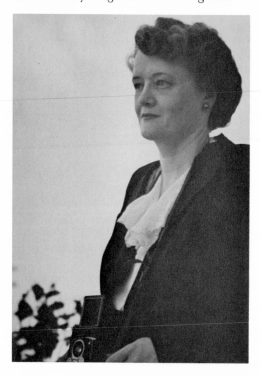

came through living. I believe that living can be an art. I balanced my work with a simple life, and I know I could not have accomplished so much photography in the city.

I never married and never wanted to. I was liberated long before the women's movement, as far as attitudes were concerned. I have accepted life and the good things that have come to me as a gift. I have been wonderfully fortunate in having a few marvelous friendships. My students also fulfilled my need to love and be loved. Some of my college students are now my very good friends. I like living alone, but I have never been entirely alone. Siamese cats have been my good companions. I have had seven of the beautiful creatures. Someone once said that a person who does not like cats does not like being watched all the time.

Through the years as a photographer, I have been "neither fish nor fowl." That is, most photographers could not understand what I was doing, and very few artists were willing to accept photography as an art. I consider myself a designer with light. I hope that my photographs have a life of their own. I have abstract and experimental negatives that I have not enlarged. Perhaps I will be able to print them in the near future.

Interior of a Church in Havana, 1942

Solarized Calla Lilies, 1948

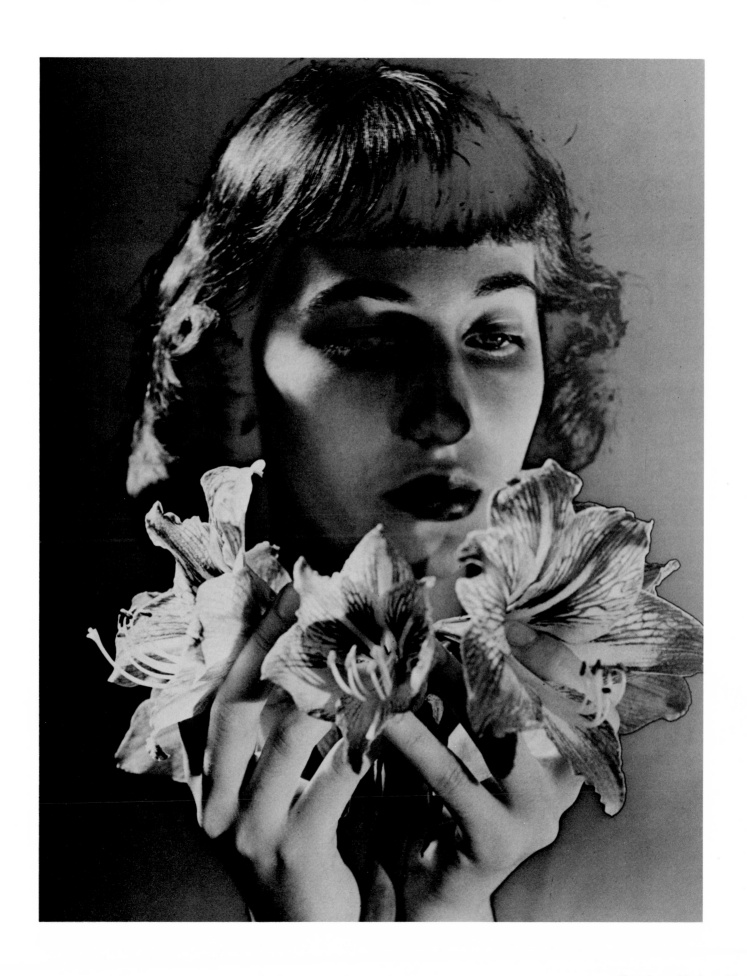

Rae Ann with Amaryllis, 1949

53

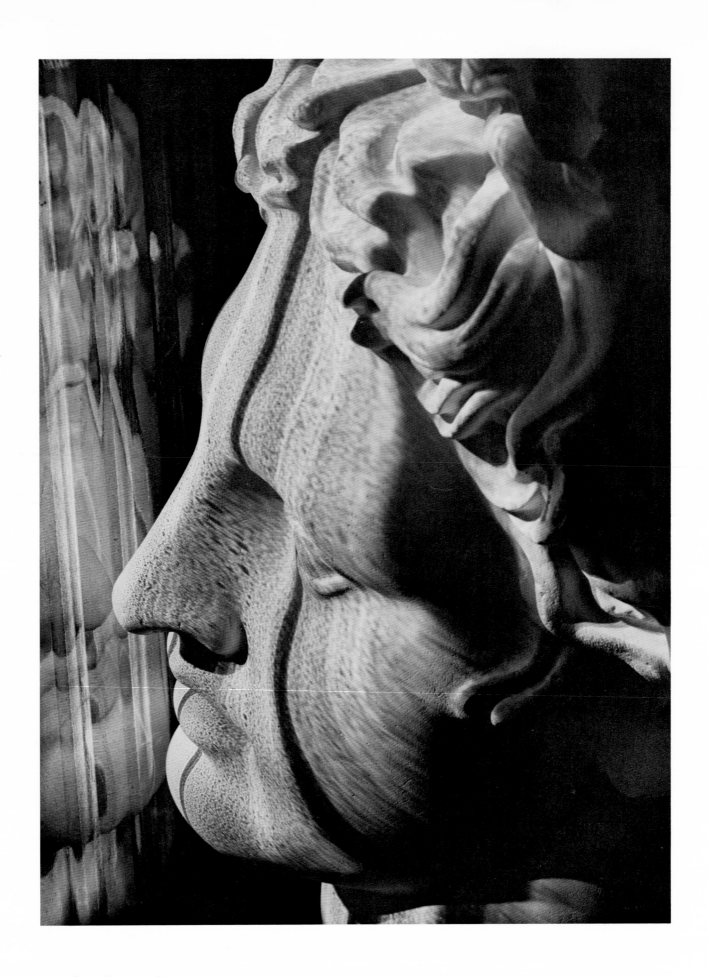

Light Follows Form of Greek Head, 1947

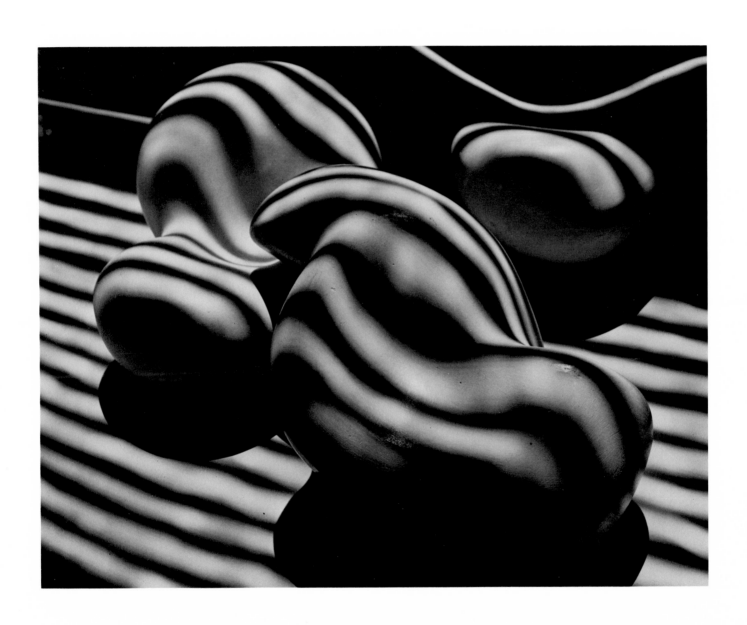

Light Follows Form, 1948

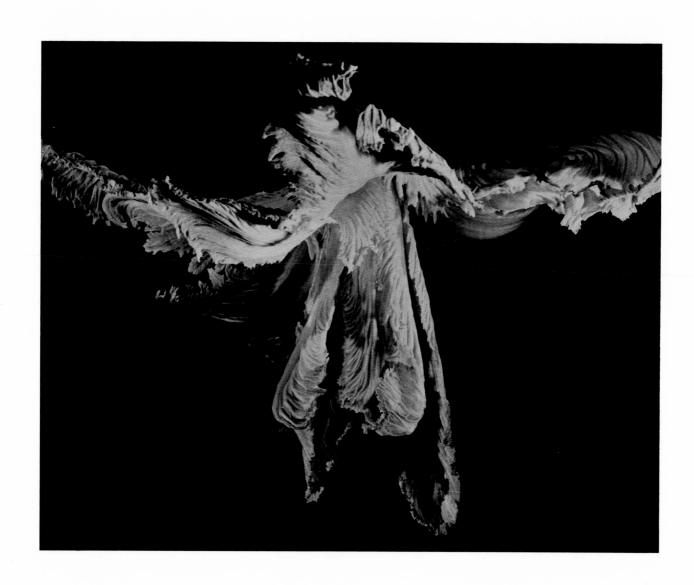

Nature Dancer, 1946

Strange Creature of Light, 1948

Light, White Paper, and Glass, 1945

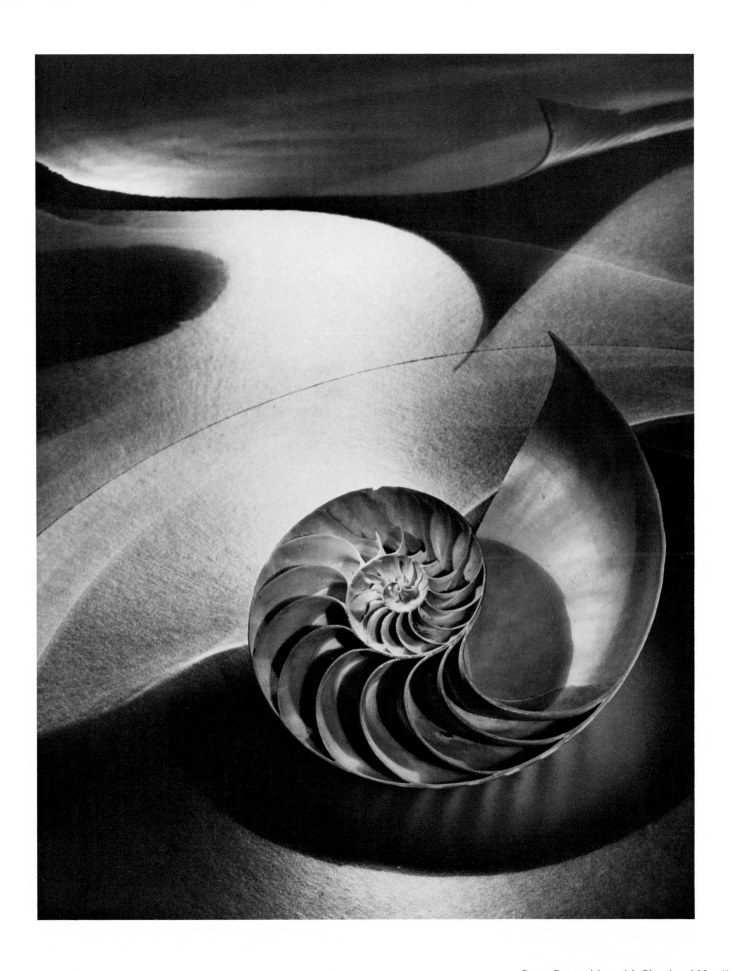

Space Composition with Chambered Nautilus, 1948

A Walk in Fair Park, Dallas, c. 1948

Winds Between the Worlds, c. 1948

Fluid Light Design, 1946

Woven Light, 1948

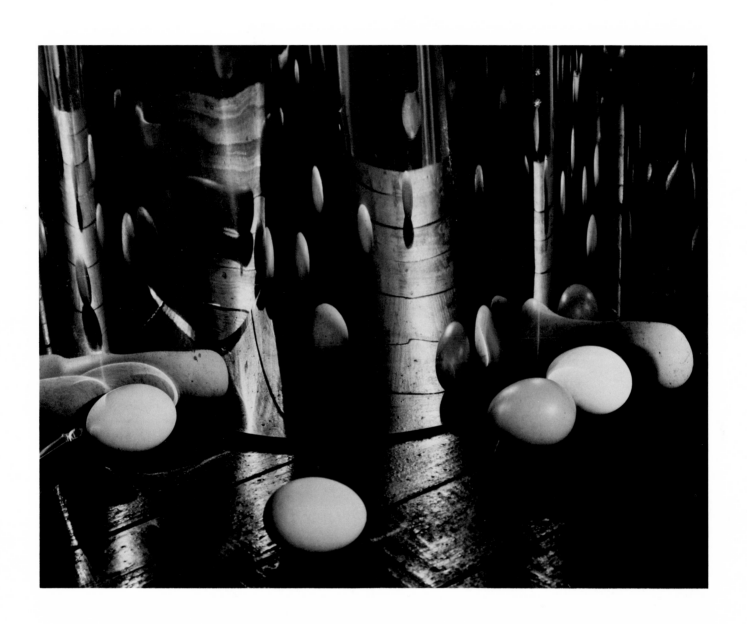

Eggs Reflected and Multiplied, 1948

LOUISE DAHL-WOLFE

A flat farm road meets wooded lane in western New Jersey and at the end of the lane in a pocket of light formed by a clearing sits a simple contemporary frame house with a yellow door. Light in the hallway falls on an animated and cheerful pair, the photographer Louise Dahl-Wolfe and her husband, the artist Meyer Wolfe. They are a well-designed pair living in beautifully decorated surroundings, a sophisticated combination of rich colors in comfortable spaces. Large windows frame Wolfe's sculpture, the walls are hung with paintings, and an elegant Oriental screen dominates the living room. It is not surprising that this home belongs to the creator of the style associated with the best days of Harper's Bazaar. *With a laugh she accepts her title of "Queen Louise." In conversation she is squarely practical,*

strong-minded, unflinching, but flexible. In her career she is known for meeting deadlines, demanding the best from everyone around her, and caring about people at the same time. Her talk sparkles with anecdotes about all the famous people who sat before her camera—from her "discovery" cover photograph for Bazaar *of Lauren Bacall as a young actress to the poignant portrait of Colette, pen in hand, propped up in bed to write during her last year of life. Over ten years ago Louise Dahl-Wolfe put aside photography as a career. In so-called retirement she has new interests—sewing her own clothes, studying bookbinding and French, and now, with the same amazing concentration of energy, printing from her negatives for shows and books, rediscovering photography for herself as she herself is being rediscovered as a photographer.*

I was born and raised in San Francisco over eighty years ago. It was a colorful city, with its large population of Chinese, and a great shipbuilding port. Our family would attend the christenings of the ships, since my father was head of the marine engineering department of the Union Iron Works—later Bethlehem Steel Company. My father's idea of entertaining a little girl was to take her to the shipyards on a Sunday afternoon.

I was ten years of age at the time of the great earthquake and fire of 1906. I would sit on the front steps of our house and watch the endless streams of refugees fleeing to the nearby hills, carrying their possessions and cats in bird cages. During the three days of burning, my job was to sweep the ashes from the ledge on the garden fence.

In 1914 I became a student at the San Francisco Institute of Art, situated then on the site of the present Mark Hopkins Hotel. Art-school days consisted of cast and life drawing, painting and composition, anatomy, lettering, color, and design. We drew in charcoal in the life class, and erased our mistakes with rolled-up pieces of sourdough bread—the recipe that was evolved by the gold miners of 1849.

The First World War was raging in Europe when the World's Fair opened in 1915 in San Francisco. The Fine Arts Palace housed the treasures of painting and sculpture collected from the great museums of Europe. This was the first time in America since the Armory Show of 1913 in New York that the Impressionists and Post-Impressionists had been shown.

In 1916 the most impressive aesthetic experience happened to me when the Diaghilev Ballet came to San Francisco. My family went to several of the performances. This was the first time that I had ever seen the perfect synthesis of three arts: painting, music, and dance. Nijinsky's modern abstract movements of the dance in *"L'Après-midi d'une faune,"* for which he did the choreography, was exciting beyond belief. The modern music of Debussy and the modern background set of Leon Bakst were as important as the dance movements, which made the spectacle into one breathtaking whole.

In 1921 I took a job designing electric signs. The work became frightfully boring and routine, which even the good salary couldn't compensate for, but, fortunately, a friend invited me to the studio of the photographer Anne Brigman. We entered her garden studio, and I was deeply impressed by the exotic color of her studio walls, which were wooden boards stained a red-violet hue of strong intensity. One would rarely see color such as this used; the use of grayed colors was prevalent, but the Bay region now was beginning to make use of modern color because of the influence of the young art professor Rudolf Schaeffer, who had returned from study in Europe and now taught at the San Francisco Institute of Art. Anne Brigman showed us her photographic slides of nudes taken in Monterey cypress trees on Point Lobos at Carmel. Photography at this time, generally speaking, was not considered an art form. Alfred Stieglitz had already started his gallery "291" in New York and also published *Camera Work,* showing his selection of photographs. He devoted an issue to Anne Brigman's nudes.

I was floored by the beauty of the Brigman photographs and entranced by the prospects of what the camera could do. When my vacation arrived, I visited friends in Carmel and we decided to do Brigmans. We had no notion of what the camera could do, but we tried with a Brownie Box fixed focus. The youngest of our group were persuaded to pose nude on the scratchy cypress trees of Point Lobos and on the lovely beach near the Del Monte Hotel. Carmel was an artists' colony then, and one could spend hours on the beach on Point Lobos and never see a soul.

We had the films developed in a San Francisco drugstore and became quite excited by the result. Our technical knowledge of photography was exceedingly limited. We took the films to a well-known San Francisco photographer, Mr. Dassonville, and asked him if he could enlarge them. He tried to hide his amusement, and I kept hoping he wouldn't recognize me as one of the models. He told us the quality of the negatives was not suitable for enlarging. We were heartbroken, but this disappointment moved me to buy an Eastman camera with a f 7.7 lens and a film pack back.

The sales clerk took a great interest in my efforts. He would point out all my mistakes, but was very kind and patient and advised me to try to judge light on my ground glass before making an exposure. There was no such thing as an exposure meter in those days—and the orthochromatic film was very slow. I kept up the "guessing game." The underexposures and overexposures were discouraging, but bit by bit I improved.

I asked the clerk what type of enlarger I should buy, but he discouraged me from spending my money and told me to use my camera as a projector—to fit it into an opening in an apple box and make a reflector with a large Ghirardelli chocolate can. I spent all my salary from the sign-designing job on film, chemicals, and imported English enlarging paper, which I used for experimenting on my makeshift enlarger.

It was then that I met Consuelo Kanaga. She worked on a San Francisco newspaper, doing feature stories and illustrating them with photographs. When she saw my equipment, she persuaded me to buy a better camera. I bought a used Thoruton Picard English Reflex, 3¼ by 4¼, with a soft-focus Venito lens, which was very much in vogue. We would use our Sundays and every spare moment to roam the city for exciting bits of local color to photograph. We were inspired by Francis Bruguierre, a native son who was the first to experiment in abstract photography and who had a studio on Post Street, the Fifth Avenue of San Francisco.

In December 1923 I went to New York for a year's study of interior decorating, and upon my return to California I became assistant to Beth Armstrong of Armstrong, Carter and Kenyon, the top decorators of San Francisco.

Nineteen twenty-six was a sad year. We were in an automobile accident and my mother did not survive. My sister persuaded me to travel to Europe in order to broaden my vision. I joined my two friends, who were living in New York, and we left for France in 1927.

We went to visit a friend from New York who was living and painting in Kairouan, the Holy City of North Africa. In his group was a Tennessean, Meyer Wolfe, a painter and sculptor, whom I later married.

On returning to San Francisco, after a year and a half traveling in Europe, I began to take photography seriously. I bought a 5-by-7 view camera with a wide-angle lens in order to photograph the rooms my decorator friends designed. Panchromatic film had just come on the market, but as yet there was no exposure meter.

My husband Mike and I decided to spend a summer in the Tennessee Smoky Mountains since he wanted to paint there, and so we rented a log cabin in Gatlinburg. In order for me to develop film we rigged up a darkroom light from the battery of our Model A Ford.

The Bank Holiday of 1933 found us in New York, in the depths of the Depression. Everywhere we saw sad-faced people selling apples on the street, but we felt adventuresome and were not discouraged by the bread lines or lines of people out of work.

The magazine *Woman's Home Companion* asked me to photograph for their food pages. We found a studio on West Fifty-second Street among the jazz joints and speakeasies of the Prohibition era. I spent endless hours, day and night, climbing up and down a ladder, pushing plates of food into harmonious patterns, to the tune of jazz and the shrieks of the emerging drunks.

An agent took my photographs to Frank Crowninshield, editor of *Vanity Fair*—which was the cultural magazine of the era. The work impressed Mr. Crowninshield favorably, and he published, in November 1933, a photograph of my Smoky Mountain neighbor, Mrs. Ramsay, in her twenty-five-year-old straw hat. The photograph was a documentary one, unusual for the time, and was much discussed in magazine circles. Mrs. Ramsey's photograph was included in the first photographic show, in 1937, of the Museum of Modern Art when Alfred Barr was director. Mr. Crowninshield asked me to come and photograph well-known people in the Condé Nast studio for *Vanity Fair,* but I knew with my independent nature I had to work in a studio of my own.

Fashion photographers were in demand at this time. Most fashions in the class magazines were sketches by artists of the caliber of Eric Willaumez and Bebe Bearard. Steichen was the first great American fashion

Louise Dahl-Wolfe, c. 1940.

photographer. I was asked to do fashions, and I hadn't the vaguest idea how one worked in this medium, but, as I needed the money, I decided to try. An advertising manager of Milgrim's Specialty Shop on Fifty-seventh Street—also a friend—offered me the use of her showroom models and the clothes, in exchange for photographs she could use in *The New York Times* Sunday rotogravure. The models were not young or photogenic, and it took hard work, patience, and great facility to make them look chic, elegant, and natural, but it was the best training I could have had.

In 1936 *Harper's Bazaar* started me off doing still lifes of shoes and accessories. However, just as I was getting bored with still lifes, I did my first fashion for them in color (1937) with the "one-shot camera." Since the work was pleasing, I was kept busy each month. Color photography in fashion, in the early thirties, was not very inspiring. One has to have a sense of putting color together in harmonious arrangements, planning backgrounds carefully, with an eye responsive to color. Most of the photographers working in fashion were geniuses in black and white. The exception was Anton Bruehl, who worked in black and white but had a most beautiful sense of color, a great sensitivity and taste in the color photographs he did for *House and Garden* and *Vogue.*

In 1938, I was sent to Hollywood. Working on the great movie lots gave me a new lease on life. I photographed many of the stars of the day: Charles Boyer, Carole Lombard, Bette Davis, Robert Montgomery, Hedy Lamarr, Ginger Rogers, David Niven, Marlene Dietrich, and many starlets, among them Joan Fontaine.

As Kodachrome, 8-by-10 size, was not on the market, we had to use the one-shot camera for color. The camera took the three primary colors on separate glass plates in one shot. For lighting we used photoflood lamps in large metal reflectors. The photographer would pose the model, arrange the lights where they were needed, and then go through the work of turning off all the lights and exchanging the photoflood lamps for photo flashbulbs before taking the photograph—a clumsy procedure and unbearable for the model. What a difference in today's world of photography!

Since color was my great love, the moment 8-by-10 Kodachrome came on the market, I began to experiment. Kodachrome had a rich range of color, was easy to work with and excellent for reproduction. I took pains with my color work and worked with the engraver to color-correct all of it for the *Bazaar*—over six hundred pages, including covers, in my twenty-two years with the magazine.

The *Bazaar* was in the hands of a great editor, Carmel Snow. I felt fortunate to be under her direction. She never interfered in the work of her artists, trusted them completely, and fought the commercial interests of the business department in order to give freedom of expression to her contributors and produce a magazine of quality and high standards for her readers.

One of the great contributions of her editorship was in publishing and discovering the new young writers of the period—Richard Wright, Carson McCullers, Eudora Welty, and others. Diana Vreeland was my fashion editor, and a great one. I worked closely with George Davis, the literary editor, which gave me the opportunity to do the portraits I loved doing—of creative people in the arts. This gave me the change I needed from doing fashion assignments. In doing portraits, I had liberty from the commercial interests, but in doing fashion, I tried to keep in mind what the dress designer was trying to say. The clothes designed by

Claire McCardell and Norman Norell were my favorites of the American designers. However, we also had the ones called "Pearls of Little Price"—which we called "musts," for they were whipped up to be the best-sellers. If they were too unphotogenic, we took an artist's license and hid them in the photograph the best way we could.

Besides the great American designers, we covered the French collections. The workmanship on these clothes was of an artistry that existed only in France. I spoke a pidgin French—or, as the French say, "*comme une vache espagnole.*" Each morning, having photographed the collections the night before, I would get a telephone call from Gremela, the studio technician, and we would talk in French. The office assistants told me laughingly that I could speak for twenty minutes without using a verb. André Gremela was a great help. He had learned photography from Baron de Meyer and later on assisted Steichen and George Hoyningen-Huene. After the war he helped Avedon and myself.

In 1958 the great change came, which Carmel Snow had predicted to me in 1947 when she said, "Life will be very different in the future for the magazine." I realized now it was the commercial machine age she was referring to; and for me, now, the new art director was part of this era. Unexpectedly, he came to my studio while I was photographing in color, walked up to my 8-by-10, and looked through the ground glass. This had never happened to me in all my twenty-two years on the magazine or, for that matter, on my commercial assignments.

Suddenly, my enthusiasm vanished. Enthusiasm for me is half the battle; it makes everything come alive. I knew then the great era of my magazine was finished, and so I resigned.

I worked for *Vogue* for a year and continued for *Sports Illustrated,* doing men gourmet cooks and the specialties they created—traveling all over in the process. In 1960 I retired to our house in the country.

In my early years I wanted to be a painter, became an interior decorator, but made my career, finally, as a photographer—loving every minute of it.

Paestum, Italy, 1927

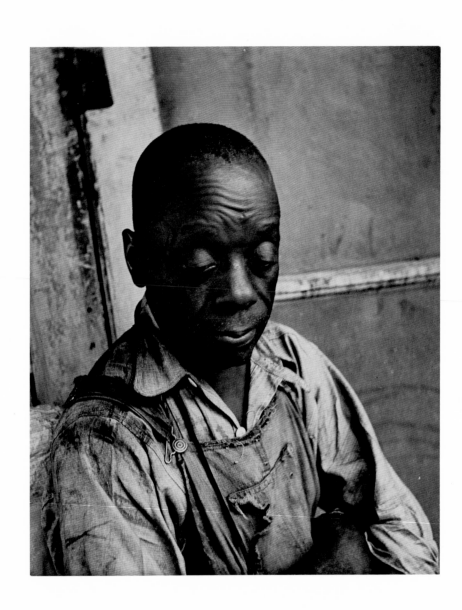

William Edmondson, Sculptor, Nashville, 1939

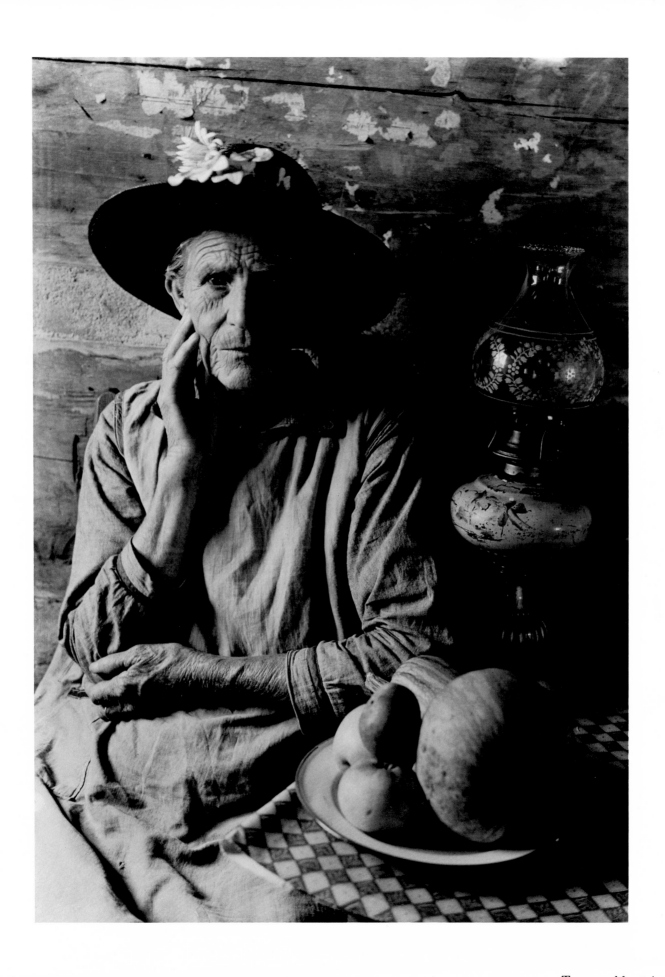

Tennessee Mountain Woman, 1932

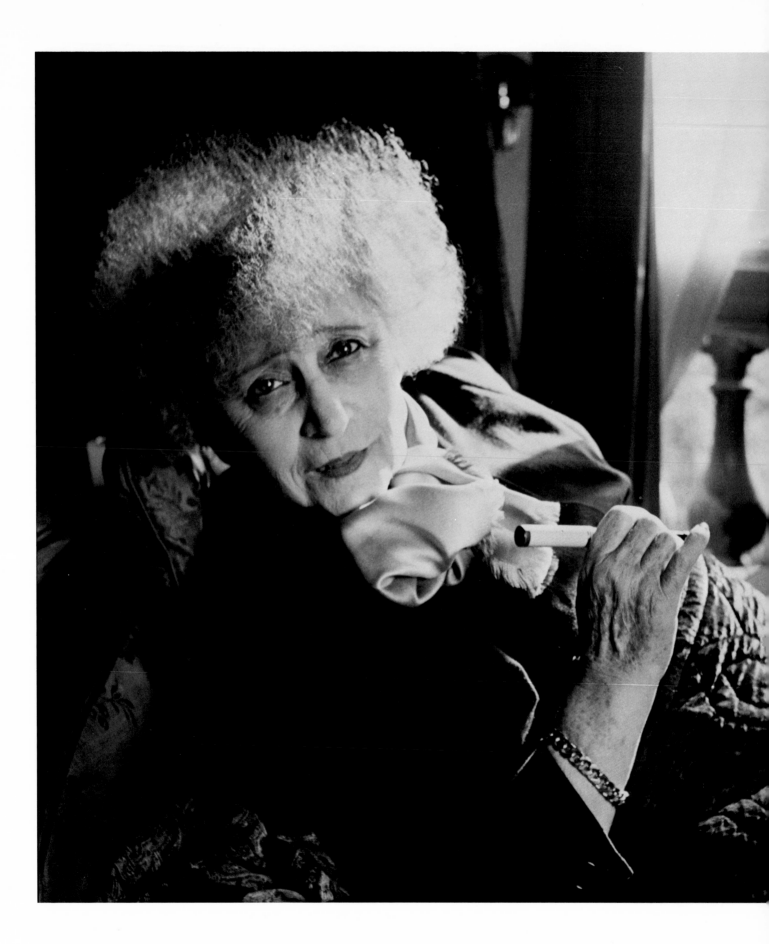

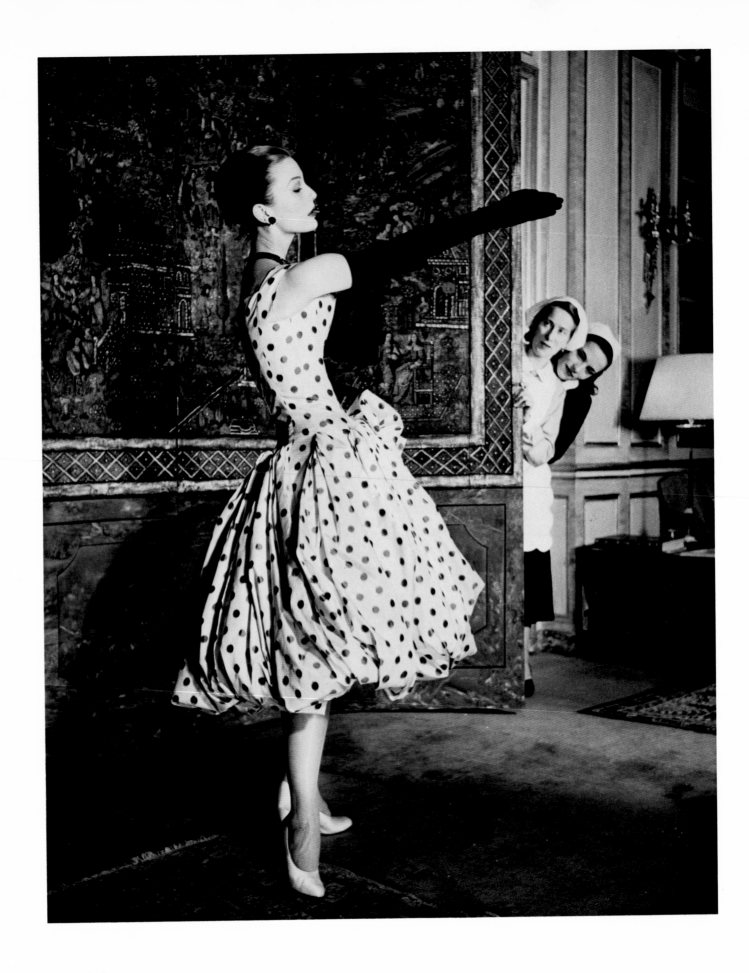

Dior Dress, Paris, 1950

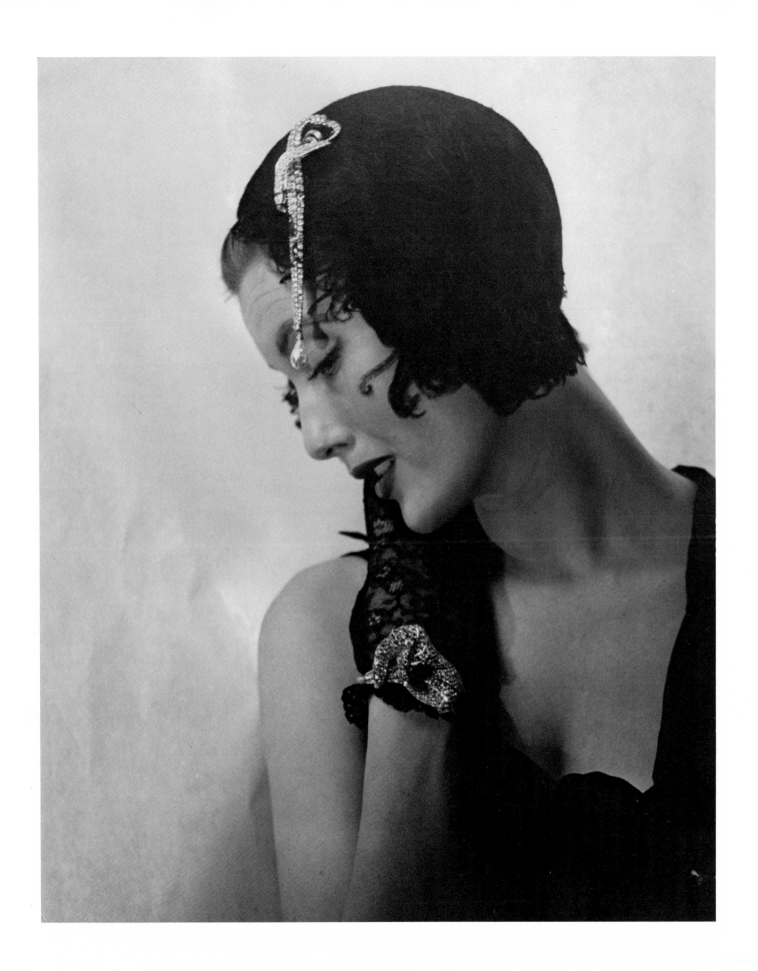

Nude, 1941

76

Night Bathing, 1939

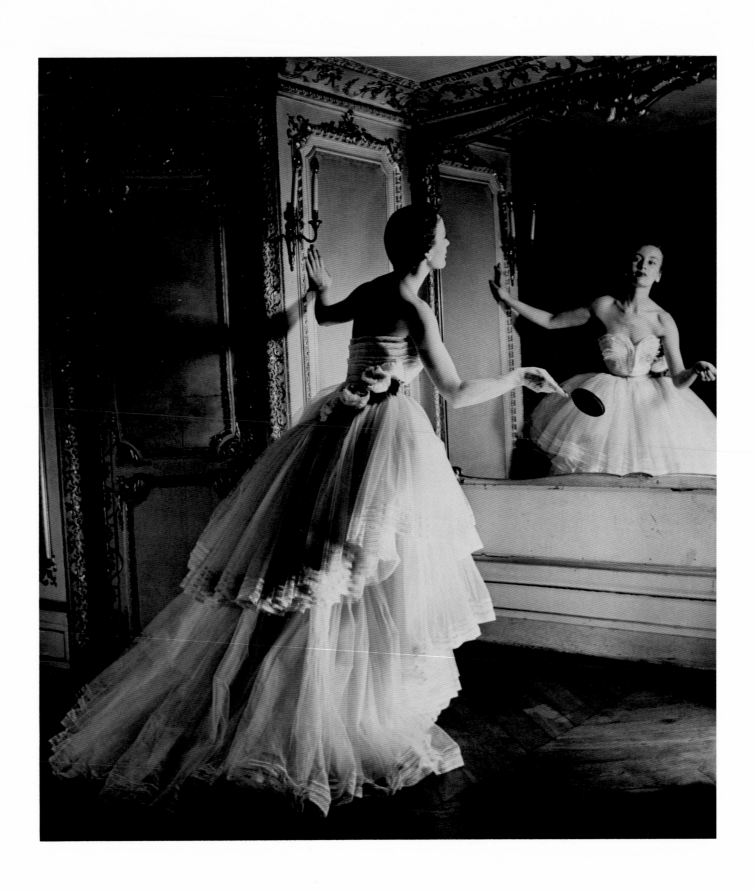

Dior Ball Gown, Paris, 1950

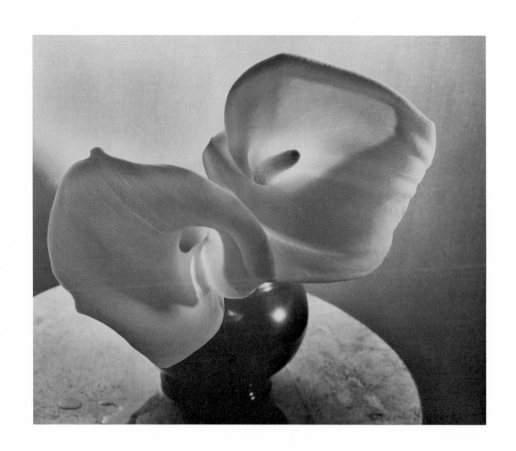

Calla Lilies, 1931

79

Cecil Beaton, New York, 1950

Mr. and Mrs. Edward Hopper, New York, 1933

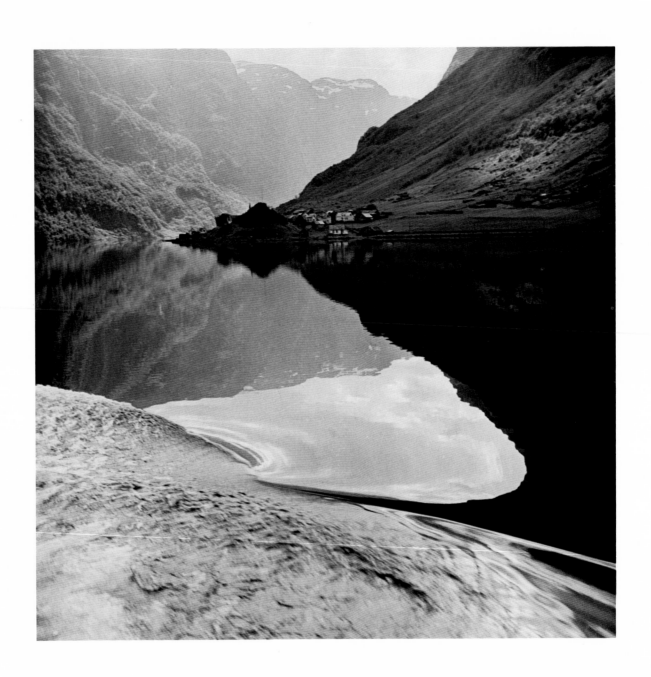

Sogne Fjord, Norway, 1951

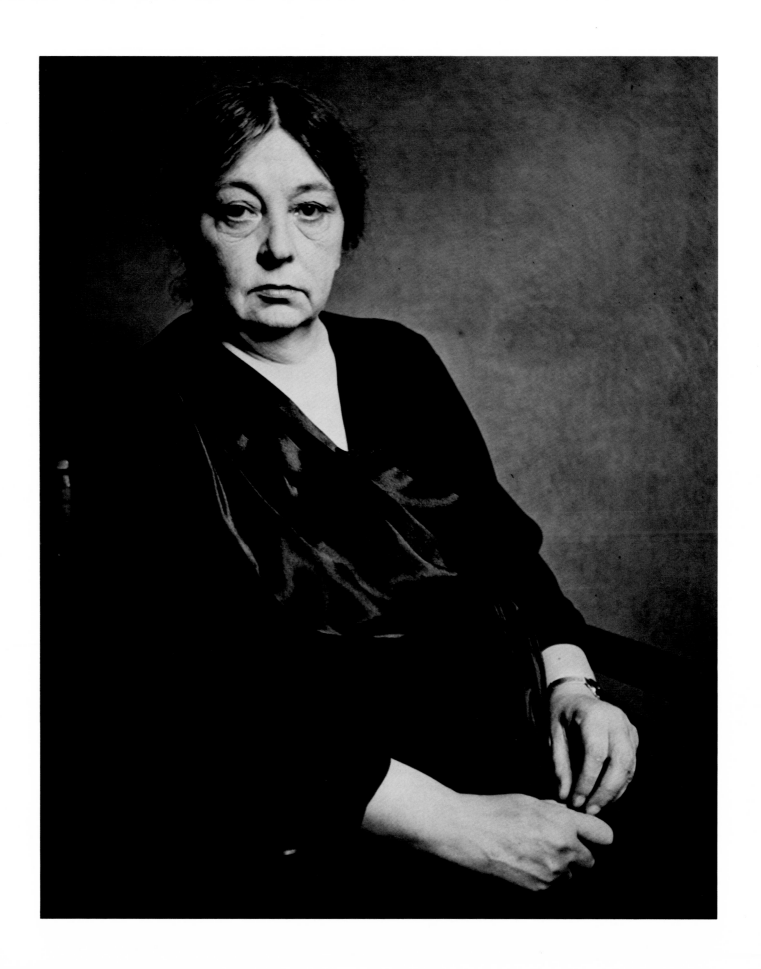

Sigrid Undset, New York, 1940

The late summer air is still. A meadow of green meets the long driveway of Nell Dorr's home, a large house made from a barn set against a hillside of pine trees. The valley could be in France or in a fairy tale, but it is, in fact, in western Connecticut. By a fireplace built into the stone wall at the end of the dining room Nell reclines on a sofa, her favorite place to talk. She is dressed in a long yellow Mexican dress embroidered with flowers at the neck and wrists. Her eyes laugh with mischief; her gray hair, not yet pinned up for the day, streams over the pillows. This visit is unusual because questions are hardly necessary. We are old friends and she will tell me her story. The atmosphere of this country retreat evokes the past in many ways: in the slow daily pace, the expanse of the lawn and the old-fashioned scale of the rooms, the family antiques and paintings, the smell of dried flowers. Through a subtle fusion of her work and her life Nell Dorr has always sought simplicity. Her life, like her work, has a timeless quality, the quality of a past period distilled through memory into poetry. Her conversation is impressionistic, her presence compelling.

I can say quite truthfully that I was cradled in photography, for our home was not just a house with our family living in it; it was also a photographic studio. The house itself was a large old-fashioned home on the village green in Massilon, Ohio.

My father was a special kind of photographer and person. He was a graduate of the Art Institute of Cincinnati and he was also a graduate chemist. My mother and father worked side by side in the studio, each doing their particular part of the work. It was in this happy world that I grew up. By the time I was ten years old, I, too, had my jobs. The first that I remember was the endless washing of the prints. The water was icy cold and my fingers would turn blue and get numb, but I was proud to be on the team. My father's praise was my reward.

The best part of the day was in the evening after supper when Papa and I would go into the darkroom. We would close the door and enter a magical world. The only light was a small red one, but one's eyes soon adjusted. I learned to weigh the chemicals according to Father's directions. He mixed his own chemicals for the solutions and was most exacting in his work. I was a proud apprentice.

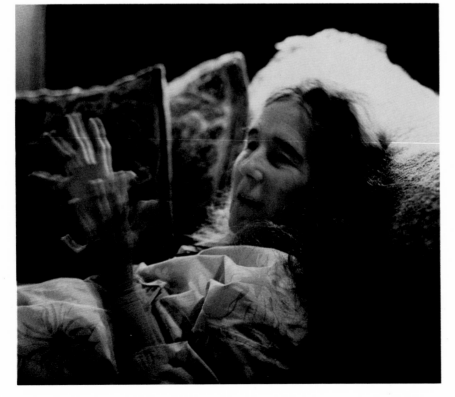

My father made my first camera for me on my seventh birthday. It was a pinhole camera, which is a simple black box with a pinhole at the front and a place at the back for a paper negative. I developed an immediate rapport with this little box. It became for me a kind of secret diary where I made my own observations of life. My father taught me to develop my own prints and to take pride in them. These small paper negatives were pasted up on the darkroom wall where I can still see them in my mind's eye.

It was during these years that I met Lillian Gish. She came to Massilon in the summers to visit her Aunt Emily, and thus began our lifelong friendship. It was her Aunt Emily who first made me aware of the beauty of a mother and her child. As I watched her bending over the cradle of her newborn baby, I knew that what I wanted more than anything in the world was to be a mother. Lillian's loveliness had a great impact on me, too. I came to realize how important beauty was and how necessary to capture and share it with my camera.

My first and only beau, Tom Koons, was a friend of my older brother and had always been like a brother to me. He became my suitor and everything was like a storybook. Our two families were old friends and I was like a daughter in Tom's home. I became engaged at seventeen, wore an engagement ring, and began my hope chest. The following year we were married in my home; Lillian was my only attendant.

We lived in the town of Warren, Ohio. It was here that our first daughter was born and my dream of becoming a mother came true. Life was simple in those days and having children was not the complicated business that it is today. One did not need to finance their college education before they were born. The doctor's bill was ten dollars and the nurse cost ten dollars a week. Life would never be this simple for me again.

After several years we moved to Miami, Florida, and when World War I was declared, Tom was taken into the army, but stationed in Miami.

By the time my third daughter was born, Tom was well established in the real estate

business. Then the "boom" came to Miami Beach. Fortunes were made and lost overnight through speculation. Tom became embroiled in the frenzy of the time, but to me it was very frightening. I just wanted to run away, to escape. I bought a small sailboat and each day I would take my camera and perhaps some bread and cheese and go down and explore among the Keys. These islands were deserted and seemed like a different world to me. I would sometimes take a child or two with me and photograph them as they played in the water and the mangroves. These pictures later became my first book, *In a Blue Moon.*

It was during this time, with my father's help, that I built my first studio. I was able to escape the turmoil by totally immersing myself in the world of picture-making. Suddenly the bubble burst. The stock market crashed; banks closed, many never to reopen. We lost everything except our house and the studio. Tom thought that it was the end of the world, but I reacted in the opposite way. My father and I made a sign and hung it outside the studio. The simple shingle read, "Nell Koons— Photographer."

It was a different world from the days of the boom. People began to help each other; it was exhilarating. My children were wonderful. They fished from the docks and gathered fruit from the neighboring groves. For a year we lived this way, on fruit and fish and grits, as I worked to build my photography business. From that time forward I was the sole support for my family. I did photos for *Gondolier,* a society magazine, and made studio portraits. Tom was unable to adjust to this and our marriage ended, although our friendship continued.

I wasn't really happy in Florida. The work was seasonal (January through April) so I decided to try a summer in New York. The girls stayed with my parents and I went north with my portfolio. It was a big step, for I had little money and no guarantee of work. My friend Lillian Gish and I made a studio in the barn at her place in Wilson Point, Connecticut. I traveled back and forth to New York looking for work. I tried the advertising agencies with no success and experienced great frustration. The

summer was hot and I greatly missed my family, but I began making pictures of Lillian's friends in the studio and slowly built up a following.

Eventually the family was together again, and I had my own studio in the city at 100 East Fifty-ninth Street. I had a show at the Delphic Gallery of my newly made collection of "famous men." Among these was a picture of the scientist John V. N. Dorr, who became my husband in 1934. The following years were hectic but wonderful. John's business took him all over the world and usually I went with him. The girls were in boarding school, and although I had many new and heavy responsibilities as the wife of an important man, I took my camera everywhere and continued to take pictures.

My three daughters grew up and married. World War II was declared. John went into the army and did scientific work for the government. My three sons-in-law were drafted as well. I bought an old house in New Hampshire without running water or electricity, but we loved it. My three daughters and six grandchildren moved in with me. Our only contact with the outside was the everyday coming of the mailman and the letters from the war-torn world to our peaceful one. We made for ourselves a magic world and out of this came the pictures that were to become *Mother and Child.* All of my photographs are the direct result of my personal history, my childhood influences of home and family, and my craving for beauty and harmony of life. *Mother and Child* was the result of the untimely death of my daughter in young motherhood. My comfort was to search through all the many pictures of the happy hours before her death, pictures made with no thought of their ever being published, just taken for the sheer joy of catching a beautiful moment. These were now treasures and I gathered them together into a little book. My book took shape, it brought a message to those who saw it, and eventually I took it out into the world.

Two of those who saw it were Alfred Stieglitz and Edward Steichen. I had seen copies of *Camera Work* and the pictures reminded me of my father's, so I gathered

some of my photographs and took them to Mr. Stieglitz. He had a little unpretentious office off his studio with just an old chair and a cot in it. He was wearing a loden cape and his hair and bushy eyebrows were all mussed up from putting it on and taking it off. I sat in the chair, which had no bottom, and he slowly looked at the pictures. When he was finished, he asked, "Do you have to make a living with these?" and I said, "No." And he said, "Then stay and photograph in your own world and don't get into the rat race."

Stieglitz was so different from Steichen, although, as he once said, they were from one root. When I first showed the pictures to Steichen there were tears in his eyes. Then he snapped out of it and said, "But I still miss my dirty-faced little brats." At that time photographs of "dirty-faced little brats" were just coming into favor and, of course, my work took the opposite view. I went home that night and I couldn't sleep. "Can a mother no longer make pictures of her own children?" I thought. I wrote Mr. Steichen a letter in the morning and I said, "In Russia they have Mr. Stalin who tells the people what they may photograph; in

Nell Dorr, Miami, Florida, 1928.

Germany they have Mr. Hitler; and now in the United States we have Mr. Steichen." His assistant, Wayne Miller, said, "Nell, that letter was the best medicine that you could have given him. He shows it to everybody." Later Steichen told me, "Nell, nothing could have done me more good; I needed that!" It was the start of a long and wonderful friendship.

According to my horoscope I am an earth child and this has proved to be true. I have always longed to live closer and closer to the earth and farther from so-called civilization. The barefoot peoples of the world are closer to reality, to timeless beauty and to the ultimate truths. I always longed to do pictures of the barefoot people, to be one with them, and several winters in Mexico gave me these precious memories, which were published as *The Bare Feet*. My most recent book, *Of Night and Day,* came about because, once again, my feelings boiled over. My eldest grandson was in the army in Vietnam. I had no actual pictures of the war, only my intense feeling about war that could not silently accept what was happening. Searching through my journals, I found words to speak for me, and searching my own heart, I found in pictures a way to speak, to release my pent-up emotions.

My picture-taking and picture-making are as different as night and day. I take my pictures quite unconsciously. I see them in my mind and need no exposure meter. It is done without thinking. I feel the exposure. My only concern is to be ready for that moment of truth, always ready to grasp it quickly before it's gone, or to wait patiently until that split-second when it appears.

In the darkroom I can relax and take time and consider. First I study the negative and decide on the paper to use. There are as many photographs possible from a single negative as the artist can imagine. This is the exciting part. I can never bear to finish with a negative, to say, "This is it." Tomorrow I can come again and make new pictures from that same negative. This is the thing that I love most of all: the making of that final picture. No one else can do that for me, nor do I ever completely satisfy myself.

I don't pick up my camera much now. I have so many negatives that I have never printed. But it's a never-ending joy to me to go over scenes, to see things in the negatives for the first time, things that I had forgotten.

From my own experience I believe that a woman can live in photography and have it reflect herself, her home, her family, her children, and leave a document of her times. In fact, women have a right to live and record their own lives in their own way and not be judged by critics or historians.

I want to stand as a mother, especially today when the work of the housewife is so degraded. I want to nourish people with my pictures. I'm not really interested in the photographic art world. I use photography like language, to say things. I speak from my life.

I have no desire to be mysterious or to show what I can do, because with photography there is almost no limit to the things you can do, especially with the lenses of today. The medium of photography adapts itself to whoever you are.

I am not nearly as conscious of my age as others seem to be. George Bernard Shaw is supposed to have said, "Is that all they can remember about me, how old I am?" We don't have any alternative to growing older and it happens so slowly that we are not really aware of it. A day passes unnoticed until it becomes yesterday and suddenly we are older. If you were to ask a child how it feels to be young, he wouldn't know how to answer. I know how it feels to be sick and how it feels to have pain and how it feels to experience joy, but I don't know how it feels to be old. Perhaps I have more understanding of other people than I did when I was younger. I know that I have more time to love and more conviction that love is the answer. The world of today is full of fears pumped into us by radio, newspapers, and television. Fears of cancer, the water we drink, the air we breathe. Fear is very destructive. I always return to love. Our lives should not depend on conditions of today or tomorrow, or on world politics or fears, but on the eternal awareness of the earth and sky and stars and knowing the small part we play in the millions of years of evolving. We tend to get so confused and overwhelmed by the events of the day that we forget the leaves and the grass that cover the earth and will cover our graves and cover us all.

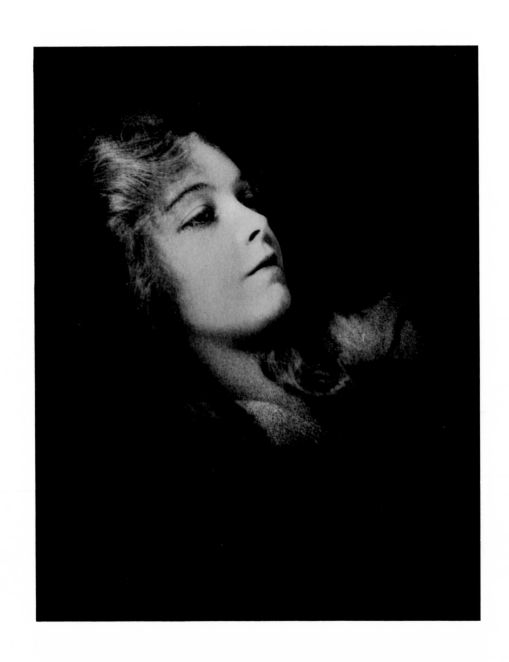

Lillian Gish, 1908

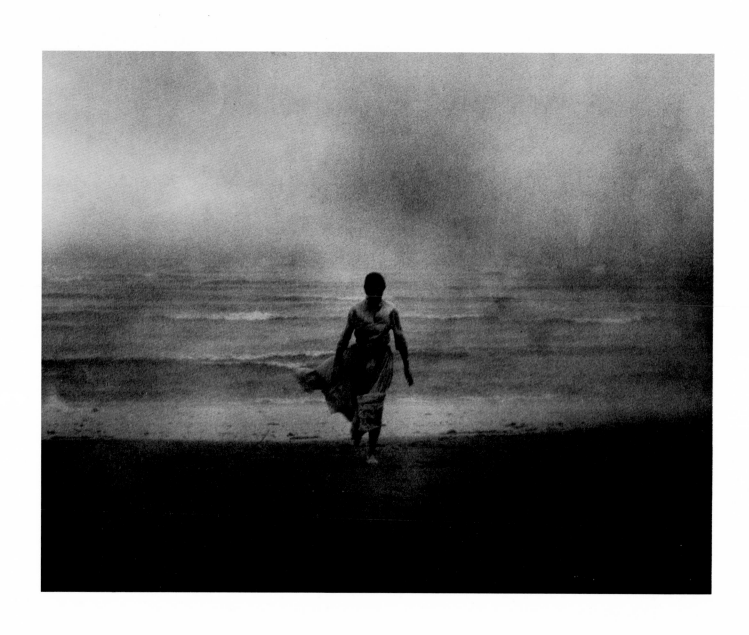

Rosa—Alone with the Sea, 1929

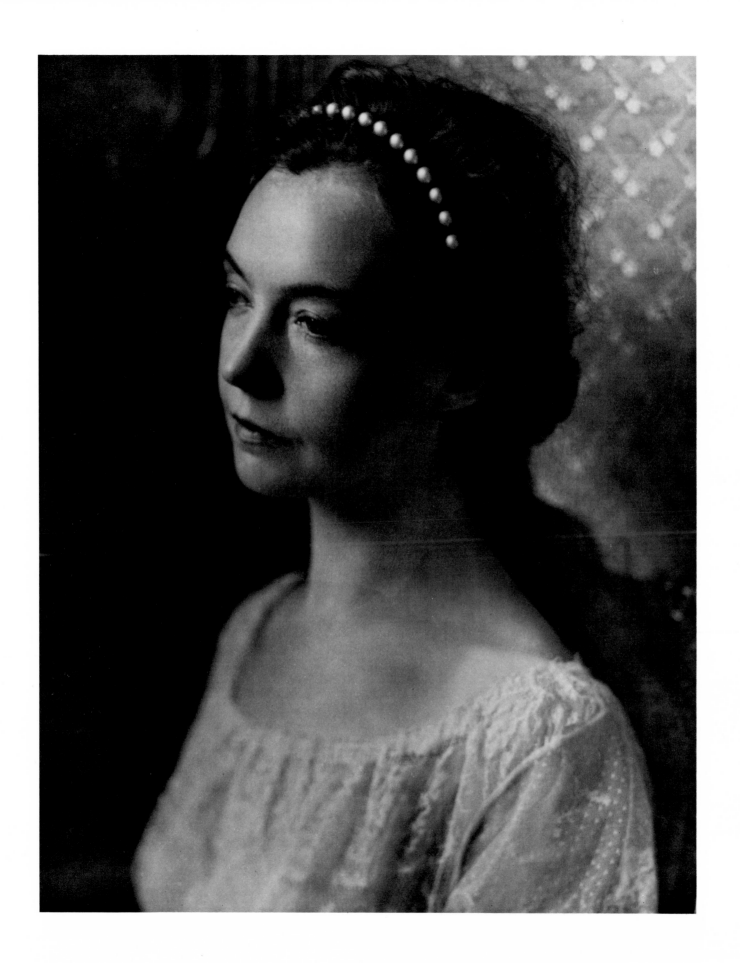

Lillian Gish, 1945

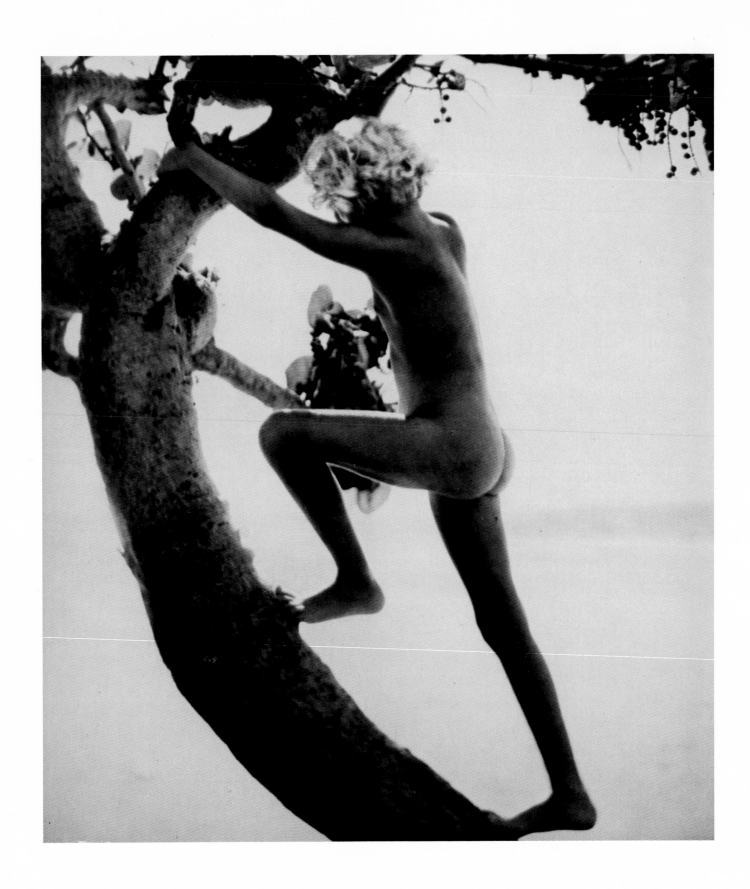

From In a Blue Moon, *1939*

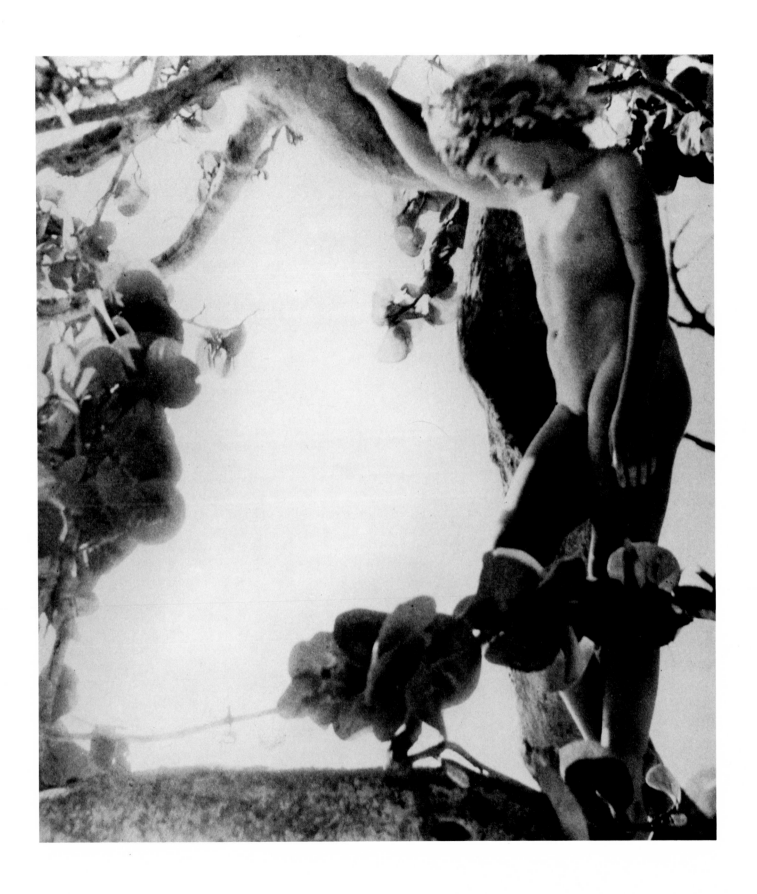

From In a Blue Moon, *1939*

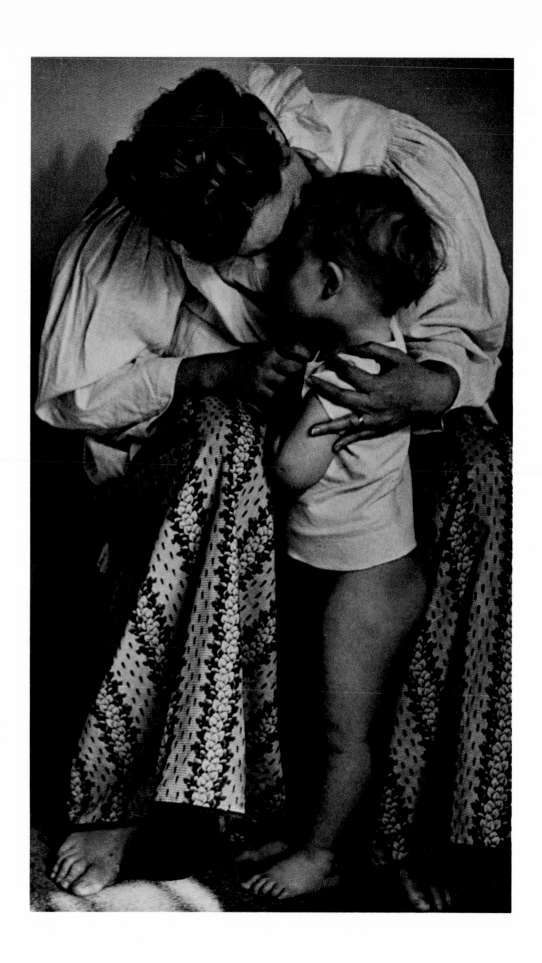

"Secrets," Win and Chris, 1942

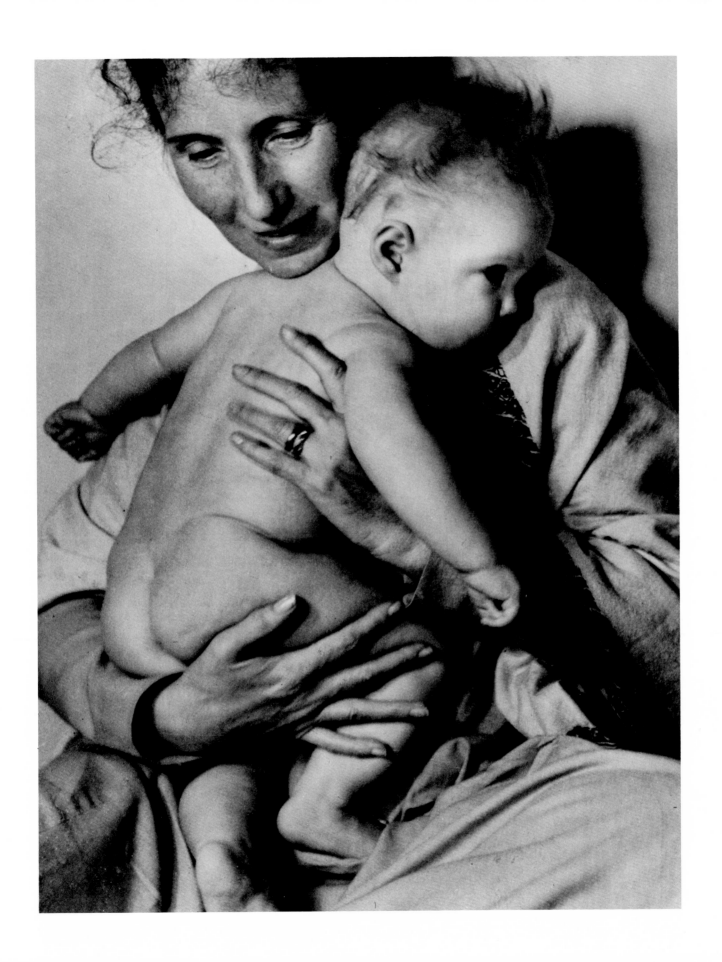

Mother and Child, 1940

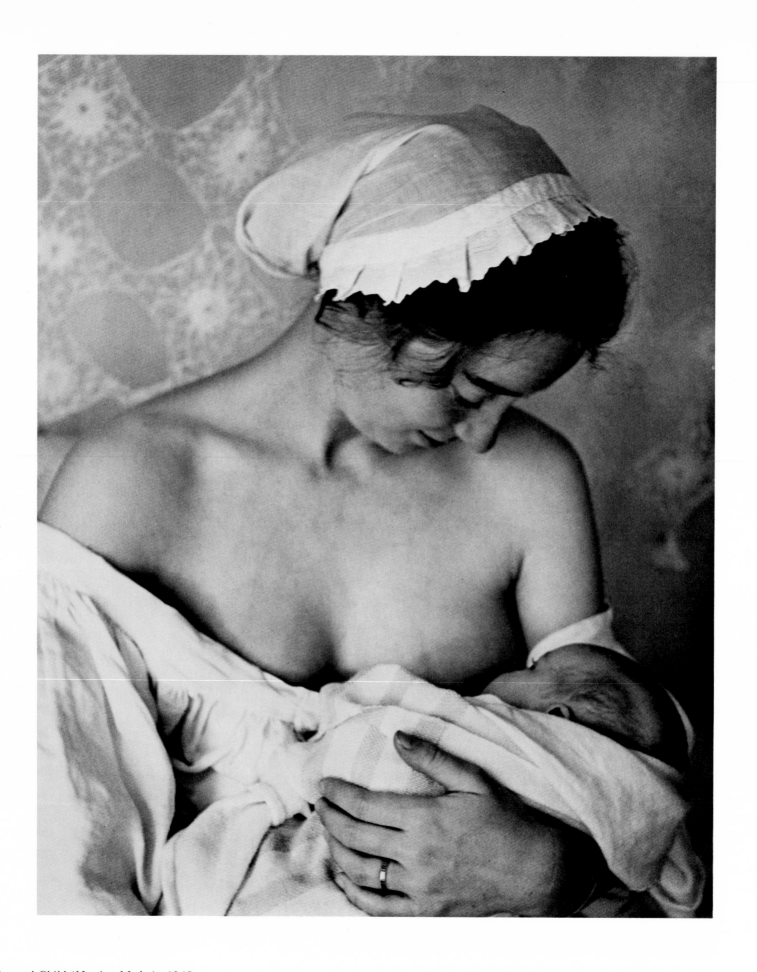

Mother and Child (Nursing Mother), 1945

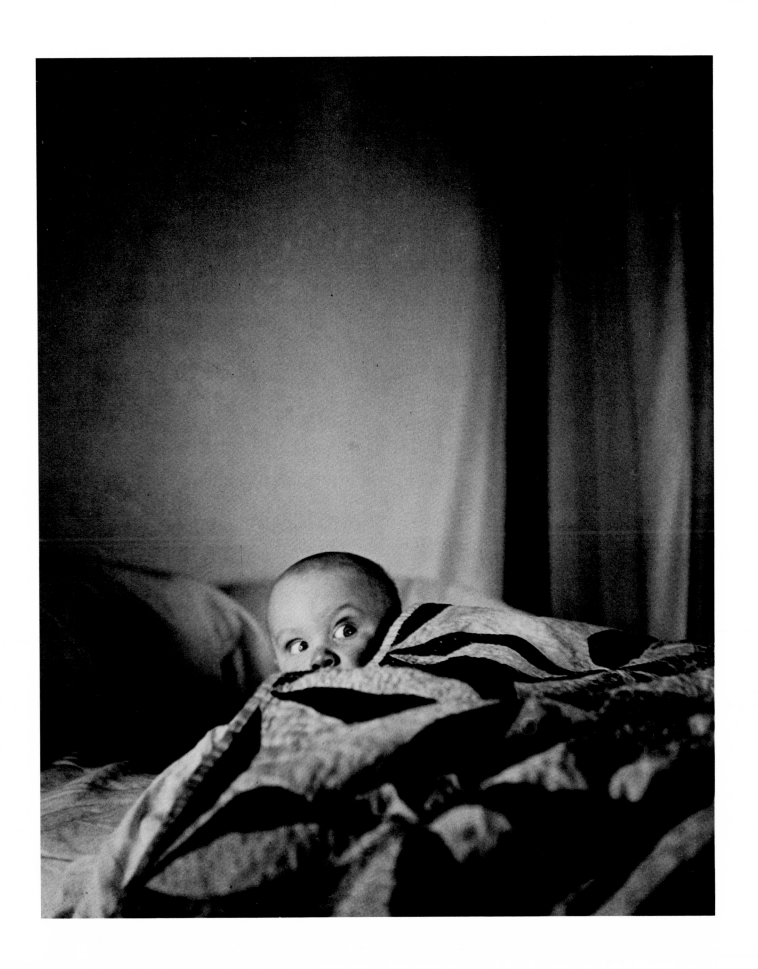

Baby in Big Bed, 1943

Flower and Chalk Figure, 1940

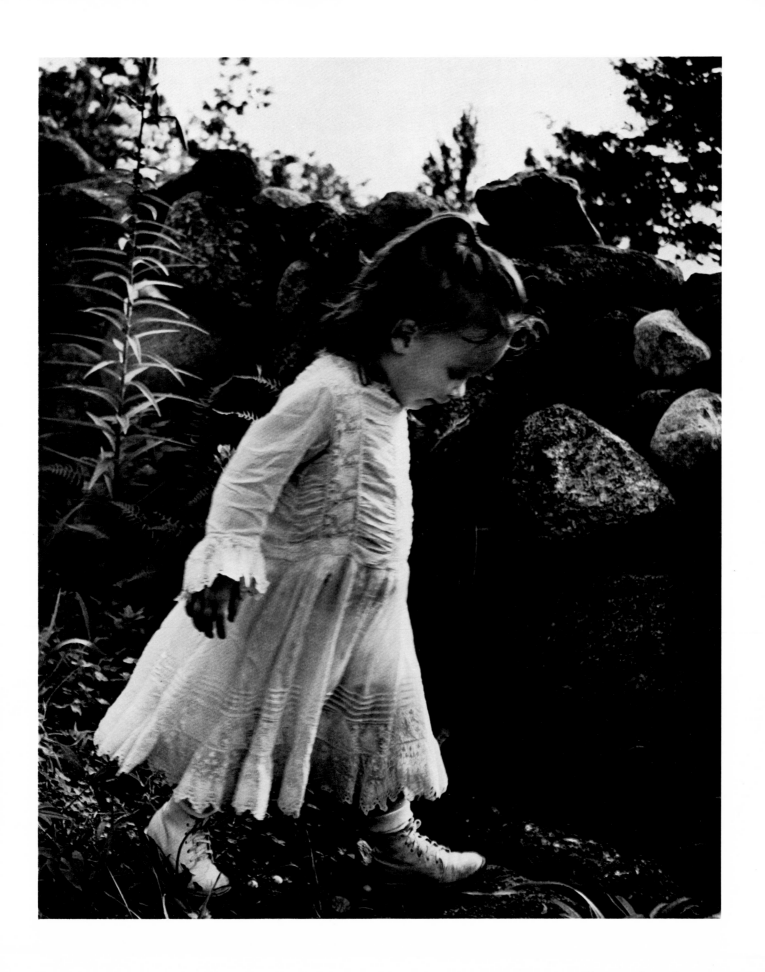

Kitten as a Small Child in White, 1950

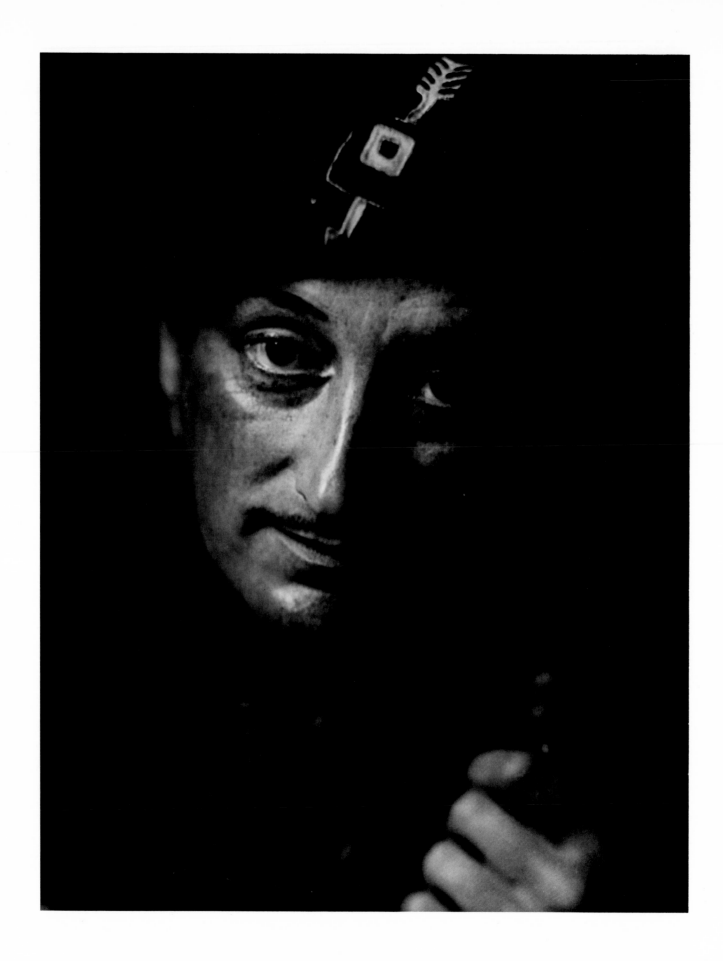

RAF Pilot, 1939

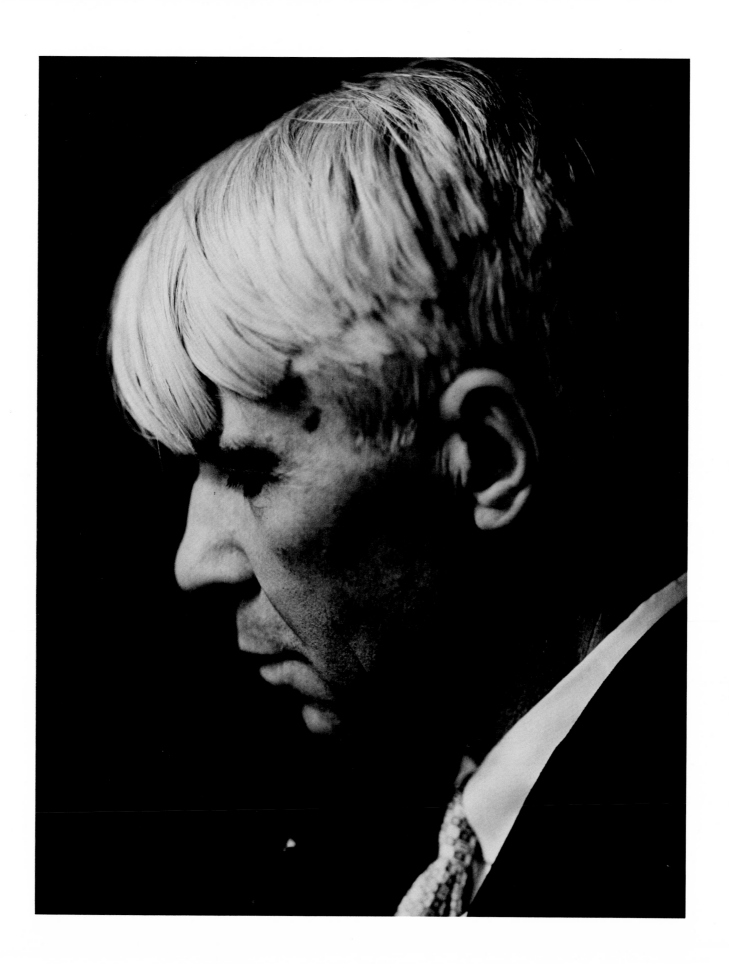

Carl Sandburg, 1939

Win, c. 1929

Abstract—used in Night and Day, *1968*

TONI FRISSELL

Along the shore of Long Island Sound the clear winter sky follows a narrow curving road bordered by slender trees. Behind them appears a stately white seventeenth-century house lit sharply by the brilliant sunlight reflected against snow still on the ground. A pond in the foreground edged by a broad weeping willow lends a nineteenth-century touch to the scene. Indeed, entering the gate is like stepping into a Currier & Ives print. Speaking from the deep curved-back Victorian chair over coffee after dinner, Toni Frissell recalls her life's story as if it were a book, each chapter an adventure story. She tells stories in sequence, inspired by the pictures in the piles of red leather scrapbooks she has kept over the years. Her husband, Mac, interjects his own memories, and after a while it is all there: friends and family scenes, the spectacular skiing trips they have shared, the sports and the fashions, the rich and famous, tea with the Churchills at Number 10 Downing Street, the experience of following American soldiers during World War II at the Italian front or on an air base in England. In photographs of her then and now Toni shows an innate sense of style, fashionably lean and elegant. Throwing a loden cape over her shoulders, she still looks the part of the fashionable, dashing, young-hearted photographer she played throughout her long career.

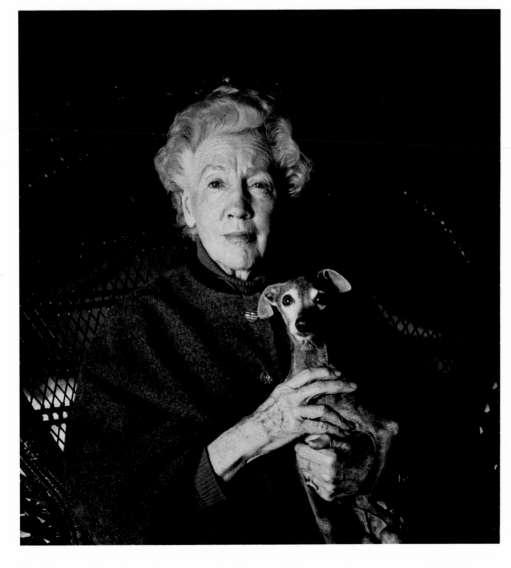

I started photography while still a child. My brothers and I carried our box Brownies at home and when we went on trips to Europe. I was the youngest in our family and the only girl. I was not exactly a tomboy but I was the water-pistol carrier for my brothers' war games. I thought that the things I should be doing, like attending parties, were tiresome.

My oldest brother Varick was my childhood hero. As a young man he created a sensation wherever he went because he was six feet eight inches tall, handsome, and sang with a wonderful baritone voice. He could have been an opera star, but he became an explorer instead, after he met Dr. Grenfeld, a medical missionary. He was terribly influenced by Grenfeld's point of view. In Varick's documentary films he believed in filming on location, a concept that became the inspiration for my subsequent photographic career. But Varick himself was *my* inspiration. We were similar in that I also was very tall for my age. I loved excitement and adventure as much as he did. Because he was a man, he could go off on risk-taking trips that I as a woman could not. But I joined him on a few. Once he went to Mexico for Pathé Films to record the Revolution. I met him and we hid in a box car, waiting next to the camera for the fighting to start. Nothing appeared but one person and one cow. So much for adventure!

Even though I was a girl I was always encouraged as much as my brothers were to do what interested me—to express myself. I hated the restrictions at school, but I was happy at the progressive Lincoln School where I acted out operas on stage. I wasn't any good at it but I must have had acting in me even as a child. I think that the imagination to create events was the basic energy that allowed me to create photographs. I tried to be an actresss—I even played a tree in *A Midsummer Night's Dream* for Max Reinhardt in the 1920s!—but I was too tall to become a serious actress.

I would say that being a photographer is almost like being an actress. There is the expectation each time I meet someone whom I am to photograph that this is the *most* important moment. Of course it isn't,

but it seems that way at the time. In a way I think actors and photographers are both shy types who lose themselves in the parts they play whichever side of the camera they are on. Because of photography I've met many fascinating famous people, great statesmen, beautiful actresses and models, all kinds. I simply feel lucky to have had the opportunity to record them all with my camera.

I took up photography seriously in 1931, which was a depression year for me as well as for the country. My mother was ill and terrible news came that Varick was lost at sea off Newfoundland during the shooting of a film. There his ship, *The Viking*, blew up. It was all over the papers and seemed unbelievable. I was in love with a Russian but he had to return to Europe. In short, my world was falling apart. I think I took my first pictures to prove myself to everyone and to keep from falling apart myself. At the same time I found a job—selling dresses at Stern's department store. From there I went to work for a friend at *Vogue* magazine as a caption writer. I couldn't spell so I was fired; undaunted, I bought a camera and took pictures during the summer at Newport. They were active, natural pictures of my friends having a good time doing such things as surfing on rubber mattresses and crabbing. I showed them to Frank Crowninshield at *Vogue*. He liked them—perhaps because they were unusual outdoor fashion shots—and he loaned me a Rolleiflex to do more. Even though I was on *Vogue*'s staff for a while, my first photographs, the series called "Beauties at Newport," were published in *Town & Country* in 1931. From that beginning I worked for *Vogue* for eleven years and then went to *Harper's Bazaar*.

Though I used small-format cameras almost from the start, I did begin officially with the Rolleiflex. Later, during the war, I depended upon my Super Ikona B because it was quicker and easier to focus.

In the 1930s the other photographers were all men, but I didn't think much about it. I used to be absolutely unselfconscious. For example, when I was very, very pregnant and photographing from an odd angle from the floor I saw next to me a beautifully creased pair of pants and perfectly polished shoes. I looked up and there was Condé Nast himself looking down at me. He said, "What are you doing down there?" and I answered, "Well, I'm interested in the way it looks from down here. I see things in my own way."

Instead of using studio lights, I took my models outside to natural settings even though they were dressed in furs or evening gowns. I wanted them to look like human beings, with the wind blowing their hair and clothes. As a photographer I was most successful when I did things naturally.

During my early days at *Vogue* Cecil Beaton was already a genius at creating backgrounds. I collected props for him. His photographs made women appear both elegant and beautiful with transparent skin. I remember a young model posing in all sorts of costumes—Edwardian dresses with long white gloves against backgrounds of chandeliers and pedestals with cupids, lace curtains, and forsythia, and even one time with a Roman warrior helmet on her head. Once he photographed Princess Paley in a great rape scene; I suppose he was portraying the *spectre de la rose*. Margaret Case at this precise moment opened the door of the bedroom and said, "Oh my goodness, how chic," while backing out and closing the door.

In 1932 I married Francis McNeil Bacon, and we had two children, Varick and Sidney. I photographed my children as they were growing up to illustrate Robert Louis Stevenson's *A Child's Garden of Verses*. In my photographs of the children I tried to capture some of the Stevenson charm. I never tried to pose the children, but I would play with them, and when they struck the right attitude, I'd act quickly. It was a challenge to combine marriage, raising children, and my career, but I was fortunate enough to have a superb old-fashioned governess to help me take care of the children. In fact, she was the same woman who had been my own governess when I was young.

During the Second World War I was determined to take war pictures. I went down to Washington to see the head of the Red Cross, who arranged to send me to England to do promotional photographs of the activities of the Red Cross there. The second time I photographed in Europe during the war was for the Air Corps. I was asked to go on a trip with a group of writers and editors. I accepted without consulting my husband. He was furious at first, but of course I went. I was the only photographer in the group on the plane flying over the Atlantic.

One subject I photographed was a briefing of a special mission headed by General Doolittle. For that kind of work I had to use synchronized flashbulbs, the strong one off to the side, the weaker one on my camera. The resulting pictures were of a human drama. It was a rough mission and the anxiety of the men came through on their faces. I also went up to Norwich to photograph the B24s and B29s on their missions, both taking off and returning with the wounded.

When I came home I no longer wanted to photograph fashions. I wanted to photograph people and events. For instance, I thought I could record the conferences of the chiefs of staff but I was turned down by Harry Hopkins.

During the war I had always wanted to photograph Winston Churchill. I finally met him after the war. Mary Marlborough called me up when I was in London and said, "Winston is going to be here next weekend at Blenheim, so bring your Kodak." I arrived the next day at Blenheim, which is a huge palace, and I met him just before lunch. After lunch Mary Marlborough said, "Winston, Toni is a good photographer—why don't you let her take your picture?" and he said, "Delighted, my dear" (already regretting it). So I rushed around with Mary to get ready, realizing that I wouldn't have much time. He began to fidget, and didn't do anything to cooperate, so I became desperate. I said to him, the greatest thinker of our time, "Mr. Churchill, you're not thinking the right thoughts." He asked me, "How is that?" And I said, "You're thinking how boring I am to detain you when you want to be taking a walk with your wife—am I right?" With that he looked gentle and I snapped the picture. Lady

Churchill said to me afterward, "I don't know how you got that photograph, because Karsh took the rudest picture of my husband ever, and I'll never have his portrait in my house." It was true; Karsh hadn't gotten the picture he wanted and he signaled to his assitant to snatch the cigar out of Churchill's mouth to get a reaction. Lady Churchill never forgave him and for years it was my photograph of him that sat beside her bed.

The second time I photographed Churchill was on Coronation Day in 1953. A message came to my hotel from Lady Churchill's secretary inviting me to photograph Sir Winston at teatime, just after the coronation. I had been photographing the peers at Westminster Abbey and had to get from there to Number 10 Downing Street in the pouring rain. I had a card in my purse that said, "Please facilitate Miss Bacon to 10 Downing Street." As we drove along we got stuck behind the Royal Procession Barrier. My heart sank as I thought I would miss the appointment. I poked my head out of the car window and showed the letter to a bobby. He looked at it, and said, "That's all right, madam; we'll give you a motorcycle escort." I felt like a queen as I

At 10 Downing Street, June 2, 1953.

passed the crowds. I imagined myself waving to them in the way the queen does, with her elbow bent. I heard the chauffeur say, "Madam, there are so many people I think we are driving on people's feet." Needless to say the whole experience was memorable and I consider the portraits of the Churchill family among my best work. I've had other adventures. I once thought of photographing a fox hunt from a helicopter for *Sports Illustrated,* and I sold this idea to the Master of the Fox Hounds down in Unionville, Pennsylvania. So, at great cost, I was given a helicopter. From the air I noticed that the horses were looking sort of skittish and indeed they were. They bolted and the hounds scattered. An old lady riding sidesaddle was thrown off her horse. I didn't realize that anything was wrong because of *me.* I just saw that the hunt was bolting all over the beautifully clipped boxwood gardens; so the next time I went above the road, I noticed that some people were shaking their fists at me. They weren't waving at all. So I said to the helicopter pilot, "We'd better sit down quickly." So we went into a field, at which point we turned the fox back into the woods. In a fox hunt this is unforgivable! Later there were great roars, and I had to call up the master to apologize.

I have always admired strong women, women of adventurous mind, women active in doing original things. When I was young, an early woman leader in Congress,

Toni and her pilot, World War II, 1945.

Isabella Greenway, took me to Paris with her daughter. I admire the grand ladies I've known but I think of myself as a sportswoman. Being a woman shouldn't interfere with the job. When I was taking pictures I went everywhere just like a man. When I was working for *Sports Illustrated* I was delighted to be paid to go photograph all the sports that interested me anyway. Sports photography is in itself a sport. I'd rather stalk with a camera than a gun. It really is a game to catch people unawares and talk them into forgetting they are being photographed.

I have stacks of scrapbooks that bring back the moments as I recorded them. I've been lucky to observe a segment of society as it was lived, and I think that my work will have greater value in the next century as a record of a vanished way of life. I gave my collection to the Library of Congress for that reason, and I haven't thought much about it since.

Today Mac and I travel a lot and we spend as much time outdoors as possible, especially when we are at home, which is my favorite place in the world. We love to eat outdoors under the oldest tree in America, which is next to our seventeenth-century house. From this perspective, it's hard to remember that I suffered agonies of fright over each picture I took, which was at the moment the only one that counted.

In 1961 I had a show at IBM called "The World Is So Full of a Number of Things." I wrote a statement for the exhibit that still stands for my attitude toward photography. I said, "In this show I have tried to capture a number of things I have seen around me, at work and on holidays, a child's world of discovery. My own varied fields of travel, ways of life both simple and splendid, and on my assignment in the European theater in World War II. Here also are moments of relaxation as well as of achievement. And most of all, here are faces that I have found memorable. If they are not all as happy as kings, it is because in this imperfect world and these hazardous times, the camera's eye, like the eye of a child, often sees true."

Five Girls Running, New York, c. 1930s

"Spring of the Mermaid," Weeki Wachee Spring, Florida, for Harper's Bazaar, *December 1947*

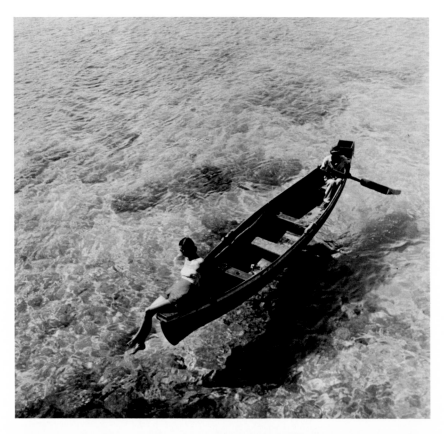

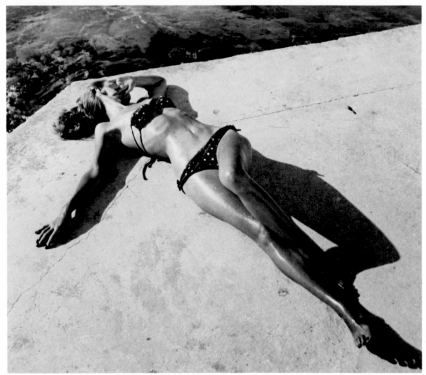

Floating Boat, Montego Bay, Jamaica, for
Harper's Bazaar, *1946. Art Director Club*
Award for black and white, 1947.

The First Bikini, Jamaica, for Vogue, *c. 1946*

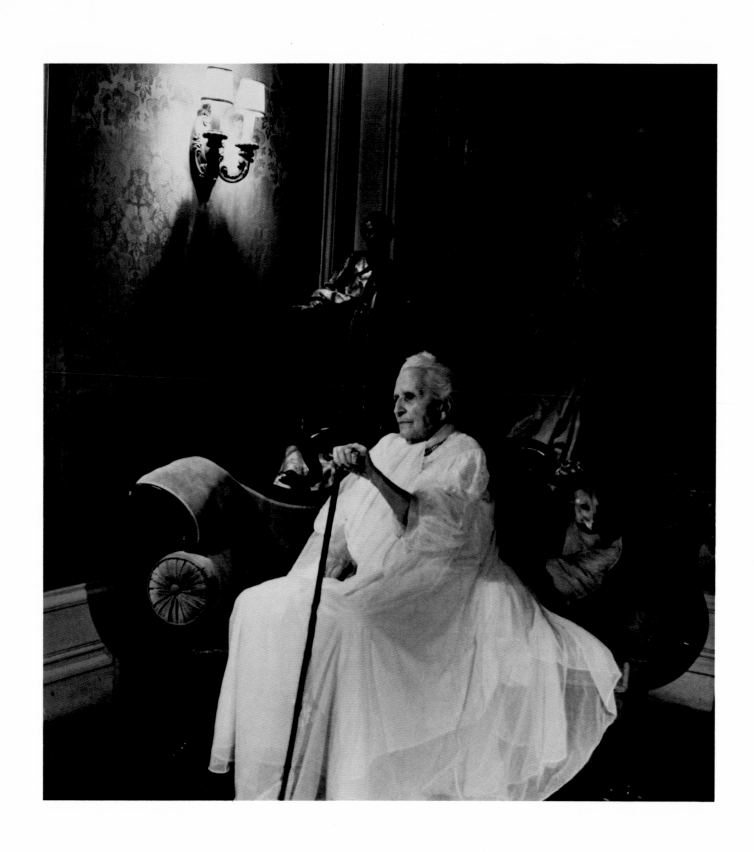

Alida Chanler Emmett at ninety-four years,
Long Island. For Life, *September 1966*

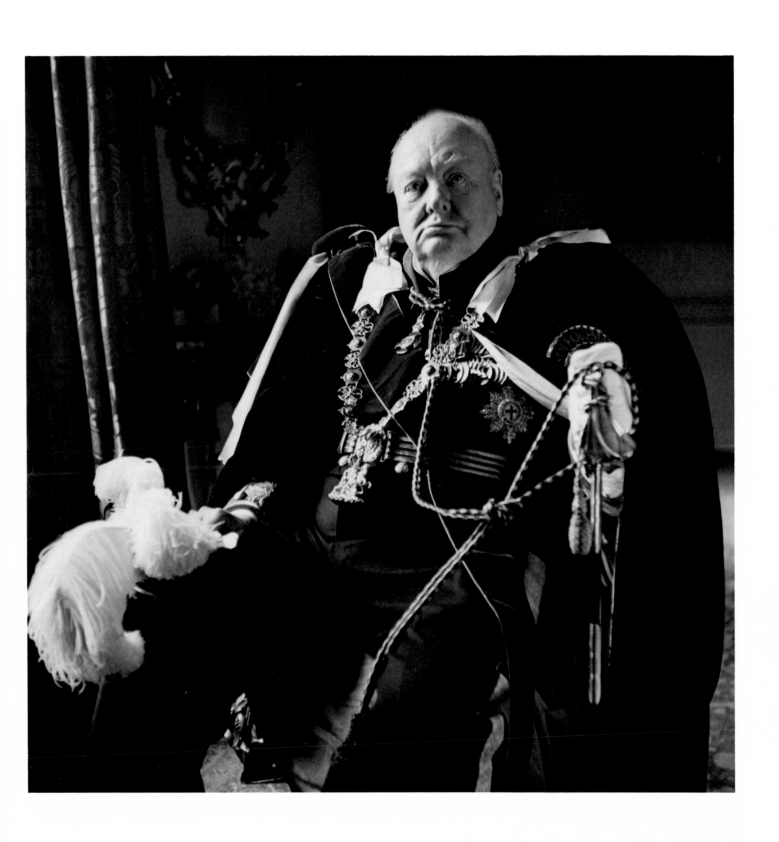

Winston Churchill in His Knight of the Garter Robes at 10 Downing Street on Queen Elizabeth's Coronation Day, June 2, 1953

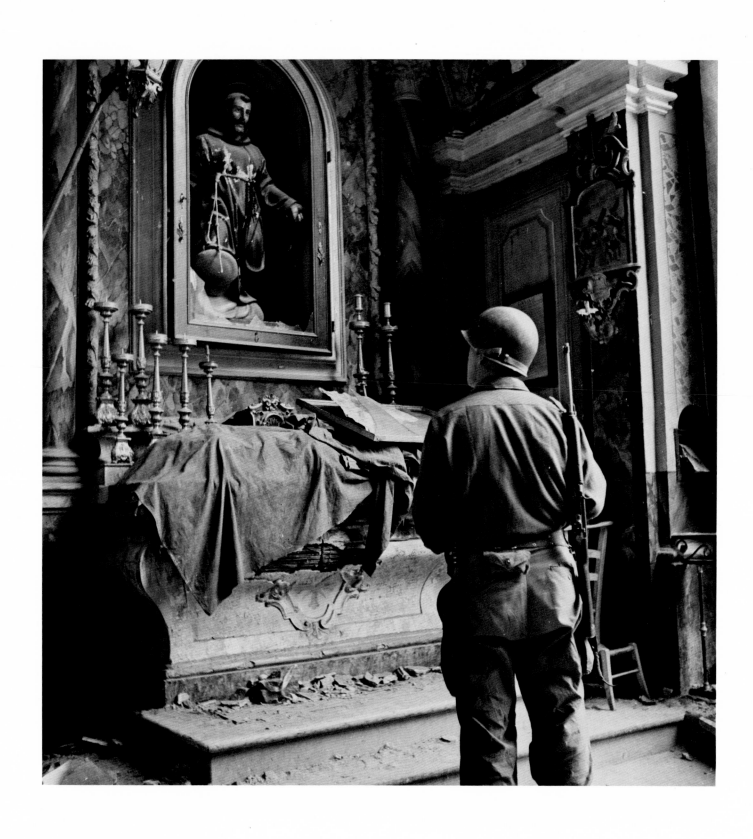

*American Soldier in Bombed Church in World
War II, Italy, January 1945*

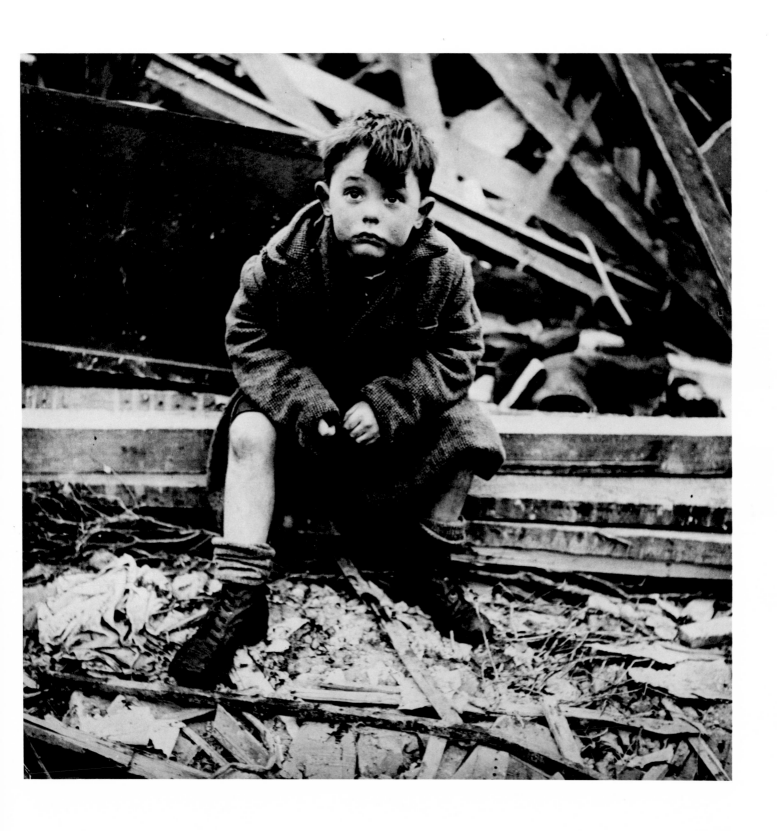

Shock—V2 London—Parents Buried in Rubble,
January 1945

Switzerland, c. 1950

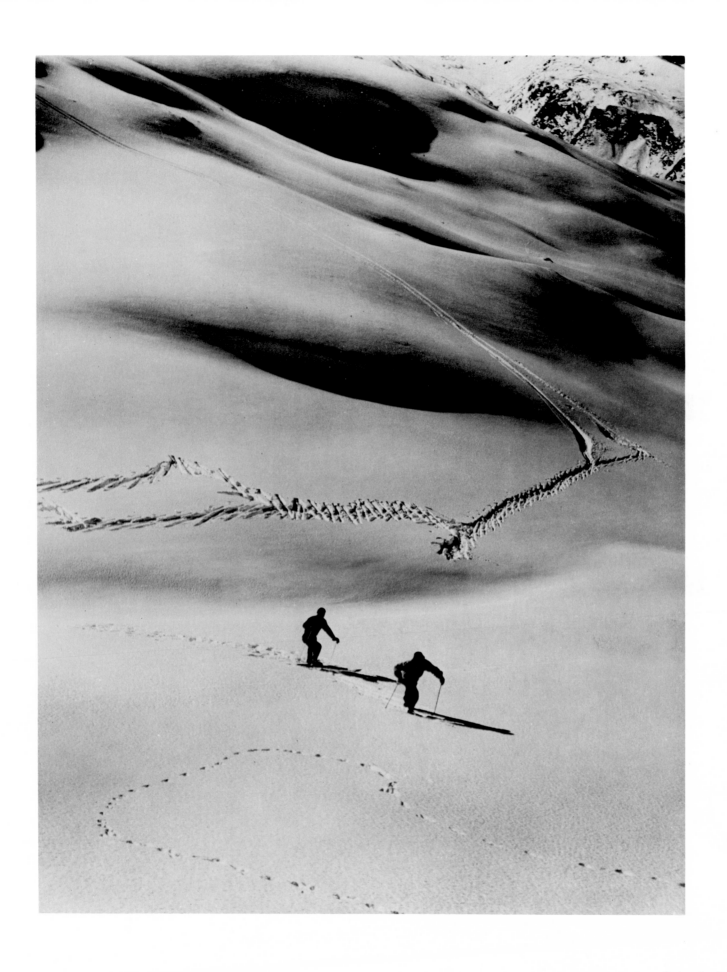

Switzerland, c. 1950

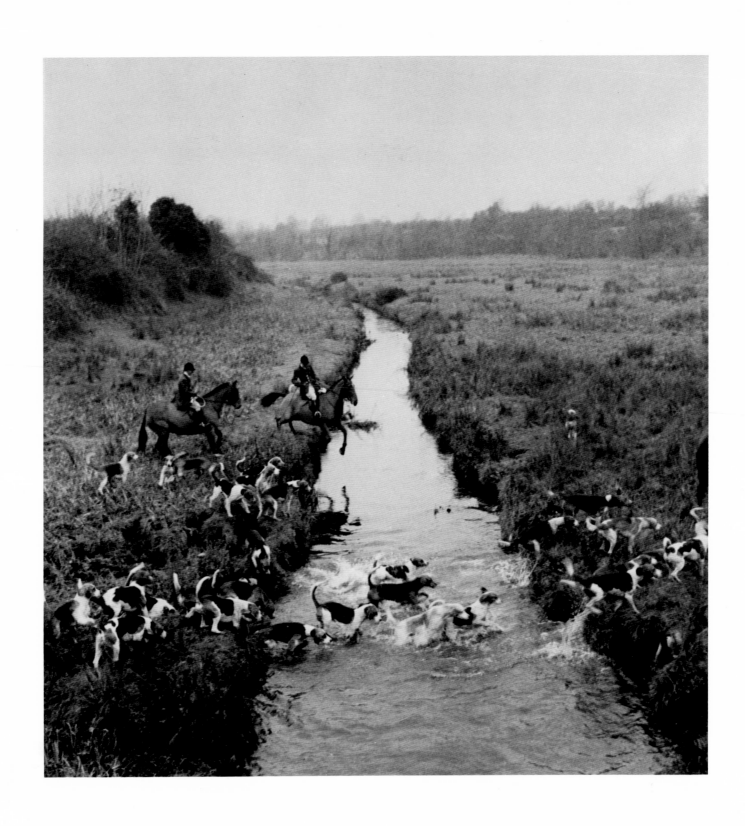

Hounds on the Scent, Meath Hunt,
Ireland, November 1956

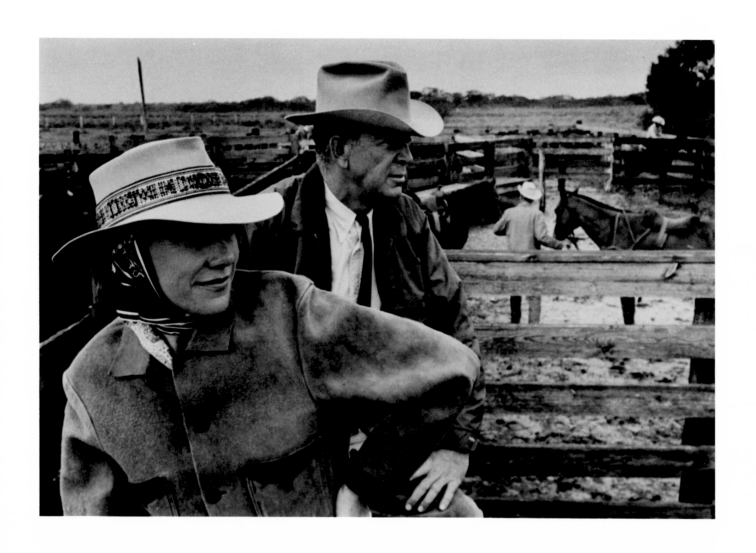

Anne and Tobin Armstrong, King Ranch, Texas,
taken for Vogue, *December 1967*

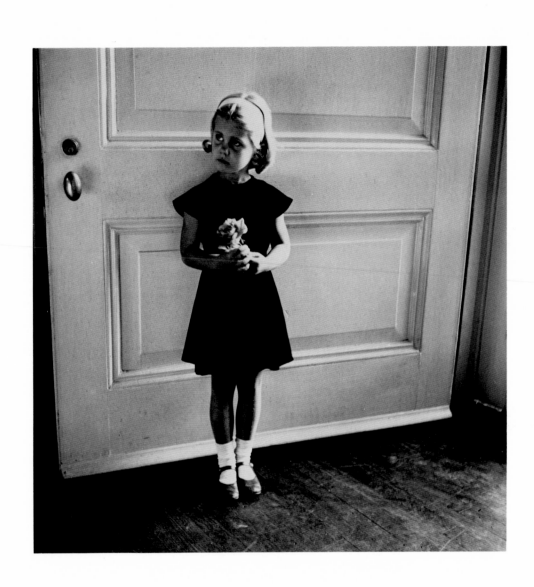

Hilary Paley, for Vogue, *September 1944*

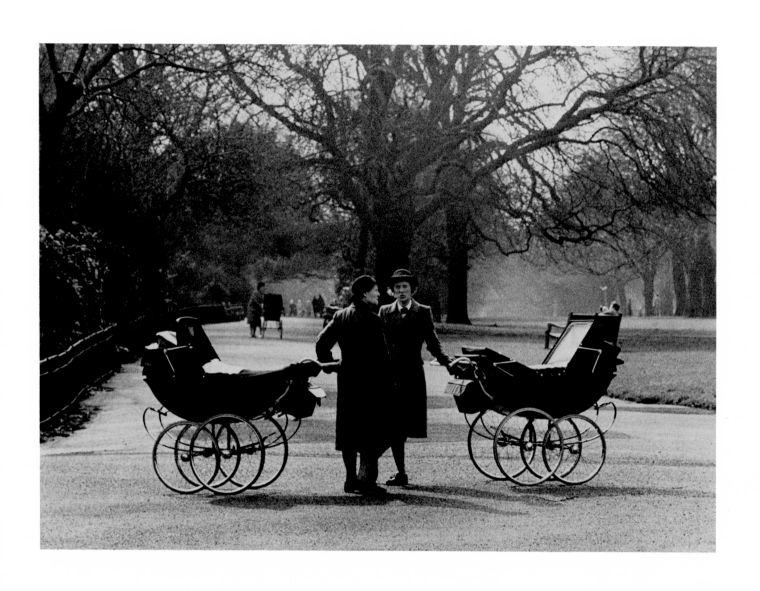

People, Too—Kensington Garden Nannies,
England, April 1963

My Daughter Sidney and Her Grandmother,
Long Island, June, 1944

Hugh, Lord David, and Jonathan Cecil,
England, June 1950

119

LAURA GILPIN

The southwestern sky of Santa Fe is turquoise blue over a mountainside hung with yellow aspens. There, in a small adobe house, Laura Gilpin lives in the landscape she has celebrated with her camera. As I enter the hall, I can hear her voice loud and clear in the library, on the phone, a long-distance call. The morning light catches her short white hair from behind, haloes her face still in shadow. Her voice continues firm and clearly practical. "Yes, yes, that's fine. I'll get to it right away." Messages are passed, helpers arrive for the day, friends come and go, and the day stretches with her abundant store of memories, told steadily with a chuckle and with plain detail in words and pictures. Photographs are everywhere—on the walls, in every drawer, cabinet, every box in sight. In the library are old lantern slides of the Navaho people; in the studio is

a standing wood cabinet crafted entirely by her father, which is packed with platinum prints; in the workshop a wall bookcase is filled with silver prints in their yellow Kodak boxes labeled by year, by place. Even as she is recounting the past for the tape recorder, the present work is in progress. Periodically, the phone rings and Laura Gilpin maneuvers through it all in her wheelchair or on crutches. The trouble is her hip, which finally gave way from too many years of lugging around heavy photographic equipment. Laura Gilpin doesn't talk much about herself but she tells a good anecdote eagerly. If she is shy by nature, her humor is hearty. In her presence I get the impression that her world continues to expand toward the horizon and that, like the horizon, it could go on forever.

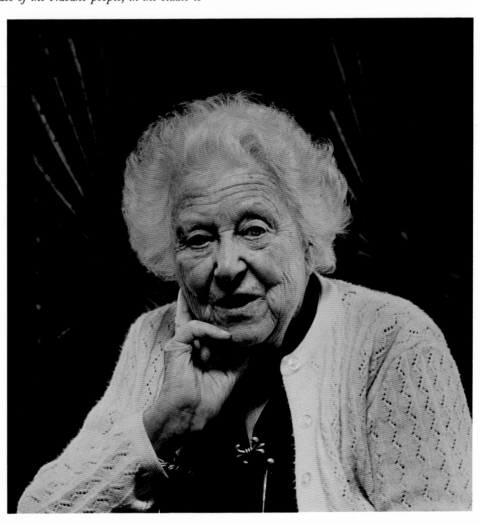

I don't recall exactly how I began in photography because it was so long ago, but I know I had a Brownie as a child. Recently I found something my father wrote in 1903 when I was twelve years old. He was down in Mexico managing a mine over the Christmas holiday. In a letter home he wrote a parody on " 'Twas the Night Before Christmas," describing things that he imagined under the Christmas tree—a train for my brother and a developing tank for me. The tank was one of those funny machines in which you rolled the film under a red apron from one side to the other and then poured in developer. I can just picture it now. I don't know whatever happened to it.

I can also date a lot of lifelong influences back to the year 1904 when I was sent by my mother to St. Louis to visit her closest friend, my namesake Laura Perry, who was blind. We went to the World's Fair every other day and it was my job to describe exhibits to her. The experience taught me a kind of observation I would never have learned otherwise. I can also remember being fascinated by some Igorot natives from the Philippines who were there.

When I was fourteen my mother took my brother and me to New York where we had portraits made by Mrs. Gertrude Käsebier; they were very beautiful, especially the portrait of my six-year-old brother. Meeting Mrs. Käsebier had a great effect on me certainly, because later when I wanted to study photography I wrote to her for advice and she was a great help to me.

In 1908 I made my earliest dated autochrome. I had learned about the Lumière autochrome plate, the first single-plate color process, from a fellow in Colorado Springs. This process was invented in 1907, so it was brand new, and I remember falling for it head over heels and making a great many plates. I don't know why I hit the exposure right, but I evidently developed a kind of sensitivity at that time. One of the problems with the autochrome was the delicacy of the emulsion. These plates were made in France, and it was very easy to get a little break in the emulsion, which would always make a green spot. I processed the earlier ones in a darkroom on a

ranch in the western part of Colorado. I was always fussing with photography as a youngster.

The San Francisco and San Diego fairs of 1915 were another transition, I guess. I went to California with a friend of my mother's. I recently found a whole envelope of negatives from the San Francisco Exposition that show my first contact with sculpture. I think I photographed every piece of sculpture that was exhibited outside in the fairgrounds. There must have been fifteen or twenty different subjects. I was so surprised at how much there was to see! That trip must have impelled me to study photography seriously because on the advice of Gertrude Käsebier I went the following year to study at the Clarence H. White School in New York.

I had been in the poultry business, raising turkeys, when we lived on the western slope of Colorado. My mother always felt that I should be independent. She was a remarkable woman and she was all for my doing what I wanted to do. In 1916 it was not the usual thing for a girl to go off on her own, but whatever I wanted to do she was for; she was right there behind me. The more that I think of her, the stronger I feel that.

While I was at the Clarence White School I often went to visit Mrs. Käsebier. Mr. White was a marvelous teacher. Paul Anderson was the technical instructor, and that year Max Weber gave a course in the history of art and design, which was a wonderful experience, and then Mr. White himself brought it all together with weekly criticisms. He would give us problems to solve. I remember some of the students (there were about twenty of them) and I can tell from my old group photograph that there were more women than men at the school.

The schooling in New York was just what I most wanted, and I soaked it up! Learning technique was different in those days. When I began photography at the Clarence White School we did not have light meters. It was a question of acquiring sensitivity of the eye to the ground glass while working under the focusing cloth.

Really, photographic technique is nothing but plain common sense, problem solving. I always go back to the first, very simple principle—that you expose for your shadows and develop for your highlights.

As I look back, I think that music helped me in learning photography. Music was a big part of my life growing up. I studied the violin, but I never got very far with it, so I let photography win. There's a great link, you know, between photography and music. One is continual sound and the other is continual tone. There you are—there's the comparison!—and it is true of so many other photographers. Ansel Adams was a concert pianist. Did you know Mr. White was a violinist? I never liked to perform but I enjoyed being with musicians.

New York was exciting but it was the big open spaces for me, so I went back west. I had the flu very badly during the 1918 epidemic. When I was well enough to get to work again I would send proofs to Mrs. Käsebier and then I'd get a letter from her criticizing them. As a result I'm the very proud owner of the first issue of the magazine *Camera Work* autographed by Mrs. Käsebier.

At the beginning of a trip to Europe in 1922 I found that one can learn a lot from accidents. The lens fell out of my Graflex into the water, so I ordered a Pinkham and Smith soft-focus lens, which was sent over to me in England. The first time I used it I found that it had a flare. In order to use it I had to stop down. This taught me a lot about solving problems.

I have always loved the platinum printing process. It's the most beautiful image one can get. It has the longest scale and one can get the greatest degree of contrast. It's not a difficult process; it just takes time. There has to be a contact negative; that's why other people don't use the process much today, though it's being revived.

The most unusual photographic work I've done was as the official photographer for Boeing Airplane Company during World War II. The work created lots of pressure and was very strenuous.

In 1945, after the war, I wanted to do a book on the Rio Grande from source to mouth. I had the nerve to start on it two

weeks before the war was over when gasoline was still rationed. I started in southern Colorado where I wouldn't need to travel very far. All of the landscape work was 8-by-10. I seldom made more than one negative simply because I didn't have enough film. That was the kind of training that the Boeing job had given me. These things all relate to one another; I can always find something interesting in a subject and in the challenge of how best to solve it.

I have always been an independent photographer, perhaps because I was alone so much in Colorado. I had to work things out for myself from the beginning. I come from a long line of Quaker ancestry and my whole belief is very simple. It is in how you behave and how you take what happens to you: those are the two main things in life. What I have done has been very natural to me. Creative work is something you have to see and feel. I record the things I see. If you're busy and interested, life seems not to be complicated.

Being a woman photographer has never been a problem. The only thing that I can ever remember about it was a very funny comment one day. I was doing architectural photographs for two architects in Denver on Sixteenth or Seventeenth Street downtown, photographing a bank across the street, and I had my 8-by-10 camera and I was under the focusing cloth. I heard a woman's voice saying, "That's it, girlie; show them how!" Personally, I can't see any difference for men or women; either you're a good photographer or you're not.

I really consider myself a landscape photographer more than anything else. For some years we lived on a ranch in Colorado and my favorite subject in school was geography, so I think I come by my love for landscape naturally.

My father was a friend of the great landscape photographer William Henry Jackson. The first series that Jackson made on a western cattle ranch was on my father's ranch. He came out to the ranch many times over the years but I didn't meet him until 1932. We had quite a talk and I remember his saying that when he was in the Southwest he was interested in archeology and landscape but not in the Indians.

It was in 1920 that I first came down to the Sante Fe area with my father. My first pictures of Shiprock I made on that trip. Later my friend Elizabeth Forster and I used to come down on our vacation every year for a month and we gradually explored a lot of the Southwest. Our first trip was in 1930. At that time I was particularly interested in photographing the ruins Betatakin and Keet Seel as well as Mesa Verde. On that trip we had an adventure—on a half a tank of gas we tried to travel seventy-two miles from Keyenta to Chinle. It didn't seem far so we didn't take much food with us. But we got lost and, to make a long story short, I had to leave Miss Forster with the car and set out on foot for help, walking ten and a half miles to a trading post. When I returned to the car with the trader's wife, Miss Forster was

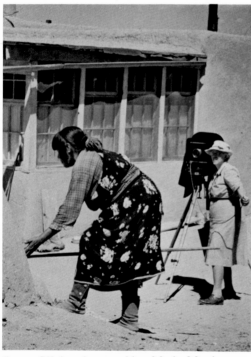

Laura Gilpin, photographing Maria Martinez baking bread, 1945. Photograph by James Cohn.

playing gin rummy with a group of Navaho, who had apparently come to help. One who spoke English told Miss Forster all about the country. At one point he said to her, "Here comes your friend. She's in Frasier's car." But there wasn't a car in sight; it was still over the hill.

The next year Miss Forster took a public health nursing job on the reservation, and during the next few years we camped all over the reservation, which gave me the opportunity to work very slowly, which is necessary to photograph the people. It is the kind of photography that can't be done in a hurry; you have to be trusted.

The Enduring Navaho project was fifteen years in the making. I had no backing, no grant or anything like that. It was just something I had to do. It was not an easy job—it took patience and more patience—but it was worth it. As things built up, I had a looseleaf dummy with prints in it to show people. All the Navaho wanted to look at the pictures; somebody would find someone they knew in a print and that always opened a door. They don't forget, they just never forget you—it's incredible. My involvement with the Navaho people has affected my own way of life, of course, as I came to understand their philosophy.

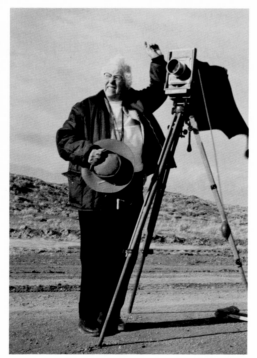

1971. Photograph by Fred Mang, Jr.

I have always had an interest in book design. As you probably noticed in the book, four is a very important number in Navaho culture. The four seasons, the four directions on the compass: everything is in fours. So I organized the Navaho book in four sections.

When I make a book I like to do the whole thing, the research, the writing, and the photographs. I never had any training whatsoever for writing and I certainly don't consider myself a writer, but the same principles are there that are in picture-making. Having something to say is the first important thing, then the problem is putting it down in an adequate design. When you are really involved in a subject and respect it, you should be able to find an appropriate way to express it.

I don't teach photography much. I don't think I'm a good teacher because I do not have the precise control that Ansel has. To me the important thing is to get the picture first. For me to get up and give a talk about photography always makes me laugh. In photographing I don't think in terms of trying to produce fine art but I know that the principles have to be there. Design is evidently a very instinctive and ingrained principle in my way of working. Lots of photographs that I've delivered were just jobs to do, problems to solve, like the advertising and architectural work I've done. But ones of my own caring—such as my landscape photography and the study of the Navaho—well, that's the work I want to keep.

Working a long time on a subject has advantages. I have photographed the southwestern landscape since I first stopped at the Grand Canyon in 1915 and I've photographed the Canyon de Chelly more than any other place. On one of my trips there I tried to find the exact spot where the great photograph with the seven horsemen by Edward Curtis was taken. I grew up under that print. It hung on our wall at the ranch for years. I'm sure that is why I have photographed so often in the Canyon.

It does give me a jolt if I stop and think about being eighty-seven, but I don't think about age much. It just seems to me when I look back that I must have wasted an awful lot of time.

The Prelude (platinum print), 1917

Fortuny Gown (platinum print), c. 1920

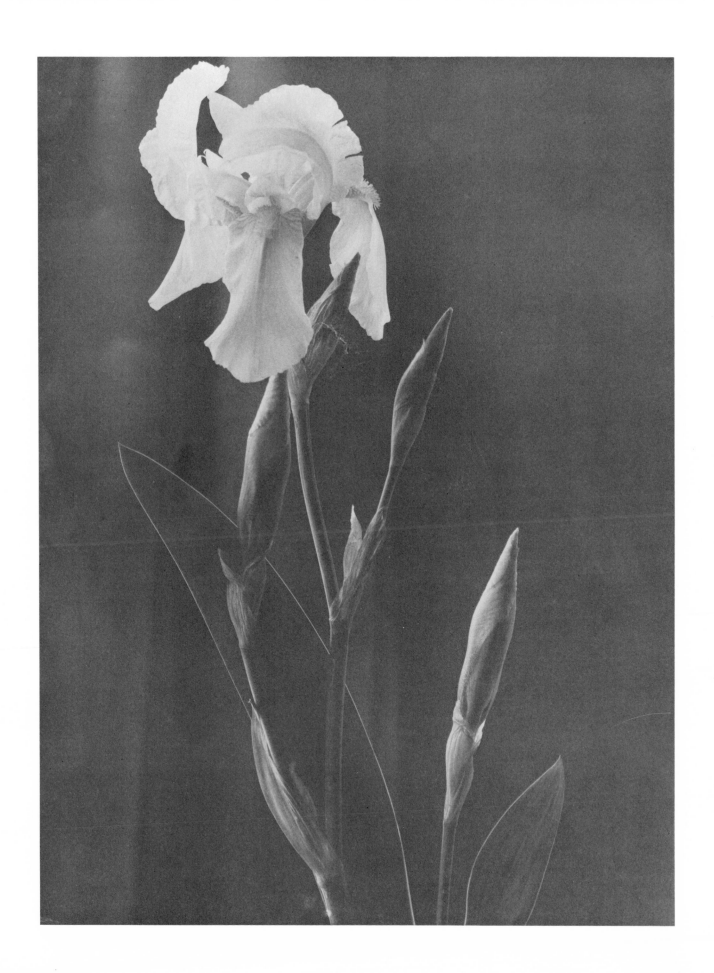

Iris (platinum print), 1925

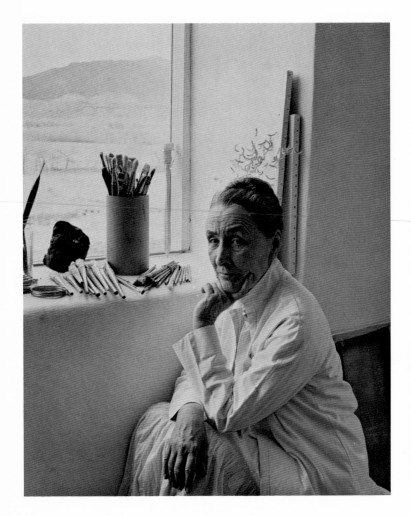
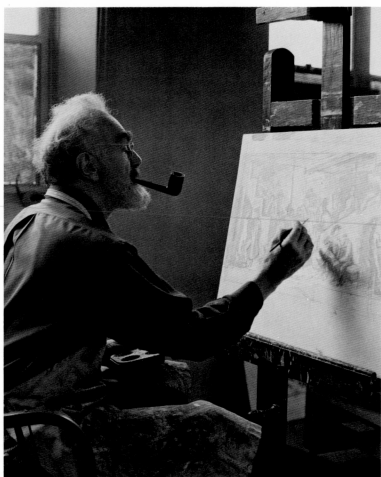

Georgia O'Keeffe in Her Studio, 1953

Boardman Robinson in His Studio, 1939

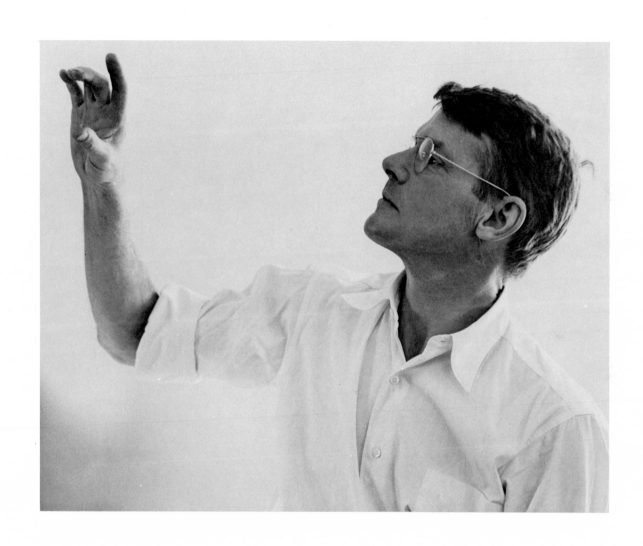

Eliot Porter, c. 1950

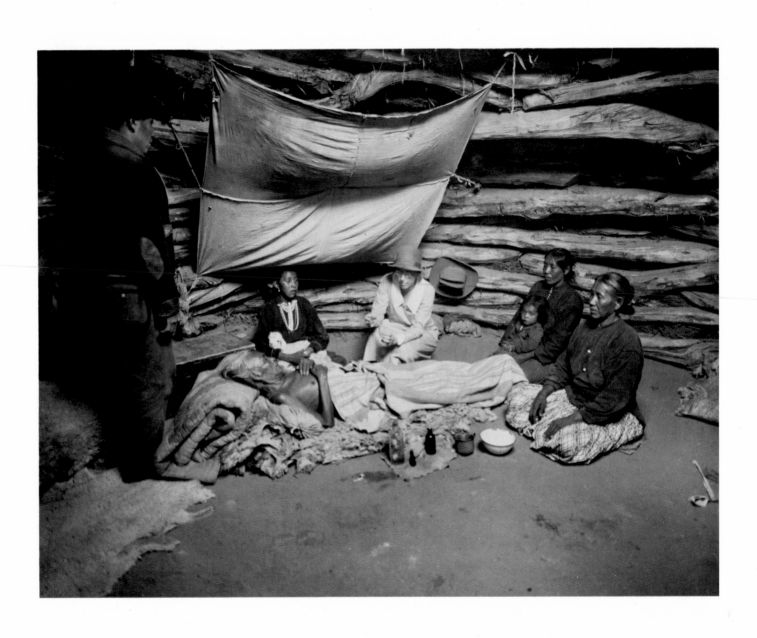

Hogan Interior with Miss Elizabeth Forster, R.N.,
Administering Medicine (from The Enduring Navaho)

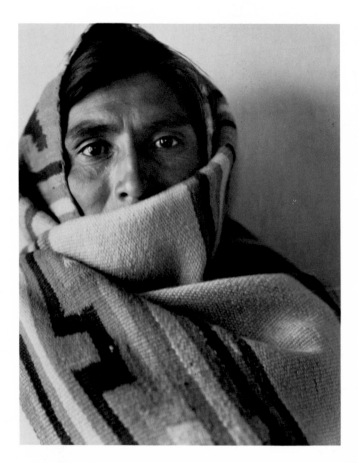 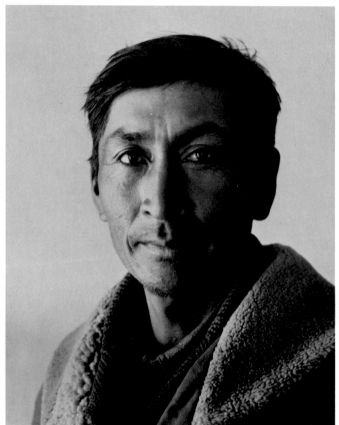

Little Medicine Man, 1932

Mr. Francis Nakai, 1932 (from The Enduring Navaho)

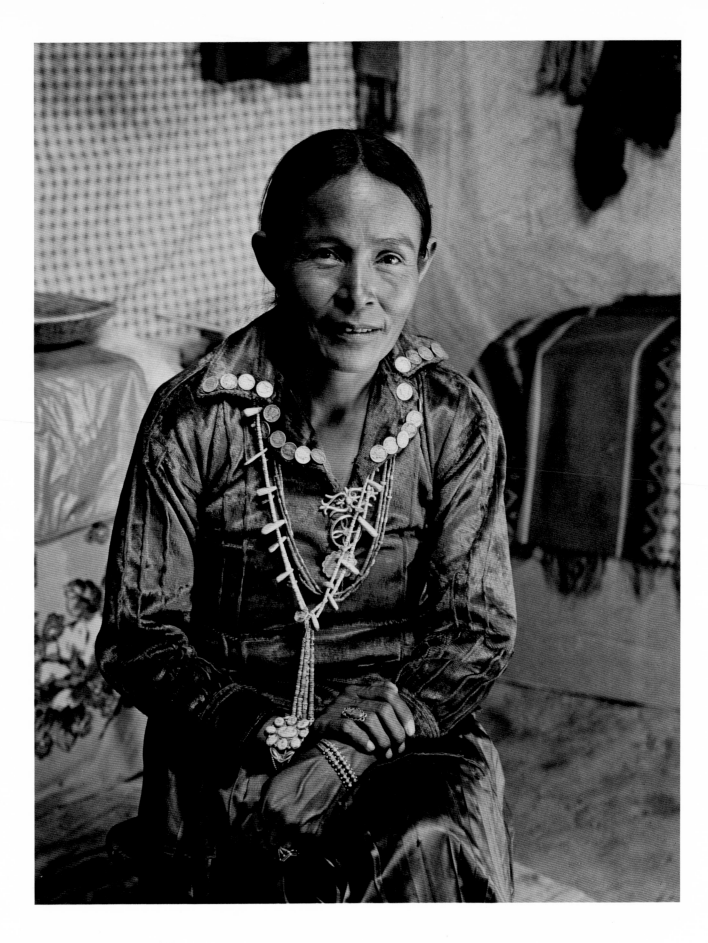

Irene Yazzie at Pine Springs, Arizona, 1952
(*from* The Enduring Navaho)

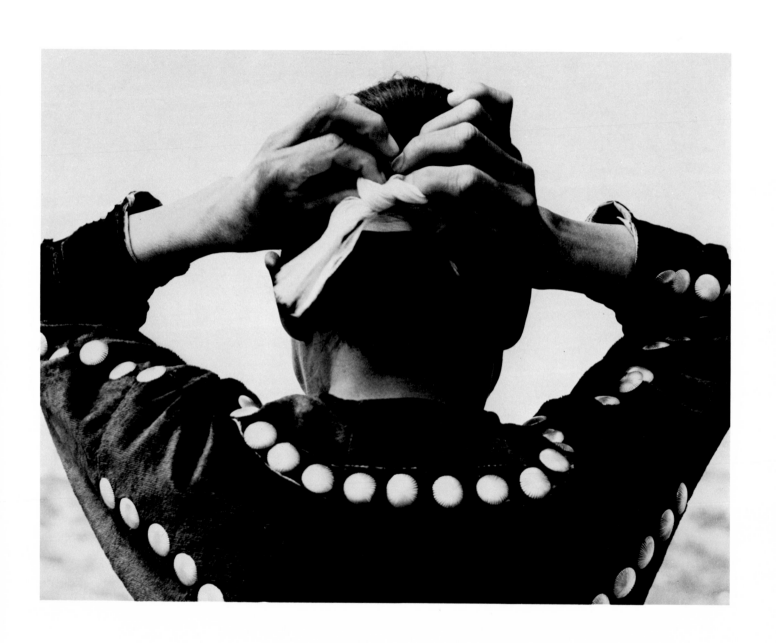

Tying the Chongo, n.d. (from The Enduring Navaho)

Canyon de Chelly, Spider Rock, n.d.

Stairway, Chichén Itzá, Yucatán, 1932

The Picuris Church, Picuris Pueblo, New Mexico, 1961

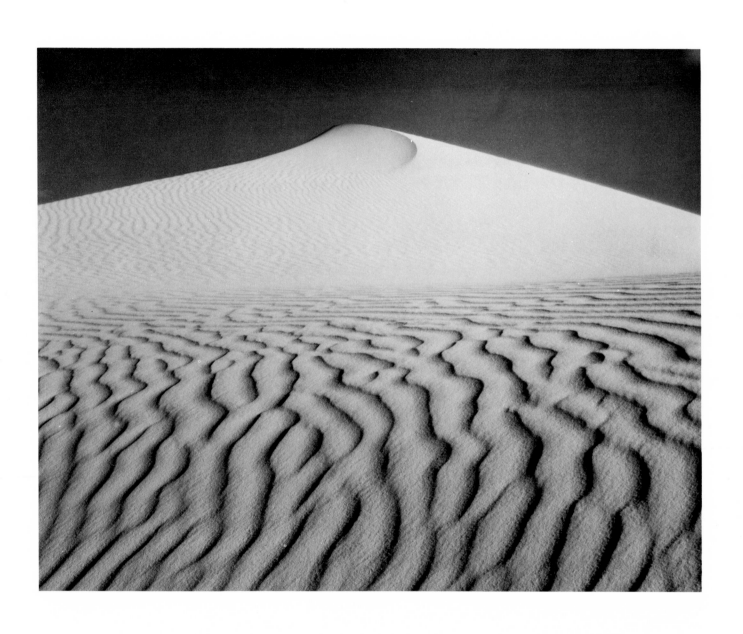

Detail of the White Sands, New Mexico, 1946

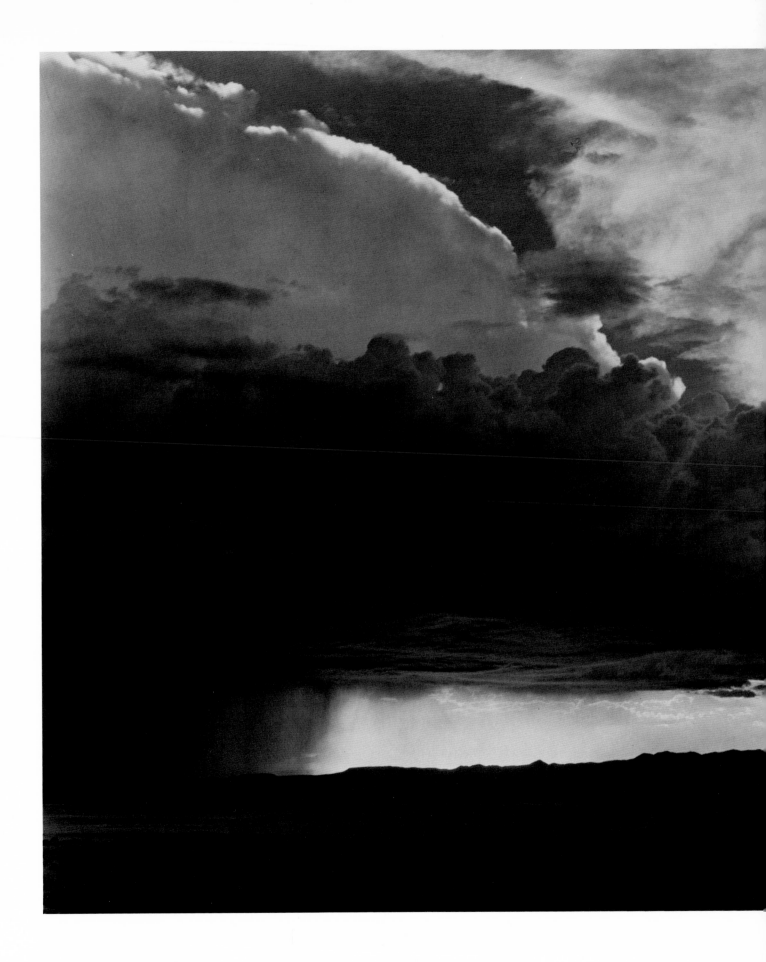

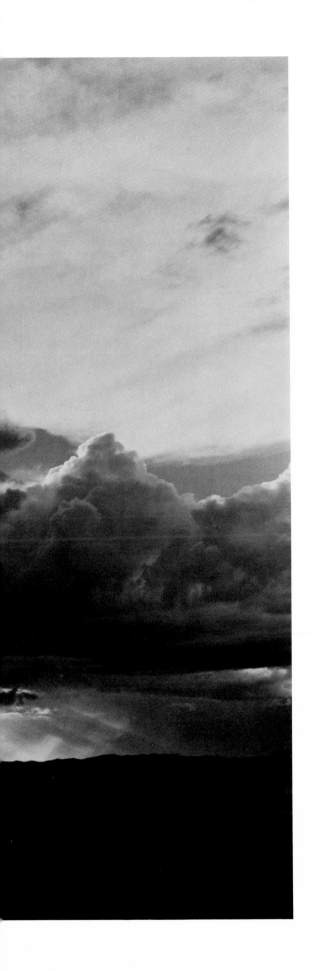

The Storm, 1946

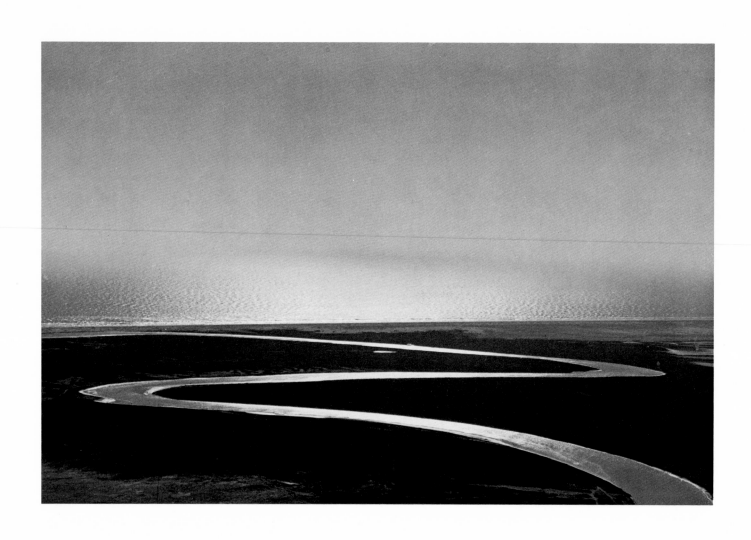

The Rio Grande Yields Its Surplus to the Sea, Texas and Mexico,
1946 (from Rio Grande, River of Destiny)

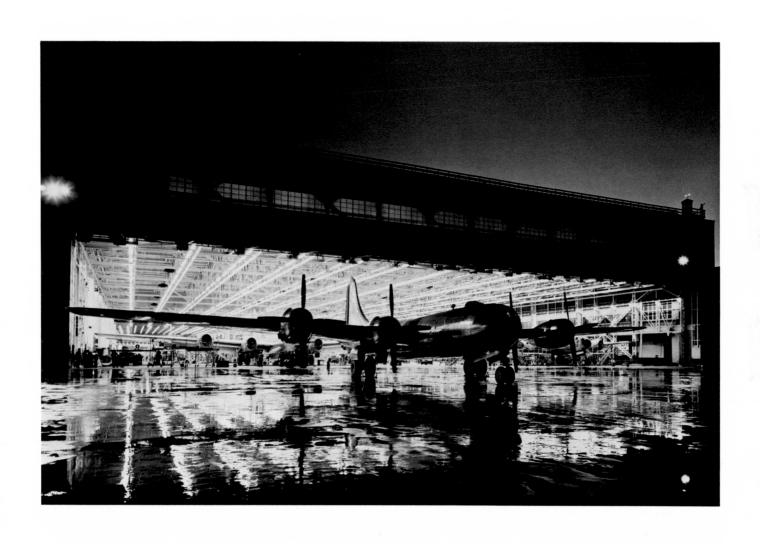

B29 Bomber Coming Out of the Factory,
Boeing, Wichita, Kansas, 1944

139

LOTTE JACOBI

Lotte Jacobi's mailbox announces "Jacobi" in capital letters alongside an old country road in New Hampshire. Next to greet the eye is her Volkswagen's license plate carrying the state's motto, "Live free or die," which turns out to be a clue to the character of her personality, her life, her work. The studio house, created from two lumberman's shacks, has the improvisational atmosphere of a summer camp or a cottage for a gardener (which she is, and a beekeeper besides). She is clearly also a saver of jars, notes, books, letters, and, of course, boxes filled with pictures. Conversation accompanies our garden tour. She talks as she walks among the day lilies, breaking off dry dead blossoms, tidying up the yard, moving the hose, watering potted plants. We check the summer vegetables, eat a few raspberries between sentences, and visit the beehives and the adjacent field of oats. At the studio, alert on the curved blue sofa, her shawls draped against the back, Lotte Jacobi seems like a bird about to take flight, yet for the moment she remains totally still. Around the room is evidence of an activist in local politics. A stack of bumper stickers proclaiming

"No Nukes in New Hampshire" sits on a carved wood chest beside her portraits of Robert Frost, Albert Einstein, May Sarton, and others. Laconic by nature, Lotte Jacobi wastes no words in her responses to my questions about her early work as a portrait photographer in Berlin—"I was born to photography"; about her resettling here as an American—"I place a high value on individual independence"; about photographing famous people—"We are all just human beings."

My great-grandfather met Daguerre around 1840 on a trip to Paris. That meeting made him a photographer. He purchased equipment and a license to use the Daguerre process, returned to Germany, and set himself up in business.

My great-grandfather, my grandfather, and my father were photographers. My father's brothers were, too, and some of his sisters married photographers. A whole family of photographers. My sister, Ruth Jacobi Roth, is also a photographer.

When I was a certain age, around twelve or so, I wanted to work at my father's studio. I was fascinated helping him when he made wet plates for reproductions. He sensitized his own paper, because the paper at the time wasn't good enough. Then, of course, I wanted my own camera. And he

said, "Well, first you have to make a pinhole camera and then we'll buy you one." He helped me build a pinhole camera. Unfortunately, the prints I made are lost. I think they were the best photographs I have ever made. Then for my next birthday, I think, I got a camera. It was a 9-by-12-cm. Erneman.

My father, Sigismund Jacobi, taught me photography and he was a perfect craftsman. He was interested in chemistry and had studied it when he was young, so he knew all kinds of things that I didn't understand, but I was very much impressed. **W**hen I was six years old my father needed a partner for chess. People told him, "A six-year-old can't play chess," and he told me, "Don't listen to them; you can do anything you make up your mind that you can do." That was all I needed. When I was six months old my mother took on a young woman to help her because she had not been very well since my birth. When she came, I opened my arms to her and there was love at first sight. So I had two mothers!

I only photograph when I am provoked or if I have to earn a living. I always have to photograph something that interests me. My father was a portrait photographer but he was interested in all kinds of different things. In the studio he had a high wall, full of negatives, mostly glass ones. Unfortunately, most of his work and mine was lost in Berlin when we came to America in 1935.

In 1913 I decided to become an actress and my parents suggested that I study with a local actress. Each time I came home I spoke more like her until finally the whole family imitated me and that settled that. In my youth I also wanted to be a gardener and beekeeper, for, as children, we spent every summer on farms belonging to my mother's family. I thought it would be best to marry a farmer. Now finally I have a garden as well as beehives.

Before the First World War I was supposed to go to England to study photography. I had an aunt who was married to a photographer in London and my parents thought that I could learn English at the same

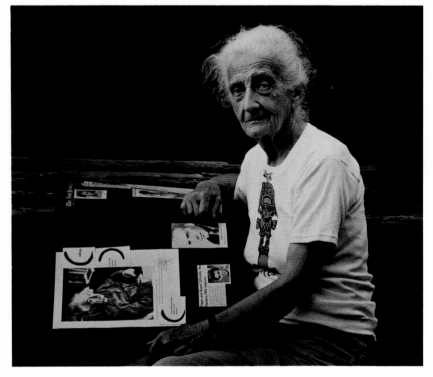

time. Because of the war, however, I stayed home. It was at that time that I got married and had a son. After some years of marriage, I got a divorce and went back to my parents and worked in the family studio. I went to Munich to study photography and art history in 1925. In my last year there I went to the film department, where I learned a lot about photography. I worked in my father's studio in Berlin until 1935. I was interested in taking photographs, not in business, which my mother handled very well. For a time my sister worked in our father's studio, but eventually she married and went out on her own. I was photographing all kinds of people and celebrities, some for the newspaper, some for magazines. I did a lot of theater photography, which I liked. I used an Ermanox camera and a tripod. The Ermanox had a very strong, large lens. I got it for the theater work but I tried it on everything. There were only nine of this type of camera made. For most of my portrait work, I used a large studio camera until 1932 when my mother gave it away while I was on a long trip to Russia. She bought a small Stegemann camera instead because it cost less money to use.

When I came over to this country in 1935, my sister and I opened a portrait studio in New York. I photographed Stieglitz at that time. His gallery on Madison Avenue was called "An American Place." I made an appointment, and when I put my camera up, he said, "Ahhhh . . . that's the same camera I photographed with for years. I can't remember the name." So I told him the name Stegemann and he was delighted. I even got a few smiling pictures of him. In the 1970s, in Rochester, the Eastman Museum had an exhibition of about forty photographs of Stieglitz and I noted that mine was the only smiling one. I liked Stieglitz very much. He broke the ground for photography as an art. There was no one like him. No one can ever approach what he did.

In New York I continued my photography. I was the first woman on the floor of the stock exchange during trading hours. I took pictures there. I did a lot of dance photography as well and I made lots of portraits. I'm one of the few people who photographed J. D. Salinger. As a photographer, I am interested in everybody. There have been only about two or three people I couldn't photograph because I didn't like them.

To make a good portrait you must get the people whom you are photographing to relax. They must forget that they are sitting there in front of the camera. Make them talk about something that you know they like. Sometimes you can use other people for them to talk to. When the subject is listening, then I photograph. When I photograph children I send the parents out. I always focus on the eyes of my subject. When people ask how I feel photographing so many famous people, I always remind them that we are all created equal. My photography hasn't changed. I always did, and still do, what I see as objectively as possible. Unlike many other photographers, I do not want to photograph myself when I make portraits of others.

The artist Leo Katz gave my second husband and me a course on how to make photograms. From this beginning my "photogenics" developed. That was around 1946, I think, because I had bought a lot of war surplus paper that wasn't really good enough for printing, so I didn't have to worry about wasting it. I also made some photomontages. To make my photomontage of the dancer, I cut out the dancer from one photograph and put it on a "photogenic" and then I photographed both to make a final negative.

I stayed in New York until 1955. My son and his wife had had a place in New Hampshire since 1948 and my husband and I spent summers with them. I moved up here in 1955 when I was almost sixty, and I stayed with my son and his wife. I thought I wouldn't sell pictures anymore because no one would come into the wilderness, but I did. First of all, many people when they heard that I had moved away from New York had me come to photograph them in New York. People came here from New York and elsewhere to be photographed; they thought that nobody else could photograph them.

At the age of sixty-four I learned to drive so that I could go to the University of New Hampshire to take some classes. I'm still driving and I'm eighty-three.

I forget that I am old unless people remind me. It's true that everything goes a little slower. It takes more time to do things. But otherwise I forget it. There are concessions one must make. I now use a lightweight Minox 35-mm. camera.

My life is too busy, much too busy. I don't have enough time. I do too many things. I have a grant from the National Endowment for the Arts, and I plan to photograph photographers.

I have become active in politics in New Hampshire. At the Democratic conventions I always speak up. Sometimes I win and sometimes I lose. I introduced art as one of the planks of the platform. I think they accepted it because they are afraid of a cranky old lady. The truth is I am a rebel at heart. You have to be that way today or otherwise you are a loser. If I am tough, it is because I have to watch out. I see too many people who are sleeping and not watching. You can't trust many people anymore, especially in the gallery world.

I have had someone to help me make prints because I stopped working in the darkroom when I was very sick in 1969–70. I had to make that decision about the darkroom. I asked myself, "Is it more important that I do my prints or that I take time to live?" I have to spend more time cooking the right things for myself now.

I want to live, I don't want only to work. I get involved in whatever I do, not thinking of what comes out of it. I enjoy it. All of me is in it. In photography I forget about technique. I just do it intuitively.

Once I was asked to give a lecture at the Photo League of New York City. I told them I couldn't lecture but they could ask me something. They said, "We only want to see how you make your pictures." I showed them, and it was so simple I think they didn't see anything. I don't think I impressed them very much. You can't see what I do. I don't need any background or anything special. I make it simple and try never to complicate things.

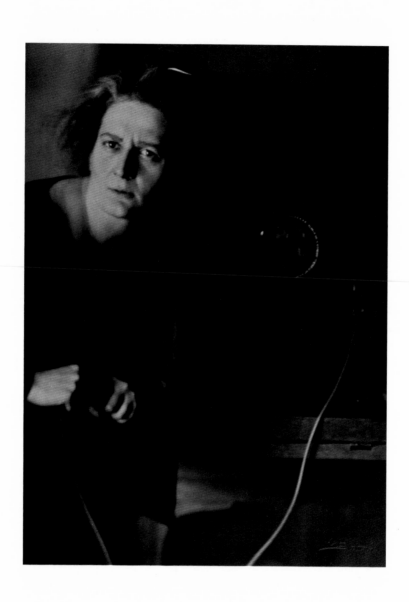

Self-portrait, Berlin, Germany, 1931

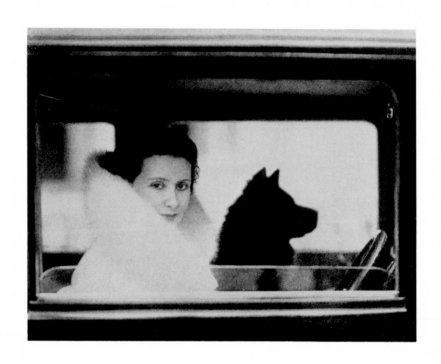

Lil Dagover, Berlin, 1930

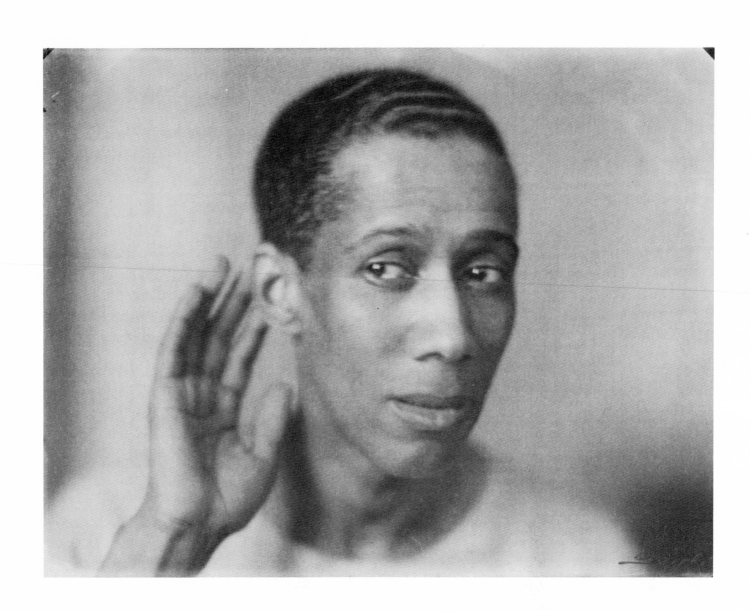

Louis Douglas, American Dancer, Berlin,
(palladium print) 1932

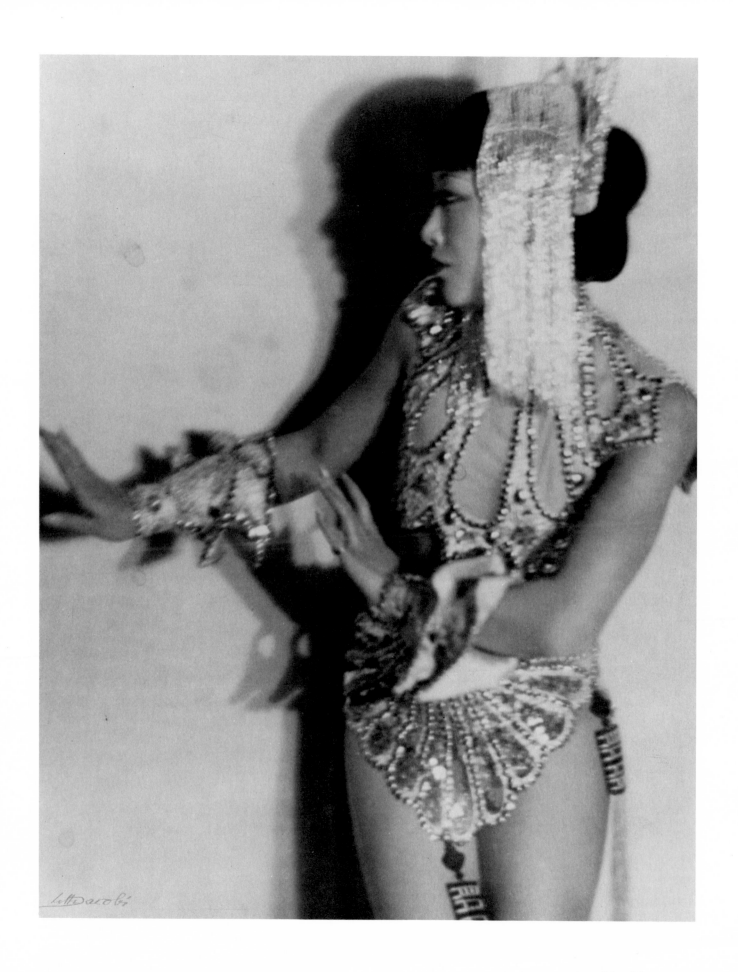

Anna May Wong, Actress, Berlin, 1931

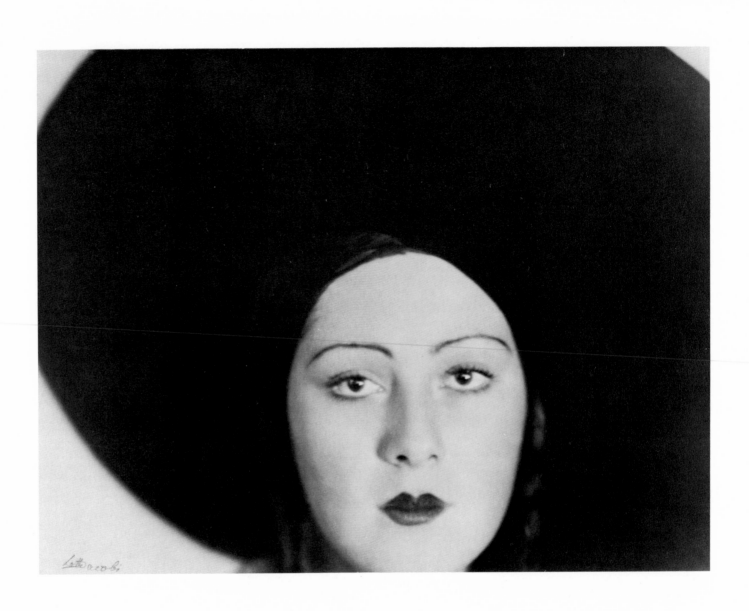

Head of a Dancer, Berlin, c. 1929

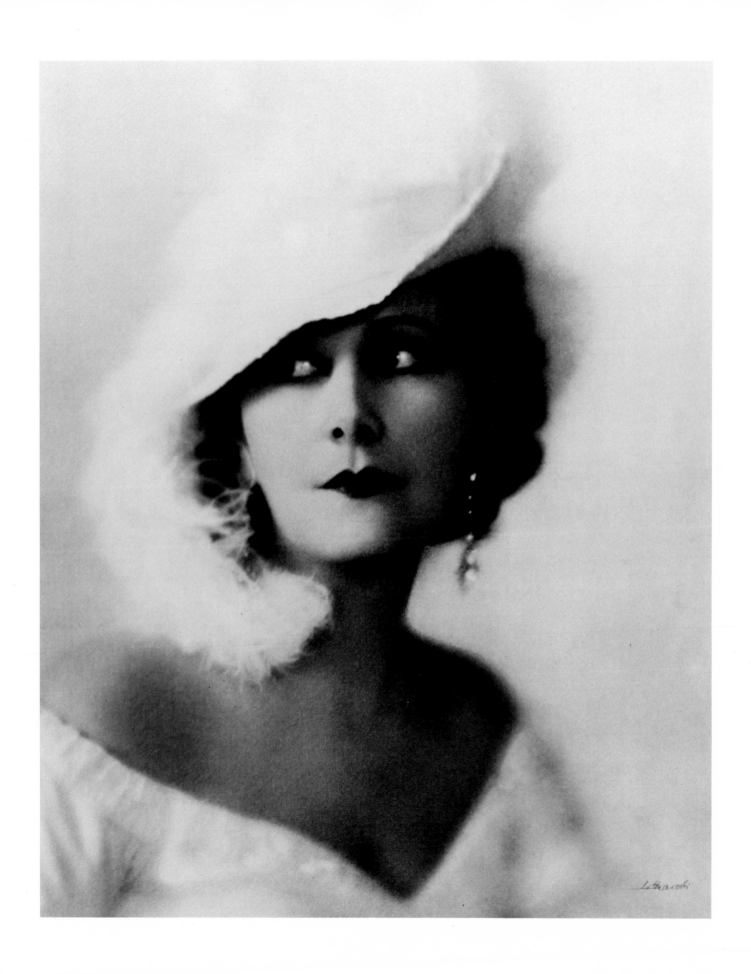

Lil Dagover, Actress, Berlin, c. 1930

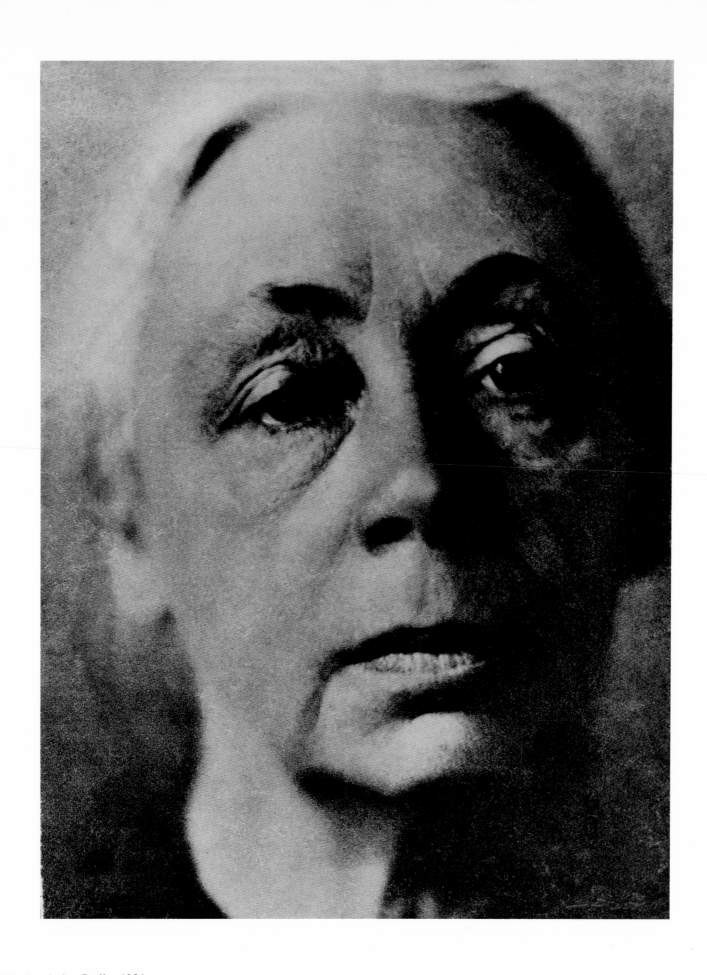

Käthe Kollwitz, Artist, Berlin, 1931

148

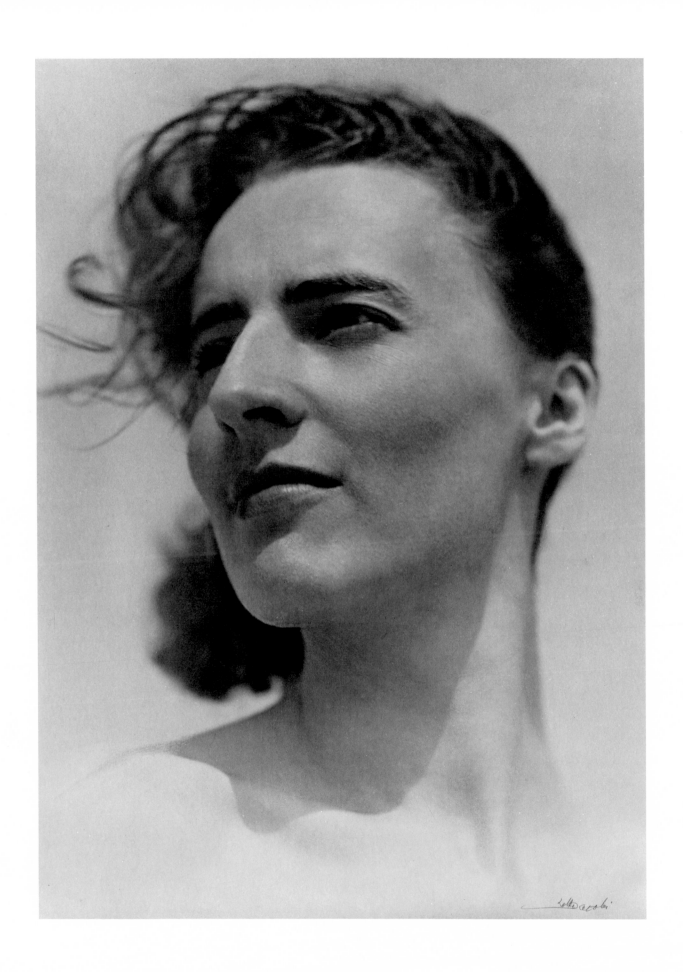

Beate Sauerlander, Amityville, Long Island, 1940

Mrs. Limbosch, Brussels, 1963

150

Albert Einstein, Physicist, Nobel Prize Winner,
Princeton, New Jersey, 1938

151

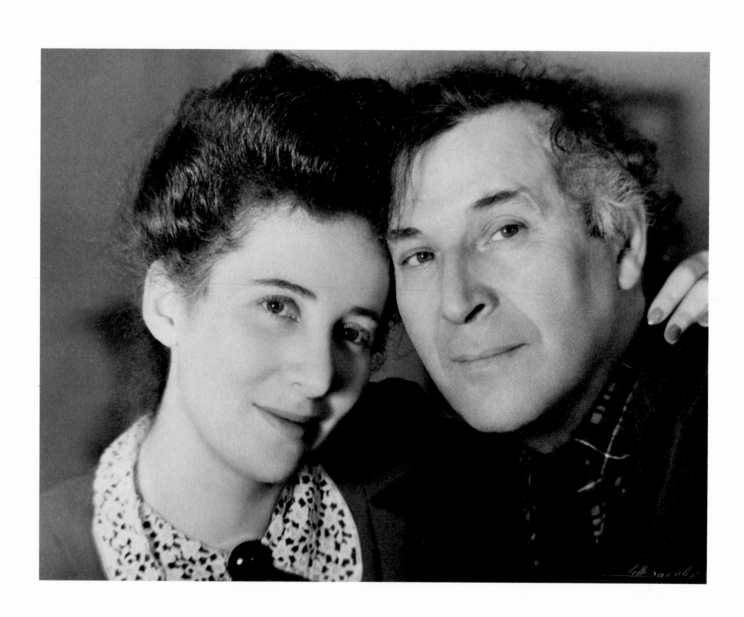

Chagall and Daughter Ida, New York, 1945

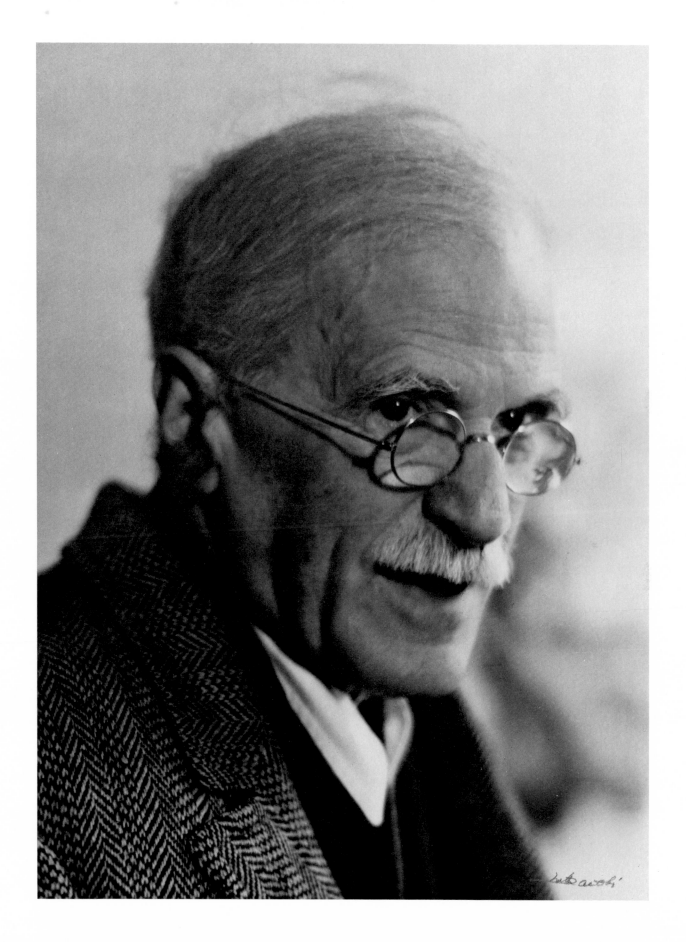

Alfred Stieglitz, Photographer,
at An American Place, New York, 1938

153

Anton Walbrook, Actor, Berlin, 1933

154

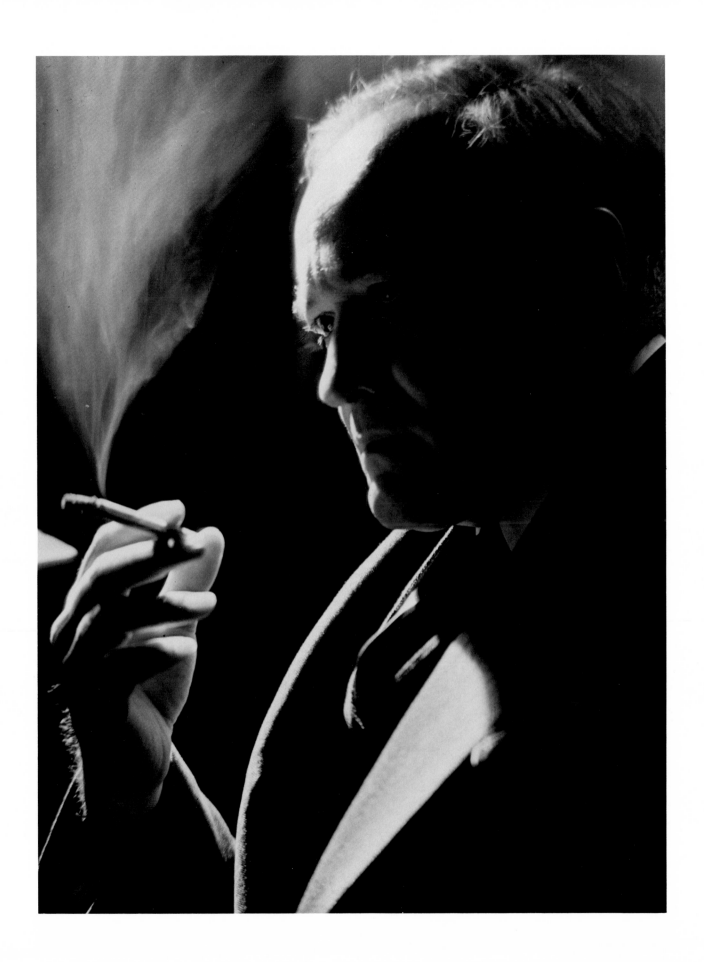

Leo Katz, Artist, New York, 1938

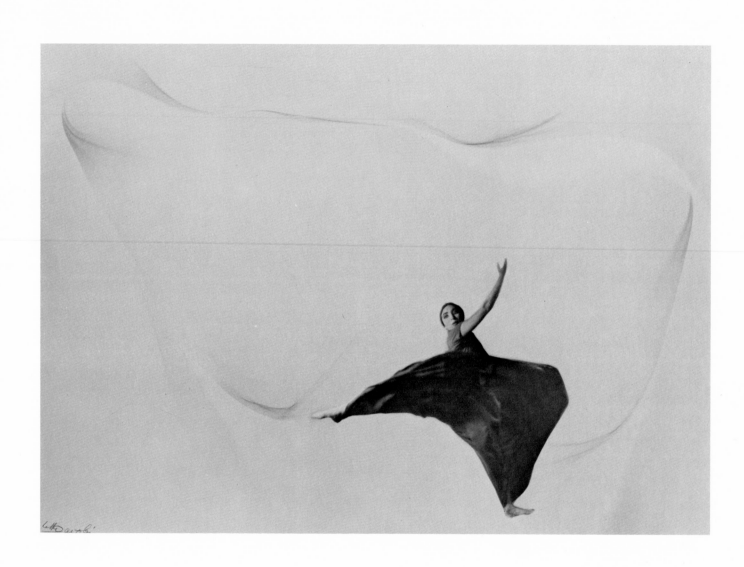

Pauline Koner, Dancer, New York, c. 1937

Photogenic "Silverlining," c. 1950

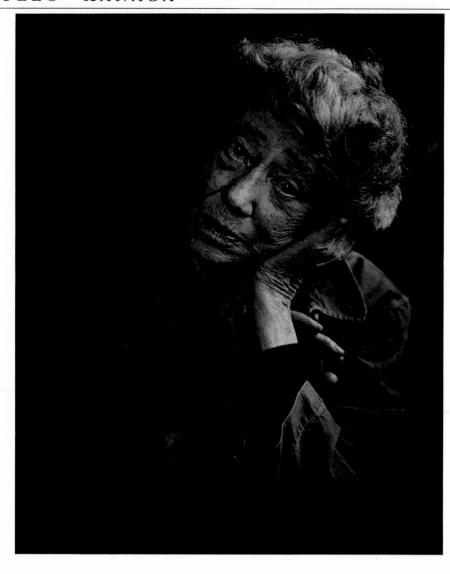

The light flickers winter-pale against the bare trees of a densely wooded ravine near the Hudson River in southern New York State. Tucked beneath the trees, there is an unusual converted ice house where Consuelo Kanaga lived with her husband, Wallace Putnam, an artist. This was their home and studio for many years and Consuelo Kanaga lived out the last years of her life here, during a long and painful illness. She died just two months after my visit. There was just enough light during our visit to catch the lines on her face before evening plunged the room into darkness. Moments of silence and discomfort expanded the intensity of the long afternoon, but she considered each question carefully and answered it fully. Her voice became animated, charged with finality and clarity, her words exact. She spoke her mind firmly, giving much thought to her way of working, of living, without flourish, with no regrets. Very little of her conversation was edited. It stands, as does my portrait of her, taken the same afternoon as special testimony to her courage.

I was born in 1894 in Astoria, Oregon, but I grew up in small California country towns like Salinas. My father had a passion for farming and ran a little magazine called *Farm and Irrigation Age.* He was a lawyer, but he was only interested in irrigation. Those were the early days of irrigation and he was a pioneer, taking trips all over the place to give advice and talk. Sometimes he would take my sister, Neva, and me with him.

My first job was as writer/reporter in San Francisco for the *Chronicle.* When I went out on assignments, I would do an article and they would send a photographer to take pictures for it. I would sort of arrange the pictures a little. The editor loved what happened, and he urged me to go into the darkroom at the office to learn the business from A to Z. Then when I could carry a camera and go out on a job, he promised me a big raise and made it sound good, but I was interested anyway. My father was outraged at my being anything as low as a photographer; but I liked it, so I did it. There I was—filing glass negatives and mixing chemicals in a big way, gallons at a time, for a big newspaper, making copies. I learned all the basics very well, printing, enlarging, and developing, and eventually I was a newspaper photographer.

I didn't work as a newspaper photographer for very long because I began to get interested in the other aspects of photography. I belonged to a camera club that had a darkroom I could use, and some of the people did pictorial photography. It was a small club. Dorothea Lange was a member. By accident, I ran across Stieglitz's *Camera Work,* and it changed my life. The cuts were so beautiful and different from anything that I had seen, and I just thought that was *it.* The prints were the most beautiful things that had ever been done in photography, and I wanted to start from there.

I began to quit the paper. I would work one day a week instead of five, and I made a very small living. I never made a big living, only a small living and lots of joy. A great deal of caring and feeling went into the making of my pictures. At that time I was doing mainly portraits. I had to learn to do something so that I could at least make a living. My family wasn't poor, but they could not keep me in the photographic state of bliss I wanted. I wouldn't even have taken the money if they had had it; I was very independent.

I found that portraits could really stand on their own because I put a lot into them and wanted them to be beautiful. I had to make fifty prints to get one that I liked, so that's why I never did get rich. At the same time I had to have creative expression, and out of every week I saved about two days for more creative work. I would use the two days looking for something beautiful. I would work in the direction of making a photograph that I could love, and then I would do the developing and the printing. I was in my late thirties and early forties then. Most of my early work has been lost or spoiled or disregarded because I've traveled around so often. Life has been one perpetual move.

I wasn't much of a household manager. I usually ate out or had a little something to eat in the darkroom or in the studio. But I would forget about eating for days. I was very fond of having a clean, shiny, waxed, and beautiful studio, but aside from that I'm no housekeeper.

I wasn't like Edward Weston. His whole life was built around his work, though he managed to provide for his children when they came. Edward was so pure; he was a true artist. I was much more interested in living. I had friends and I visited and lived and walked in the hills and stayed all night on Mount Tamalpais and did things that appealed to me. Sometimes I photographed but really I have no regrets at all. I think I could have done a great deal more in photography had I been less fond of daylight and daybreaks. It wasn't that I was especially carefree, I just liked people.

I knew Imogen Cunningham well. Her husband taught etching at Mills College. I love this story because it's typical of her life. She had two twin red-headed little boys and another boy, all three of them dynamos. I went there one day for tea and couldn't breathe. The kids kept rolling around our feet and knocking tables and chairs over, wanting attention and being pests. Imogen said, "Connie, you wait, I've set their tea party in the back of the house, and when they go to have it, you and I can have ours and have a few minutes together." But before we could get one drop of tea in us, those kids had gulped all of theirs and come back to knock our tea over. They were just impossible, She had children, a husband, and a fairly large place to take care of . . . cooking, washing, ironing, shopping for clothes. At night, when her hellish big day was over, she'd go down in the laundry room where she had a little darkroom squeezed off in the corner and work at her photography. I've never known anyone with such will or such energy. I thought she was terrific, but I wouldn't have had that life. I couldn't have taken it, though I was inspired by the beautiful woman she was.

I'd like to live in an attic with a skylight; that would suit me. I loathe all conventional things. I never really lived in an attic with a skylight or starved, but I've never been rich nor have I wanted to be. I've always had enough, but very little.

I was in that f/64 show with Edward Weston, Imogen Cunningham, Willard Van Dyke, and Ansel Adams, but I wasn't in the group, nor did I belong to anything ever. I wasn't a belonger. Edward was one of the originators but I don't think he went along with it for long. It was a lovely friendly thing.

Louise Dahl-Wolfe and I were girlhood friends. She wasn't a photographer when I first met her. We traveled in Europe together and took lots of pictures on that trip, but nothing that counted much. She wasn't serious about photography yet; she had a little tiny camera, a little Graflex. She was very mechanical besides being artistic.

When I met Wally Putnam, I thought I was finished with domestic life but he's unusually nice. And he's interesting and creative. We didn't have a family, but I wish I had. I would like to have had a child.

All my life I have done portraits. When we first moved to New York, Wally worked nights for years, so we made a good living and didn't have to think of money. We were going to live in Harlem. I wanted to have a studio there and make a book about its people. Blacks are beautiful people, and I was particularly attracted to them. They're very photogenic. I made one photograph of a girl with her face in a flower. She was a lovely girl, so I found a flower and had her pose for me. That's the way I got pictures.

Steichen loved my work; he was the most encouraging friend I ever had. I met him one day at the Modern Museum. I was going to take an elevator and he stepped out and just threw his arms around me and said, "Why, Consuelo Kanaga!" He knew me and apparently he had seen some of my work in magazines and felt a kinship. He included me in some very fine shows, including "The Family of Man." He especially liked my "She is a tree of life to them" photograph and gave it a great deal of attention. When I met Steichen, I was showing a little, entering pictures in some of the camera magazines. Sometimes when he was writing about his show, he would speak of me; he was always pushing me forward.

I met Stieglitz when I first came to New York. A friend took me to call on him and then I saw him from time to time in his gallery. I didn't have a portfolio in those

days, so I took one or two prints in to show him. I never had enough to show, I was so busy trying to make a few good photographs that I could look at. I was not able to look at them half the time. I'm very critical of my own work.

When I wanted to photograph, I would go out and try to *see* something. I'm moved by everything. When I was working for the *New York American* the paper fed a hundred of the poorest people in New York at Christmas with one hundred baskets of food. I did three or four photographs of them and it took me a long time. I looked around for the people I wanted to photograph. I found an old woman and her son

Consuelo Kanaga and Wallace Putnam on their honeymoon, 1936. Photograph by Ralph McClellan.

and I thought she was marvelous looking. I asked her if I might photograph her, and she said, "Photograph a bony old woman like me?" I said, "Yes, I like bones." She was literally starving. Her little boy had gone to stores and gotten bits of wood to use as fuel; he stacked them neatly to the ceiling. They used an old broken-down coal stove in the basement where they lived; the floor was damp. But all around the mantle were reproductions of the most beautiful works of art that this child had fancied and cut out and carefully pasted up. He was an extraordinary little boy. I did those photographs to help get funds to feed them.

My photograph of the camellia has a sort of story; everything seems to have a story. Somebody came into my studio one day all dressed up and took her fur coat off. A camellia was pinned on her lapel and its leaves had begun to wilt so she tossed it on the table. As soon as she left, I put it in the water and photographed it. It seemed too beautiful to be allowed to die without consideration.

When I was a newspaper photographer, it was quite an unusual profession for a woman, since most photographers were men. They were wonderful to me; I never had any feeling that men made it difficult for women. Nobody made it difficult for me. Working on a newspaper is different from what Imogen or Louise did. For instance, when I worked on the *American,*

they gave me bonuses if I got a difficult picture. They would give me twenty-five dollars or fifty dollars if I got something that was hard to get. Often the editors were critical of the men because they hadn't done something, while praising the girls and saying things that would antagonize the men. Then the editors would laugh; they knew exactly what they were doing. They were trying to stir the men up, using me as a stick. I knew it, and I always offered to share any bonus I got.

I could have done lots more, put in much more work and developed more pictures, but I had also a desire to say what I felt about life. Simple things like a little picture in the window or the corner of the studio or an old stove in the kitchen have always been fascinating to me. They are very much alive, these flowers and grasses with dew on them. Stieglitz always said, "What have you got to say?" I think in a few small cases I've said a few little things, expressed how I felt, trying to show the horror of poverty and the beauty of black people. I think that in photography what you've done is what you've had to say. In everything this has been the message of my life. A simple supper, being with someone you love, seeing a deer come around to eat or drink at the barn—I like things like that. If I could make one true, quiet photograph, I would much prefer it to having a lot of answers.

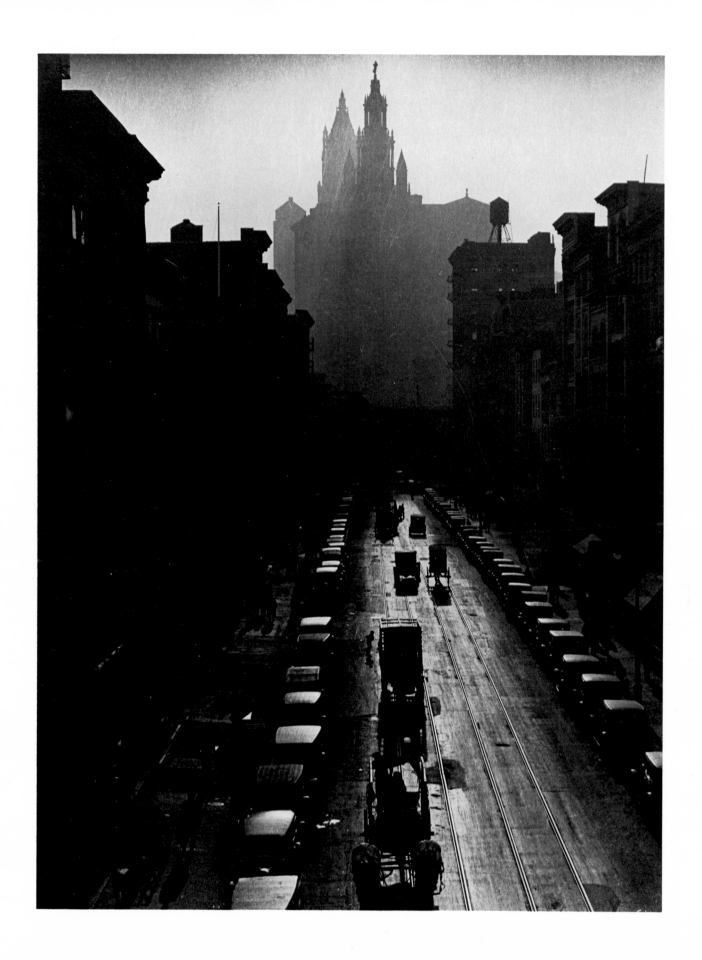

Downtown New York, 1924

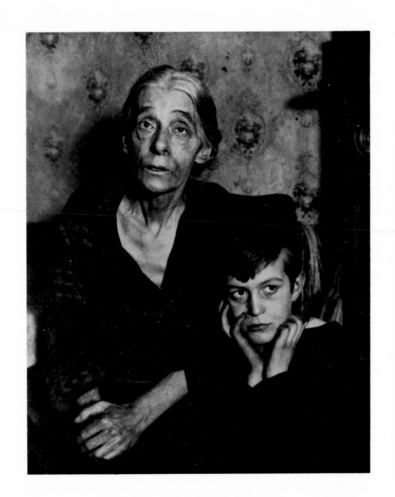 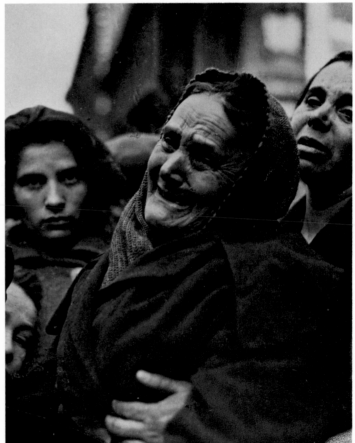

Widow Watson, 1925

Fire, 1925

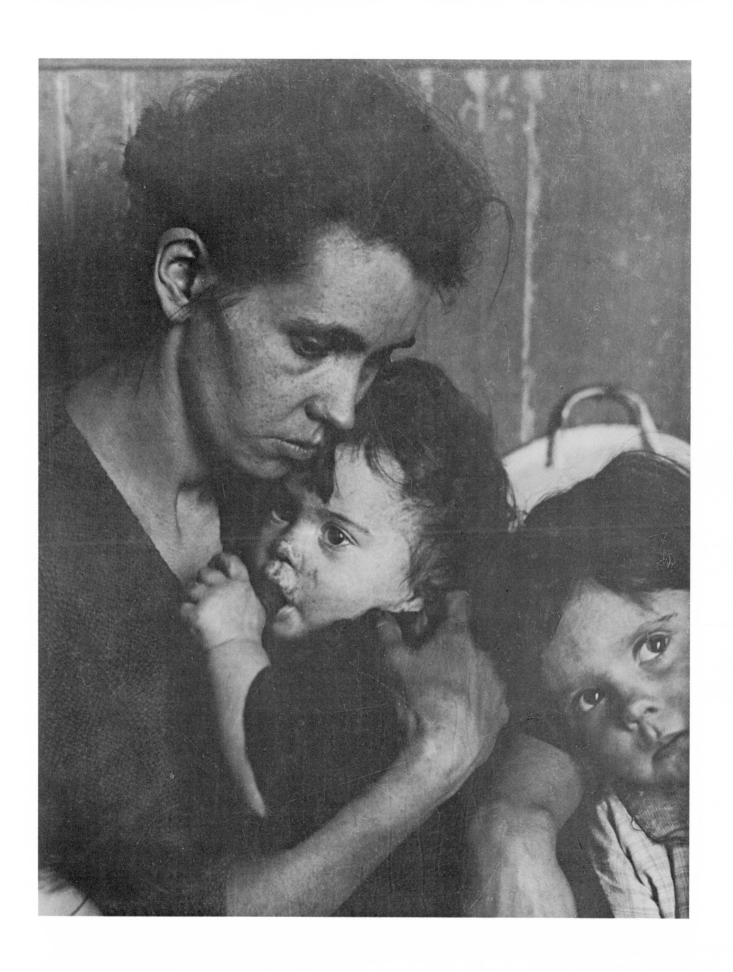

One of the Hundred Neediest, 1928

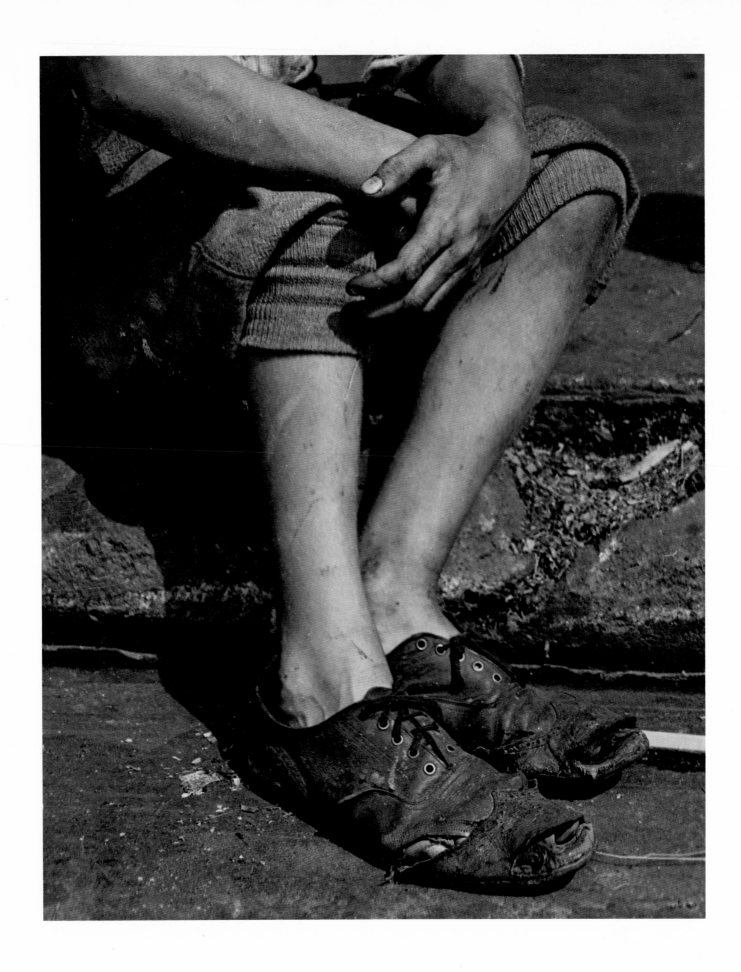

Poor Boy II, 1928

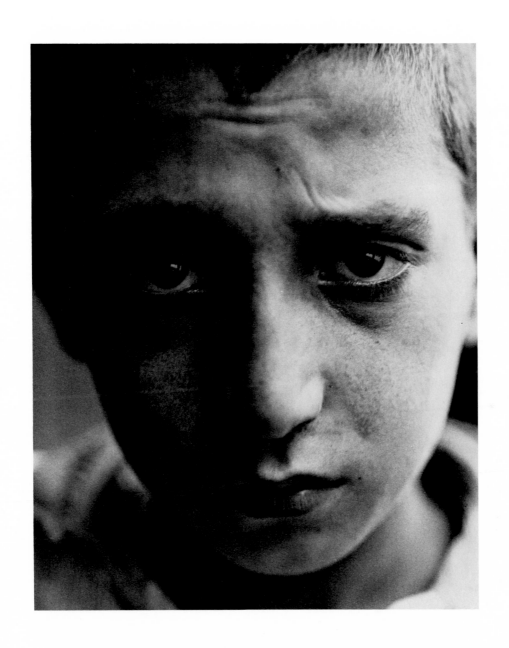

Poor Boy, 1928

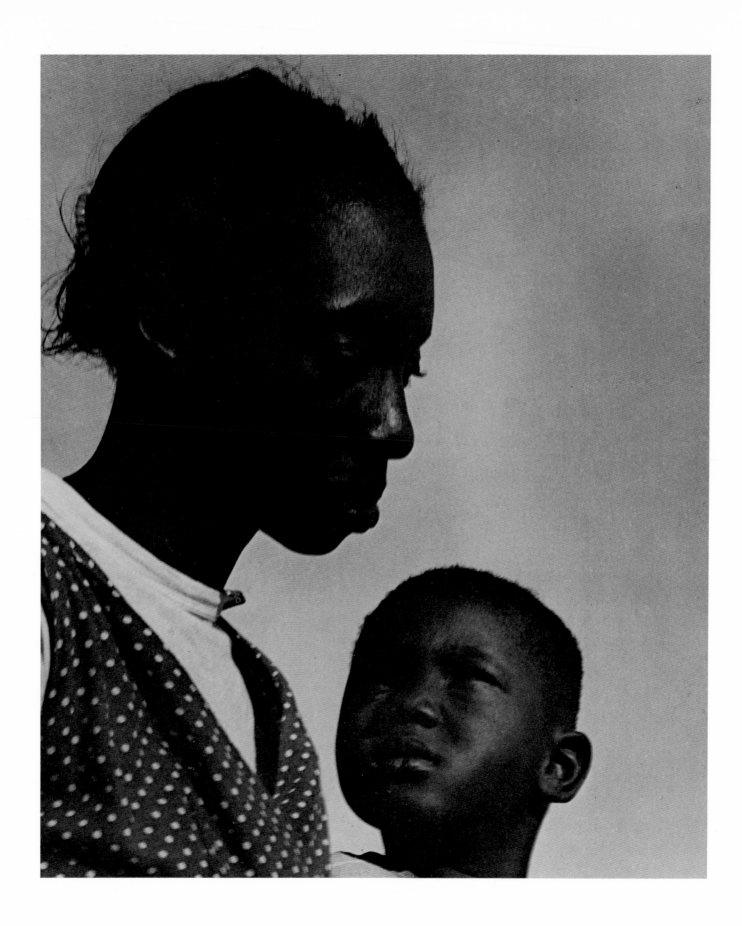

The Question, 1950

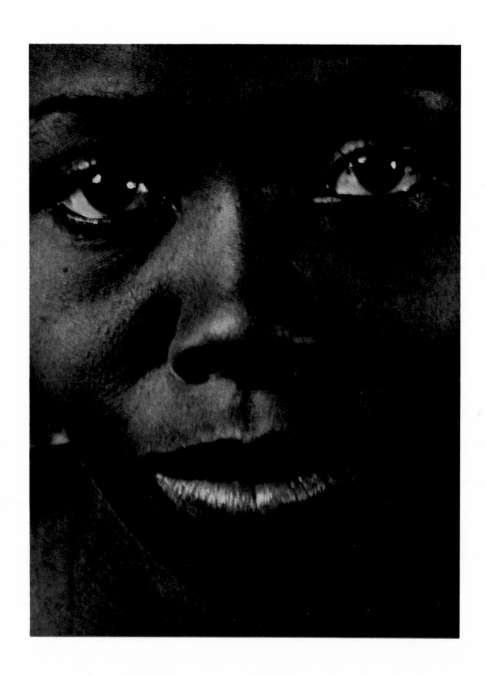

Annie Mae Meriweather II, 1936

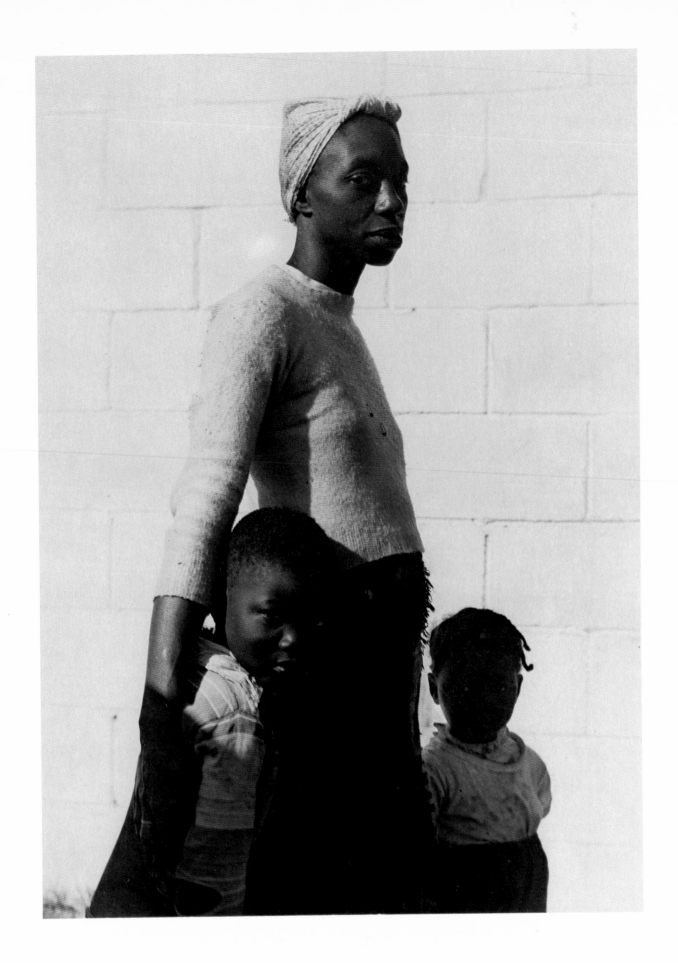

"She Is a Tree of Life to Them," 1950

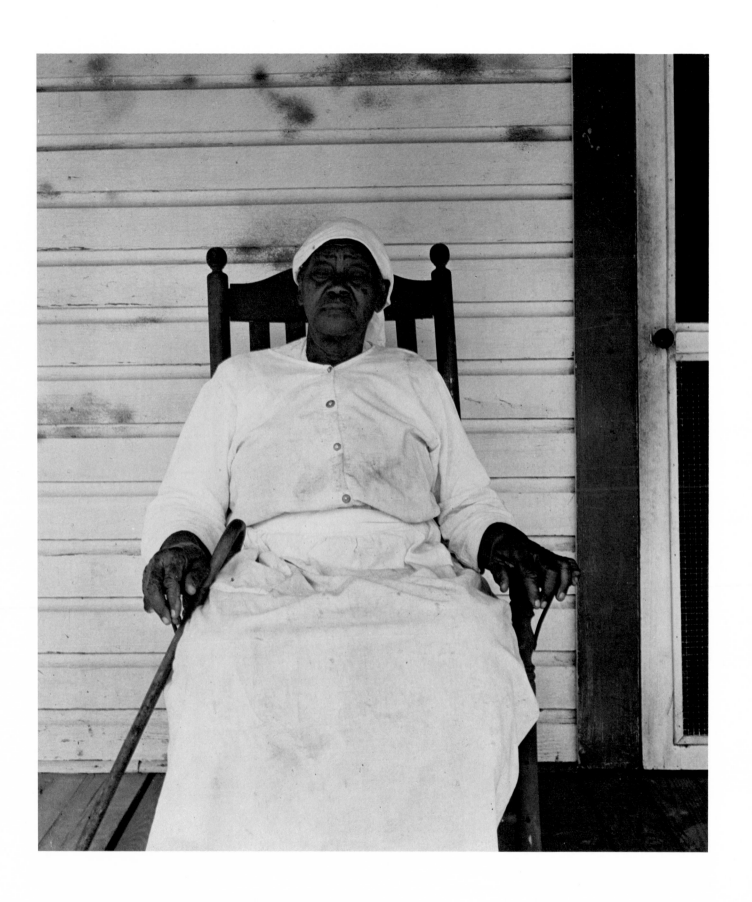

After Years of Hard Work, 1950

San Francisco Kitchen, 1930

The Camellia, 1927

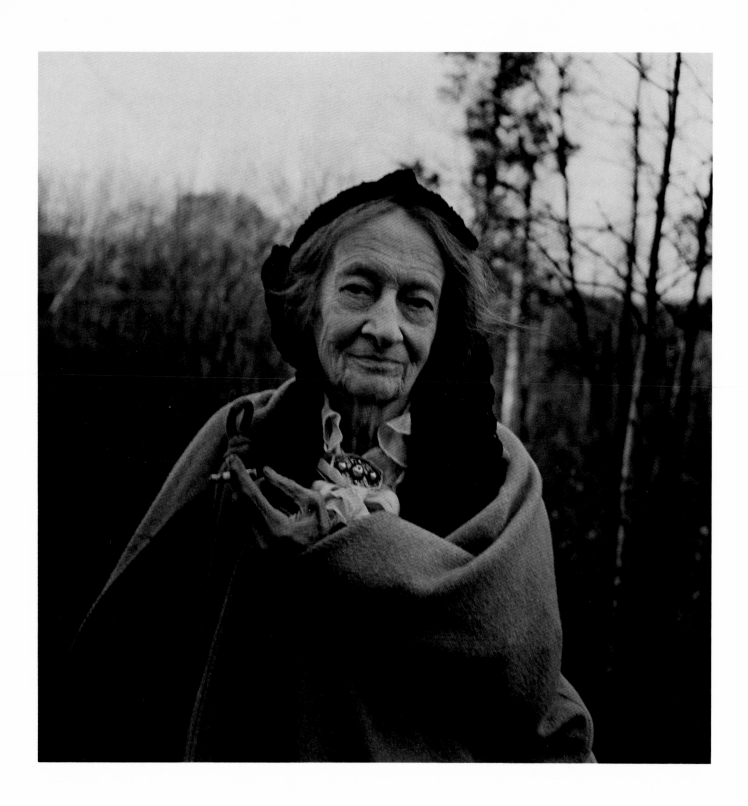

Amy Murray, 1936

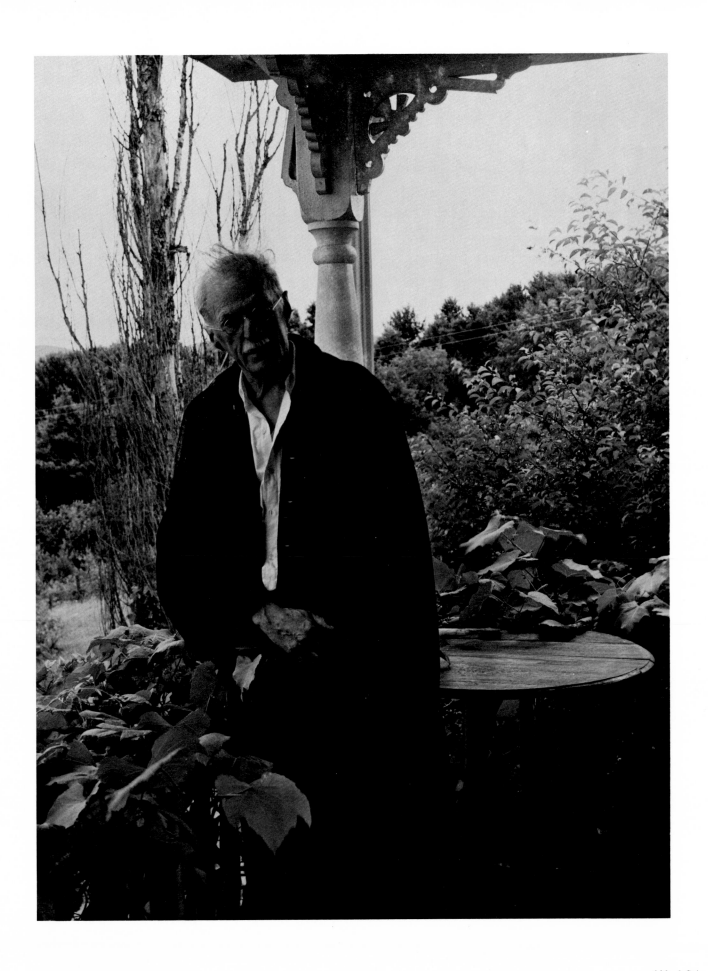

Alfred Stieglitz, 1936

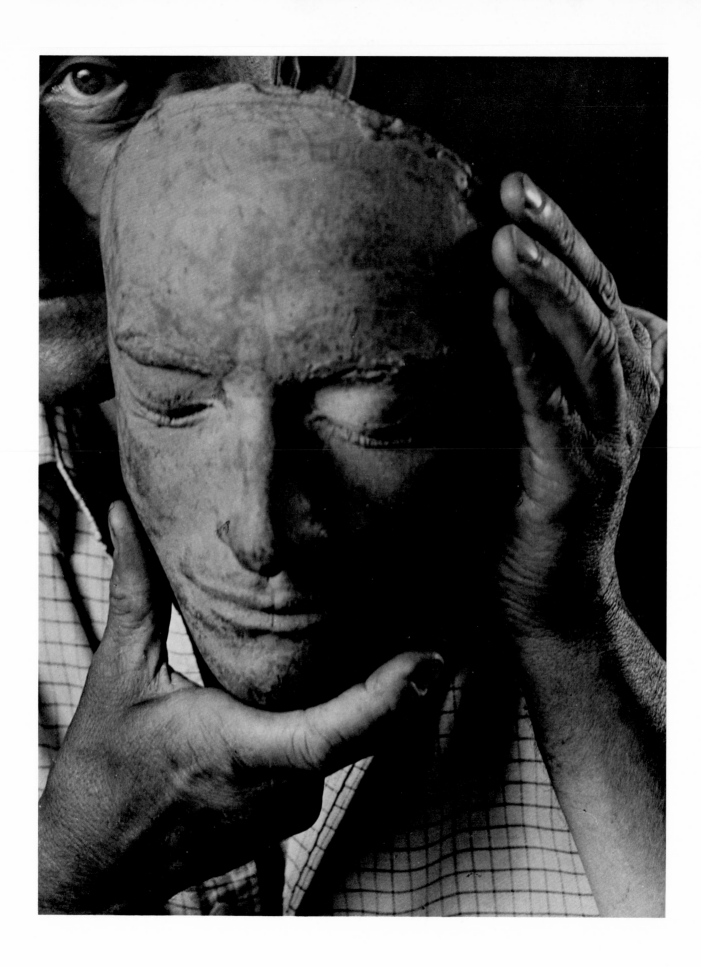

Wharton Esherick, 1940

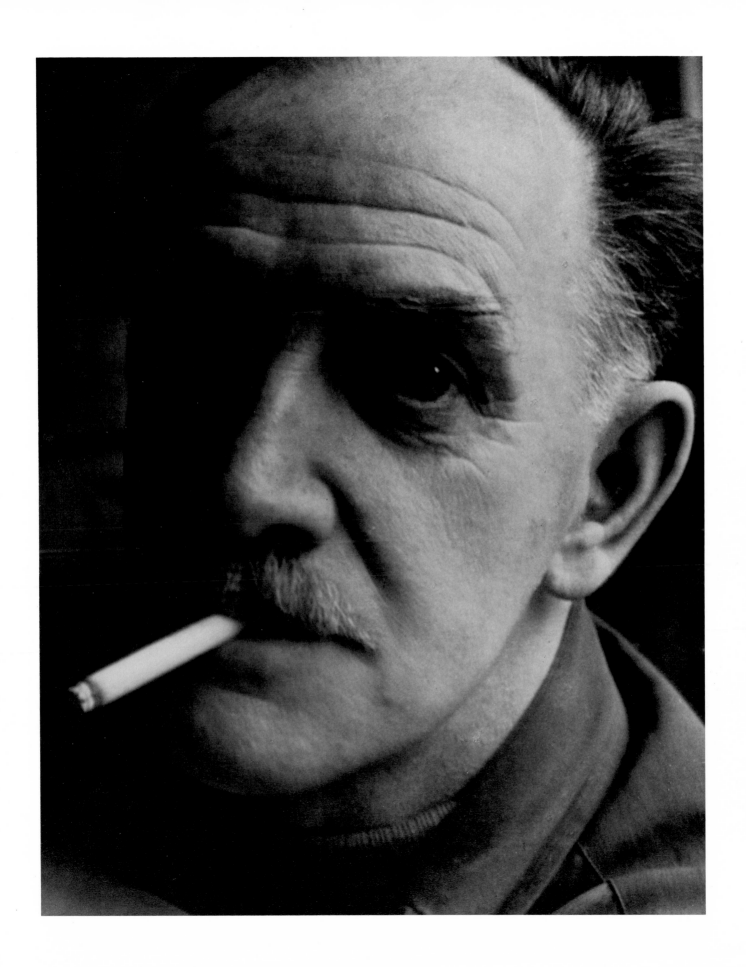

Milton Avery, 1950

BARBARA MORGAN

A stark 1940s house sits at the top of a slope of grass in Scarsdale, New York. It is early evening and the way to the front door is partially hidden behind a tangle of vines on the right, and large rocks and wood stumps piled on the left. At the doorway Barbara Morgan stands laughing, unconsciously striking a pose, her feet planted solidly in stout work boots, her caftan covered with birds-in-flight patterns of red, white, and blue. She and her late husband, Willard, designed this house and raised their family here. This is where she carries on today as an artist and grandmother. To be in her house is to be caught in the rhythm of her day—swept right along with the staff of helpers she has to keep up with the extraordinary demands for prints and exhibitions and lectures. Conversation takes place in movement, starting around a low table piled with books. Ideas come from everywhere: prehistory, Indian and Celtic lore, education, science, religion, children, marriage, her own life and work. It is hard to stay on the subject; she is more interested in ideas than in telling her story. Every table holds boxes and notes and books and plants. The walls and shelves are filled with paintings and books, prints and fossils, shells and grandchildren's handicrafts. In the studio where she once photographed dancers there is now a labyrinth of files for the accumulation of a photographer's lifetime. The stacks of freshly mounted prints for her large portfolio take over the work space and Barbara willingly takes over the conversation.

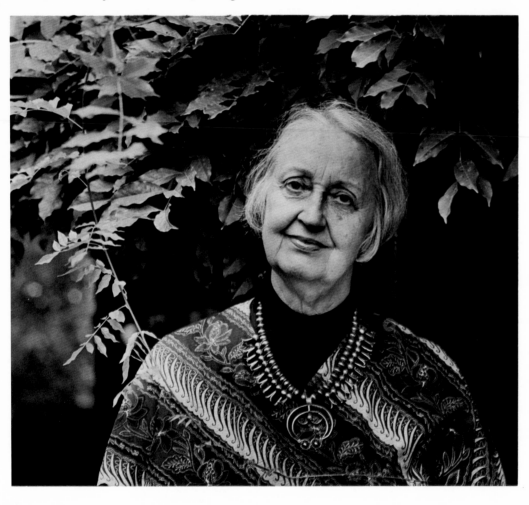

My father used to tell me, "Believe nothing: examine everything." He said, "Don't believe me, even if I love you and I'm your father," and he really meant it. I learned as much from him as I did from college. My father was the youngest member of his family, and when he was ready to go to college, his father was ill and didn't have the money, so my father decided, "Hell, I'll teach myself!"

My mother was a teacher and loved literature and poetry. Through my childhood, after dinner, with a big Webster's Dictionary on the table, my parents would read everything from Darwin and philosophy to English literature.

My inspiration to convey "rhythmic vitality," as in dance photography, and to make "visual metaphor," as in photomontage, came from my childhood in presmog California. These experiences literally shaped my creative life. Most important were two early discoveries. First, when I was about five, there was a small painting of a tree above my bed, which I had never been aware of. I awoke at dawn one morning when the sun was beaming on the painting. Excited and mystified, I thought, "How can a tree get into my bedroom?" Hopping out of bed, I ran to my parents' room saying, "There's a tree in my bedroom! How did it get there?"

My mother said, "It's not a real tree: it's a painting of a tree. Your great-uncle Benjamin Coe made it, and he was an artist." Then I said, "I'll be an artist."

My parents were delighted and gave me paints, paper, and brushes. I remember my father saying, "I will never give you an ordinary toy for your birthday or Christmas, but I will give you whatever you need to create things."

When I was about six, sitting outdoors with my whimsical but philosophical father, he picked up a pebble and said, "Doesn't this look as if it were not moving? But millions of atoms are dancing in it!" Then he took me into the house to see illustrations of atoms in *Scientific American* magazine and said, "Atoms are whirling inside us right now—and in everything. So the whole world is dancing—even when the outside looks still."

When I started as an art major at the university of California at Los Angeles in 1919, I expected to be a painter. But as a kid, I had always written poems. How could I give that up? A group in my basic literature class formed a Manuscript Club, where we shared our verse. It was then that I realized my written poetry was a backflash from the "visual metaphor," that I was seeing in my mind's eye when writing a poem. So when I started photography it was natural for me to begin with photomontage, which is image-as-metaphor.

Another link to my dance photography came from studying figure drawing. In this course the model would sit on a stool totally static, and I became bored. My interest was in movement. When I asked the professor if it would be possible for the model to move, the indignant reply was, "You are learning anatomy!"

I heard that the dance department on campus was inviting an experimental dancer to teach a new style she had studied with Isadora Duncan. With a few painter friends I went to see the dance teacher, Bertha Wardell. We told her that although we would never be dancers, we would appreciate learning about movement. For a year or more we went to her once a week for an hour and a half, each of us taking turns being the "musician" and using her various percussion instruments. We would try to feel the beat while seeing the gestures. This made us highly sensitive to surprise rhythms. What I found especially interesting was that Isadora's "life spirit" went along with my father's philosophy that "without movement, life can't exist."

A Japanese student in our art classes helped me to understand Esoragoto, the meditative method painters in Japan use to *become* the tiger—or whatever the subject is—before painting it. This empathy of the painter with the subject is similar to the empathy of the photographer with the mood and gesture of the subject.

In 1925 I joined the UCLA art faculty, teaching basic design, beginning landscape painting, and woodcut print-making; and I married Willard Morgan, a young writer who was illustrating his free-lance articles with his photography. Since we had little money, he set up his darkroom in our bathroom. Surrounded by drying negatives dangling over trays for washing prints, I was introduced to photography. Willard was excited about photography and determined to convert me, saying that "Photography will be the twentieth-century art. Why don't you become a photographer—not just a painter?"

Shocked, I thought he was crazy, but he was convinced that photography would become the international language, "because gesture can communicate universally, more than words can." As of 1979, this has become an obvious fact. Willard had another basic intuition, that photography could serve mankind as art—not for art's sake, but for life's sake—by integrating meaningful subject matter (such as sociology, science, or philosophy) with finely composed art.

Since I was the youngest member of the art faculty, it was my job to hang exhibits. In 1926 the director of the art department told me that although the university trustees would object to photography being exhibited as art, she was going to take the risk, because she felt deeply that the photographs of Edward Weston (just returning from Mexico) were truly creative art—although he was then almost unknown. I had not heard of Weston, but the next day when we hung his show together, I was instantly inspired. We became lifelong friends. Nevertheless, although I was convinced of the importance of photography, I had no impulse to photograph. But Willard was determined. He said, "If you teach me composition, I'll teach you the technique of photography."

But my real introduction to photography came during the summer vacation months when I wasn't teaching. Willard and I would go to the magical Southwest, where I painted for my coming exhibits and Willard found subjects for his future magazine articles: the Grand Canyon, Mono Lake, cliff dwellings, Santa Fe, Taos and the Penitente country, Canyon de Chelly, and Rainbow Bridge. Most important were the Indians and their dance rituals. Although I would be painting hour after hour, Willard got me to wear a Leica camera so that I could shoot the unexpected while he was

off photographing and experimenting. The Indian dances were the most inspiring experiences for me. A friend, who was a descendant of a Conquistador family—and felt some guilt for her ancestors' domination of the Indians—had done an anthropological study of the Southwest Indians, whom she venerated. She helped us to understand and she taught us how to behave so as not to hurt their feelings.

At that time the Indians considered the camera the "evil eye," so we couldn't photograph the rituals as we wished—although we did shoot a few with the small Leica. The Sun Dance, Rain Dance, Snake Dance, Corn Dance, and many other rituals were day-long ceremonials keyed to the rising and setting of the sun. These were truly cosmic experiences—the sharing of the total life with Father Sun and Mother Earth. Always studying rhythm, I would take my pulse in the morning and evening to discover how it built up during the day from the emotions I shared with all the people absorbed in the day-long rhythmic chants and dances. By sunset my pulse was several beats faster—not frantic, but ecstatic! While observing the dance movement under the sky, I sensed the growing harmony among the people absorbing the dance. This is the great blessing that dance can give.

By 1930 Willard had so many published articles illustrated by the Leica photographs taken in the Southwest that the E. Leitz Company asked him to come to New York to help promote the Leica camera, then hardly known in the United States.

Our first child, Douglas, was born in 1932, and I was still able to paint, but the turning point came in 1935 following the birth of our second son, Lloyd. I was reading Isadora Duncan's book, *My Life,* and I came to the section in which her children drowned. I was shocked because I realized that when I painted, I lost track of everything else. Something could happen to our children if I were totally involved with my painting. I knew that I must be a mother first, and therefore I wouldn't have time to paint. This thought went through me like wildfire!

I told Willard the story. He said, "Look, Barbara, you are a photographer. You have been unwilling to realize that, but you are! You can create through photography. I can be with the children at night while you work in the darkroom. Most photography is done in the darkroom, anyhow, so you can be a mother and a photographer—both!" Within the next few days he found a studio near our apartment, set it up, had a darkroom sink made, and that's how I got started.

When I became a photographer emotionally and practically, the only way I could feel honest about photographing seriously was to photograph with imagination, rather than recording, for if I merely echoed the obvious, I would lose my creative integrity. Therefore, I began with photomontage, knowing that it could only come from creative imagination.

In 1935, after I had accepted my validity as a photographer via photomontage, I still had the urge to be a good mother, for we adored our children and they came first. How could I coordinate all these complexities? I finally developed a three-channel system so I could have multiple concepts in mind simultaneously (like a three-way montage). Channel one was my family—getting meals and taking care of the boys; channel two was my creative work; and channel three was community responsibility.

Later in 1935 I attended a performance of Martha Graham's company, which was then scarcely known. The dances moved me deeply, for I felt intuitively that there was some connection between her choreography and Indian dance rituals. Later, a friend introduced me to Martha, and I suddenly imagined that I could express her movements and meaning in photographs. It hit me just like that. I said to her, "I have seen Indian dances in the Southwest and felt the wonderful spirit. When I saw your dance, I had a strange feeling that there might be a connection."

Martha agreed. "Absolutely. When Louis Horst and I were in the Southwest, Indian dance inspired me and has been one of the greatest inspirations of my life."

I said, "I would like to do a book on your work."

And Martha said, "I will work with you." Just like that.

We worked together on and off for five years, and in 1941 my book, *Martha Graham: Sixteen Dances in Photographs,* was published. Another reason I photographed Martha's work during the Depression was that her dances with American themes were a needed spiritual lift. She would explain her inspiration and the philosophy of each dance to me—and I would study the performances to search out the essential gestures. I never photographed a theater performance, but only in my own studio or on a noncommercial stage, where I did my interpretive lighting. This led me to photograph other gifted modern dancers: Doris Humphrey, Charles Weidman, José Limón, Valerie Bettis, Erick Hawkins, Merce Cunningham, Pearl Primus, Hanya Holm, Jane Dudley, Asadata Dafora, Anna Sokolow, and others. These photographs were not done for any commercial purpose.

Barbara Morgan in her studio, 1942. Photograph by Willard Morgan.

In 1941, after the publication of the Martha Graham book, we moved from New York to the suburbs to give our sons some experience with nature and the pleasure and responsibility of caring for animals.

I continued to photograph dancers in my new Scarsdale studio where I was also creating photomontage, photographing nature and people, including children at the summer camp Treetops at Lake Placid. This experience became my 1951 book, *Summer's Children: A Photographic Cycle of Life at Camp.* I showed children doing organic gardening, caring for animals, learning about nature, enjoying pottery-making and other crafts, mountain climbing, and swimming—all in a cooperative, creative spirit.

My next book, in 1972, was a cross section of my work: dance, photomontage, people, children, nature, and junk, and now I am trying to complete a teaching book, *Dynamics of Composition,* inspired by questions that students ask.

With photography aiding today's astronomers to record the faint light from distant galaxies, we, Earth's people, on the third planet from the Sun, are beginning to realize that we are only tiny specks in the cosmos, and that in coexistence, rather than competition, lies the hope for the future of our children. Willard's 1925 prediction, "Photography will be the twentieth-century art—and the international language," is in 1979 on its way to being realized.

I don't think too much about old age. I get a kick out of the fact that I was born in 1900, because I feel the cycle of the centuries, but I don't take age too seriously. Because of my father's philosophy of everything being in transition via metabolism, getting old doesn't scare me. In fact, I see death as simply part of the continuity of total cosmic life, and I don't want to inhibit other lives. That's why I want to work as long as I can. My hope is that photography will contribute to global harmony.

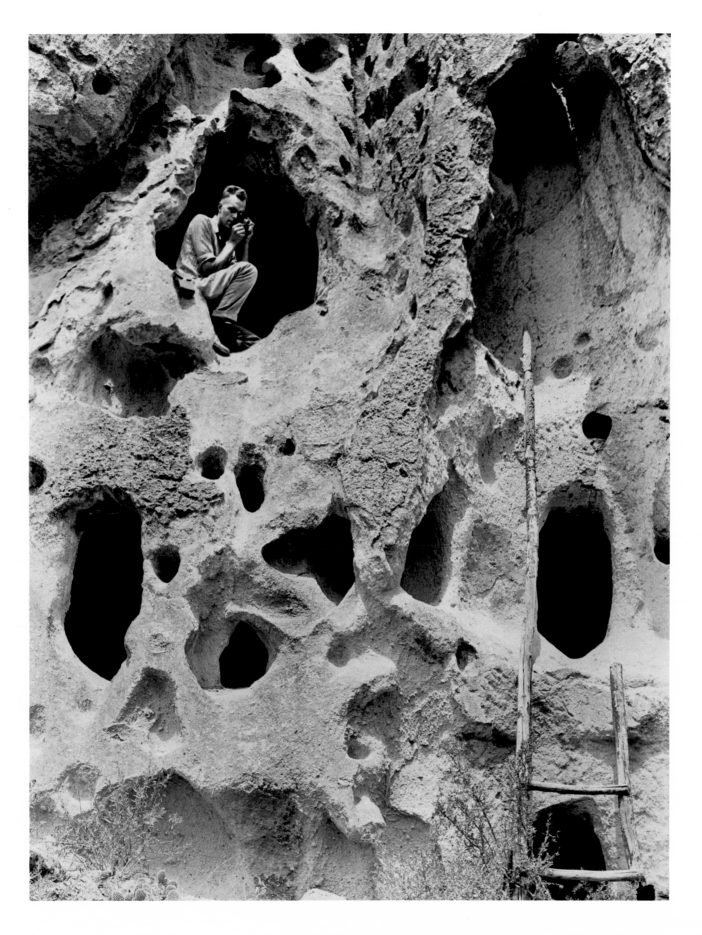

Willard Morgan with Model A Leica
in Bandelier National Monument, 1928

Tossed Cats, 1942

Children Dancing by Lake, 1940

Pregnant, 1940

Samadhi, 1940 (light drawing)

Funkia Leaf, 1950 (*solarized*)

186

Lloyd's Head, 1944

Corn Leaf Rhythm, 1945 (macro)

Martha Graham—"Ekstasis," 1935

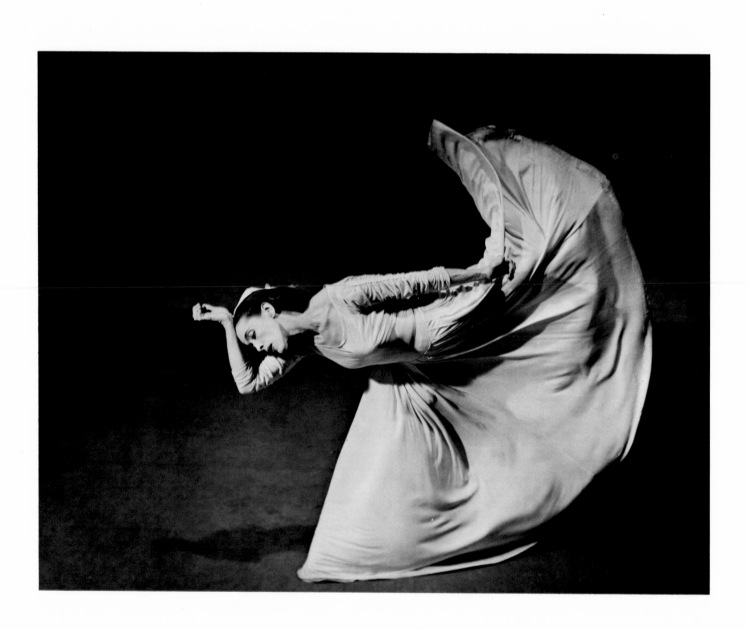

Martha Graham—"Letter to the World," 1940 (kick)

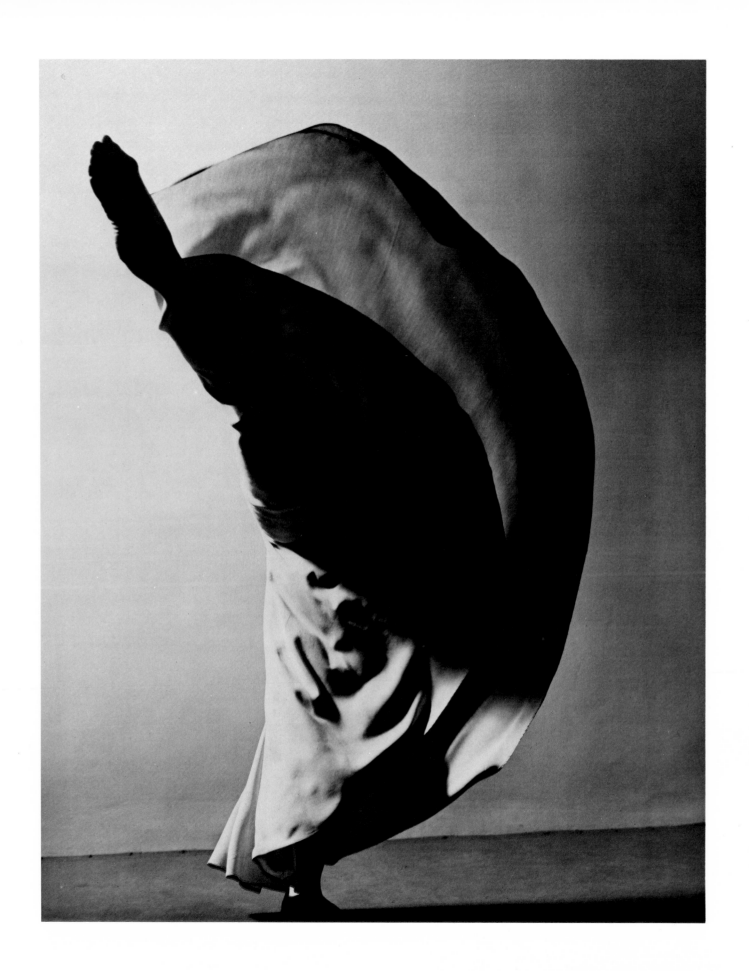

Valerie Bettis—"Desperate Heart," 1944

191

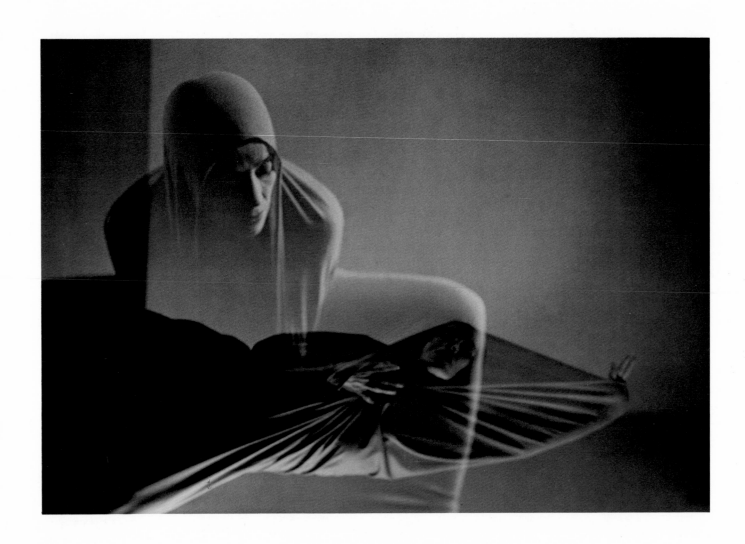

Martha Graham—"Lamentation," 1935

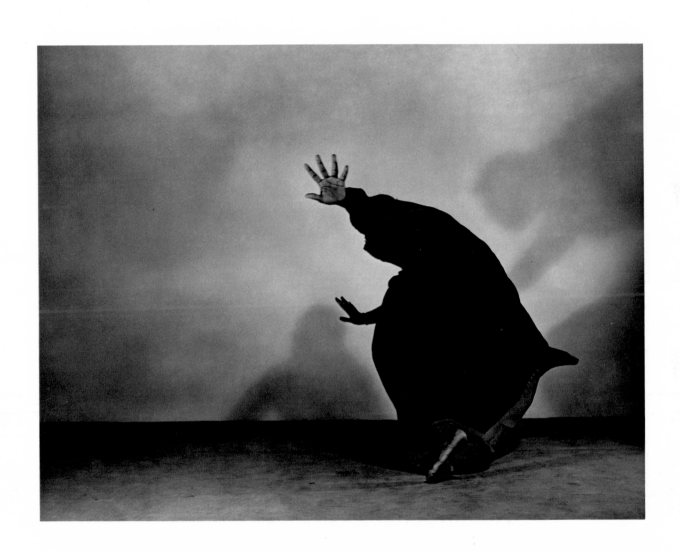

Pearl Primus—"Speak to Me of Rivers," 1944

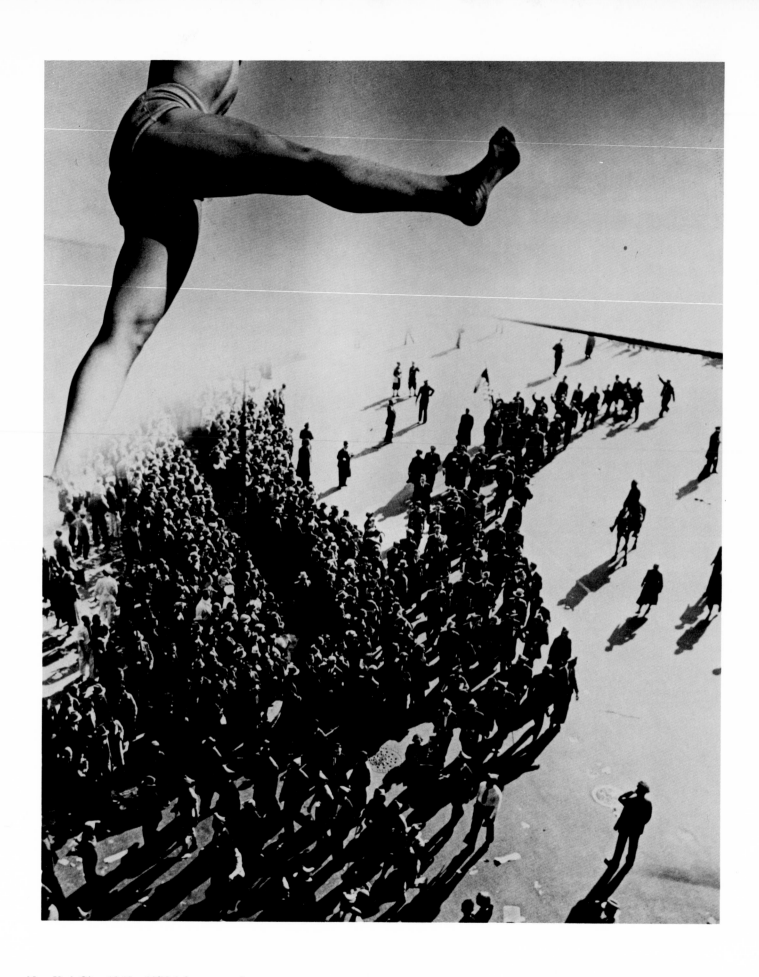

Protest—New York City, 1940s–1970 (photomontage)

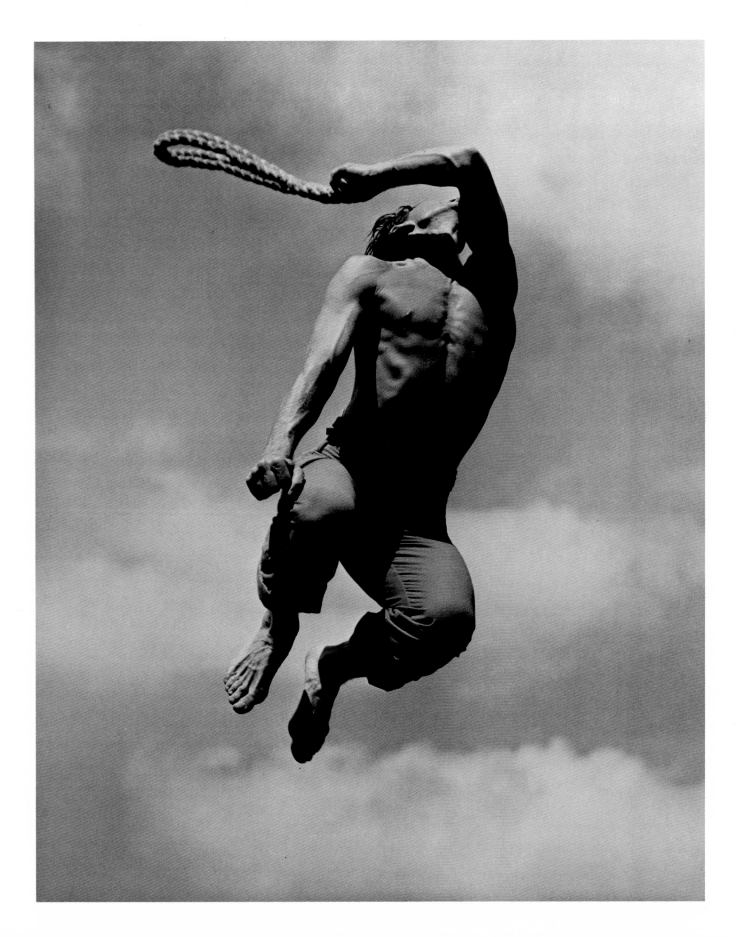

Martha Graham—"El Penitente," 1940
(solo Hawkins, El Flagellante)

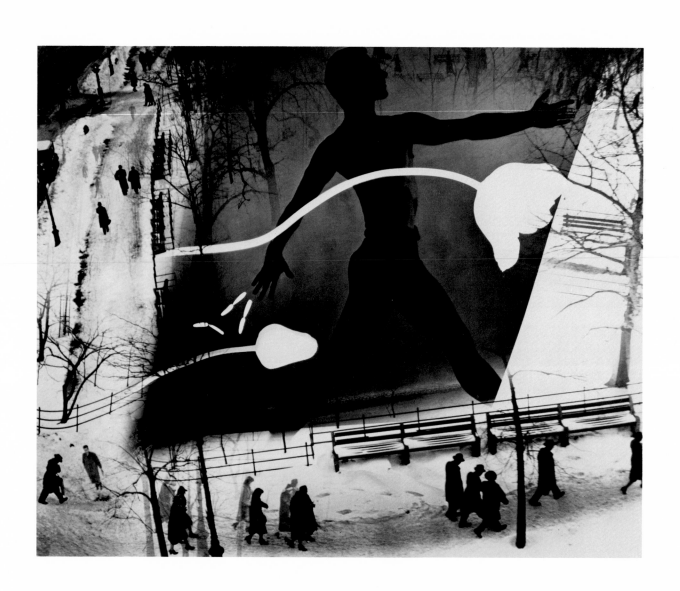

Spring on Madison Square, 1938 (photomontage)

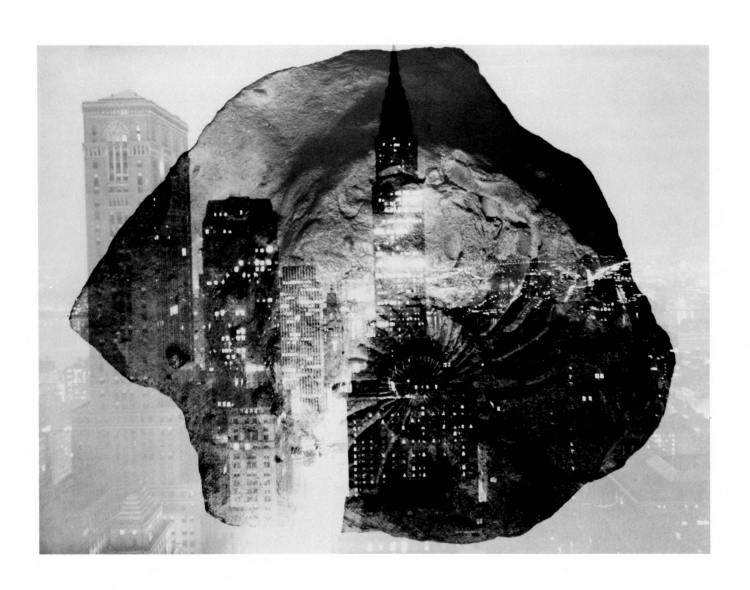

Fossil in Formation, 1965 (photomontage)

197

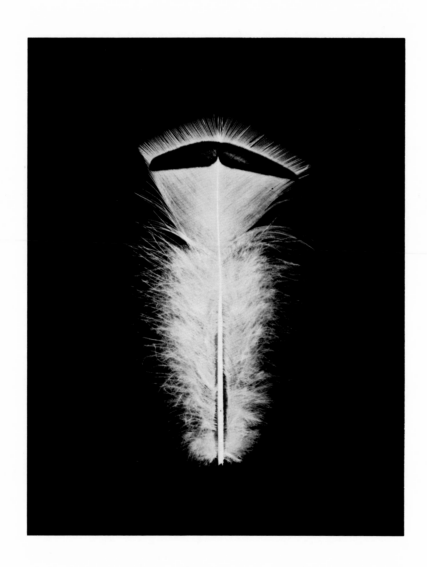

Feather Icon, 1942 (macro)

BERENICE ABBOTT

BIOGRAPHICAL NOTES

1898	Born in Springfield, Ohio, July 17.
1918–21	Attended Ohio State University. Studied painting and sculpture in New York.
1921–25	Lived in Paris. Assistant to Man Ray, Surrealist painter and photographer. Opened portrait studio, photographed the artistic and literary Parisian community including André Gide, Jean Cocteau, James Joyce, Marie Laurencin, Marcel Duchamp, and André Maurois.
1926	First exhibition in Paris, "Portraits Photographiques" (introduced by Jean Cocteau), at Au Sacre du Printemps Gallery.
1927	Purchased the prints and negatives of Eugène Atget after his death in the same year
1929	Returned to New York City.
1932	Exhibition at Julien Levy Gallery.
1935–39	Hired by *Fortune* to make series of portraits of American businessmen and by *Life* to make series of scientific subjects. Photographed "Changing New York" documentation for Works Progress Administration Federal Art Project.
1937	Exhibition of "Changing New York" photographs at the Museum of the City of New York.
1939	Published *Changing New York* (text by Elizabeth McCausland).
1938–58	Taught at the New School for Social Research, New York.
1941	Published *A Guide to Better Photography.*
1948	Published *The View Camera Made Simple.*
1951	Read paper "Documentary Photography" at Aspen Institute's Conference on Photography, Aspen, Colorado.
1958–61	Worked with the camera to explore physics for the Physical Science Study Commission of Educational Services, Inc. Produced "The Image of Physics," an exhibition circulated throughout the country by the Commission and the Smithsonian Institution.
1968	Left New York for Maine; published *A Portrait of Maine.*
1969	Exhibition at the Hall of Photography, Smithsonian Institution, Washington, D.C.
1970	Exhibition at the Museum of Modern Art, New York, with concurrent publication of *Berenice Abbott: Photographs.*
1971	Honorary doctorate, University of Maine.
1973	Honorary doctorate, Smith College. Exhibition at Witkin Gallery, New York.
1975	Exhibition at Focus Gallery, San Francisco. Participated in "Women of Photography: An Historical Survey" exhibition, San Francisco Museum of Art.
1976	Exhibition at Marlborough Gallery, New York, and Lunn Gallery Graphics International, Washington, D.C.
1978	Participant, along with Lillian Hellman, Emily Hahn, Janet Flanner, and Kay Boyle, in symposium called "Women and the Arts in the 1920s in Paris and New York" at Rutgers State University.

SELECTED BIBLIOGRAPHY

BY BERENICE ABBOTT

Books

Changing New York. Text by Elizabeth McCausland. New York: E. P. Dutton, 1939.
A Guide to Better Photography. New York: Crown Publishers, 1941.
Twenty Photographs by Eugene Atget. Portfolio of modern prints made by Abbott from Atget's negatives, with introduction. 1956.
Magnet. Text by E. Valens. Cleveland: World Publishers, 1964.
The World of Atget. New York: Horizon Press, 1964.
A Portrait of Maine. New York: Macmillan, 1968.
The Attractive Universe. Text by E. Valens. Cleveland: World Publishers, 1969.
Berenice Abbott: Photographs. New York: Horizon, 1970

Articles

"It Has to Walk Alone." *American Society of Magazine Photographers,* November 1951, pp. 6–14.

ABOUT BERENICE ABBOTT

Articles

Elizabeth McCausland. "The Photography of Berenice Abbott." *Trend* 3:1, Spring 1935.
Elizabeth McCausland. "Berenice Abbott—Realist." *Photo Arts* 2:1, Spring 1978.
Leslie Bennetts. "Creative Women of the 20s Who Helped Pave the Way." *The New York Times,* April 10, 1978.

RUTH BERNHARD

BIOGRAPHICAL NOTES

1905	Born in Berlin, Germany, October 14.
1925–27	Attended Academy of Fine Arts, Berlin.
1927	Moved to New York City.
1929	Worked for photography section of *The Delineator.*
1930	Began her career doing work in advertising and fashion photography.
1935	Trip to California. Met Edward Weston.
1936	First one-person exhibition in Los Angeles, where she moved from New York.
1939	Moved back to New York for work.
1941	Went to Sanibel Island, Florida, to photograph seashells.
1942	Met Alfred Stieglitz.
1943	Worked in Mendham, New Jersey, as a farmhand, member of the Women's Land Army.
1947	Moved to Hollywood.
1953	Moved to San Francisco and began teaching private classes, "Photographing the Nude" and "The Art of Feeling."
1958	Began to teach regularly at the University of California and to give lectures, classes, and workshops all over the United States.
1962	Participated in an exhibition at the Museum of Modern Art, New York.

1967	Participated in "Photography in the Fine Arts," Metropolitan Museum of Art, New York. Exhibition at the Focus Gallery, San Francisco.
1971	Held a master class at New York University and the International Foundation for Concerned Photography, New York.
1975	Exhibition with Ansel Adams, Silver Image Gallery, Tacoma, Washington. Participated in "Women of Photography: An Historical Survey" exhibition, San Francisco Museum of Art.
1976	Exhibited at Sidney Janis Gallery, New York.
1977	Exhibited at Witkin Gallery, New York.
1978	Participated in "Recent Acquisitions," San Francisco Museum of Modern Art. Exhibited at the Canon Photo Gallery, Amsterdam.

SELECTED BIBLIOGRAPHY

BY RUTH BERNHARD

Books

The Big Heart. Text by Melvin Van. New York: Fearon Publishers, 1957.
The Gift of the Commonplace. Portfolio. 1935–70.
The Eternal Body. Portfolio. 1948–70.

Articles

"Growth of a Photographer." *Contact* 4, 1964
"Nature Photography II." *Pacific Discovery* 16:1, January–February 1973.

ABOUT RUTH BERNHARD

Articles

"American Aces." *U.S. Camera,* 1939.
"The Workshop Idea of Photography." *Aperture* 9:4, 1961.
"Light"" *Aperture* 14:1, 1968.
"Being without Clothes." *Aperture* 15:3, 1970.
Marilyn Sanders. "In Her Vision." *Westways* 69:8, 1977.

CARLOTTA M. CORPRON

BIOGRAPHICAL NOTES

1901	Born in Blue Earth, Minnesota, December 9.
1905–20	Grew up in India; educated in English boarding schools.
1920–26	Moved back to United States to study art at Eastern Michigan University and Teacher's College of Columbia University.
1928	Summer in Europe.
1932	Summer in England to study medieval architecture.
1926–28	Taught at Woman's College (now Huntington College), Montgomery, Alabama.
1928–25	Taught at School of Applied Arts, University of Cincinnati. Bought her first camera as instructional aid for a design course.
1935–68	Taught design, advertising design, art history, and creative photography at Texas Woman's University in Denton, Texas.

1936	Studied photography technique at the Art Center in Los Angeles for the summer.
1944	Worked with Georgy Kepes.
1945	Participated in "Design with Light" exhibition at the Art Alliance, Philadelphia. Met Alfred Stieglitz.
1948	One-person exhibition, Dallas Museum of Fine Art.
1952	Participated in "Abstraction in Photography" exhibition, Museum of Modern Art, New York.
1953	One-person exhibition at Art Institute of Chicago.
1975	Participated in "Women of Photography: An Historical Survey" exhibition, San Francisco Museum of Art.
1977	One-person exhibition at Marcuse Pfeifer Gallery, New York.
1978	Participated in "Works on Paper: Southwest 1978" exhibition, Dallas Museum of Fine Arts. One-person show, Galleria del Milione, Milan.

SELECTED BIBLIOGRAPHY

BY CARLOTTA M. CORPRON

Articles

"Designing with Light." *Photographs. Design Magazine* 51:1, October 1949.
"Light as a Creative Medium." *Art Education* 15:5, May 1962.

ABOUT CARLOTTA M. CORPRON

Mabel E. Maxcy. "A Creative Approach to Photography." *Texas Trends in Art Education,* Autumn 1960.

LOUISE DAHL-WOLFE

BIOGRAPHICAL NOTES

1895	Born in San Francisco, November 19.
1914	Studied design and color under Rudolph Schaeffer and painting with Frank Van Sloan.
1921	Met Anne Brigman.
1923	Went to New York City; studied design and decoration. Took summer course in architecture at Columbia University.
1927	Traveled in Europe with Consuelo Kanaga.
1928	Met Meyer Wolfe (her future husband) in Tunisia.
1929	Worked in New York as a decorator.
1930	Lived on Russian Hill, San Francisco. Met Edward Weston.
1932	Photographed in Tennessee.
1933	Met Frank Crowninshield, editor of *Vanity Fair,* which published her "Tennessee Mountain Woman" in November. Worked for Saks Fifth Avenue, Bonwit Teller, and *Woman's Home Companion.*
1936–58	Worked for Carmel Snow, editor of *Harper's Bazaar,* doing still-life, portrait, and fashion photography. Made many photographic trips to South America, North Africa, Caribbean Islands, Hawaii, Spain, Italy, Scandinavia, England, and France.
1937	Participated in first photography show at the Museum of Modern Art, New York.
1957–62	Worked for *Sports Illustrated.*
1959	Worked for *Vogue.*

1960	Went to Rome for *Sports Illustrated* to report on sports fashions at Olympic Games.
1961	Moved to Frenchtown, New Jersey. Studied book-binding, sewing, and French. Participated in history of fashion exhibition.
1965	Exhibited with her husband's work at Country Art Gallery, Westbury, Long Island.
1975	Participated in "Women of Photography: An Historical Survey" exhibition, San Francisco Museum of Art.

SELECTED BIBLIOGRAPHY

ABOUT LOUISE DAHL-WOLFE

Articles

"Photographing Fashions." *Look*, July 16, 1940.
Helen Morgan. "Look Behind Success." *You*, Summer 1940.
"Good Housekeeping Finds Out What a Woman Photographer Does." *Good Housekeeping*, August 1941.
"Las Photos de Louise Dahl-Wolfe." *Norte* 2:12, October 1942.
Peggy Badge. "Louise Dahl-Wolfe." *Cover Girl*, May 1945.
"Los Caminos de Louise Dahl-Wolfe." *Americana* 1:1, March 1947.
"Louise Dahl-Wolfe." *Pageant*, September 1947.
"America's Outstanding Woman Photographers." *Foto*, September 1950.
Sarah Tomerlin Lee. "The Individualist." *House Beautiful*, March 1965.
"Louise Dahl-Wolfe, Quiet at Home." *The New York Times*, December 16, 1973.
Carol Felder. "Criticism of Her Art Started a Great Career—in Photography." *Delaware Valley News*, February 1, 1974.
Eve Zibart. "Through the Looking Glass." *The Tennessean*, May 1, 1974.
Emily Van Ness. "Dahl-Wolfe: Reflections on a Golden Age." *The Sunday Times-Advertiser* (Trenton, N.J.), September 28, 1975.

NELL DORR

BIOGRAPHICAL NOTES

1893	Born in Cleveland, Ohio, August 28.
1900	Moved to Massilon, Ohio, where her father had a professional portrait studio in the family home.
1910	Married Thomas A. Koons.
1911	Daughter Virginia C. born.
1912	Daughter Elizabeth L. born.
1913	Daughter Barbara N. born.
1923	Moved to Miami, Florida.
1929	Took photographs of children in the Florida Keys, which became *In a Blue Moon*. Built a studio and photographed important visitors for *Gondolier* magazine
1931	Divorced from Thomas A. Koons.
1932	Moved to New York City. One-person exhibition of photomurals at Merle Sterner Gallery, New York.
1934	One-person exhibition at Delphic Gallery, New York. One-person exhibition at Grand Central Art Gallery, New York. Exhibited in Paris, France. *Mangroves*, a softcover folio, published in limited edition. Married scientist John Van Nostrand Dorr.

1939	Published *In a Blue Moon*.
1940s	Summers in New Hampshire, where much of her book *Mother and Child* was photographed.
1947	Made *The Singing Earth*, a 16-mm. film with sound, with the Kurtgraff Ballet.
1949	Made *Through the Dorr Way*, a 16-mm. film, with Erica Anderson about the Dorr-Oliver Company. World Wide.
1954	Published *Mother and Child*.
1955	Participated in "The Family of Man" exhibition by Edward Steichen at the Museum of Modern Art, New York.
1958	Made *The Golden Key*, 16-mm. film about a doll's wedding, using Tasha Tudor's dollhouse and collection of antique dolls.
1962	Published *The Bare Feet*.
1964	One-person exhibition at the Washington Art Association, Washington, Connecticut.
1967	Exhibition of *Mother and Child* at the Minneapolis Art Institute.
1968	Published *Night and Day*.
1975	Participated in the "Woman of Photography: An Historical Survey" exhibition, San Francisco Museum of Art. Published *Life Dance* (text by Covington Hardee).
1976	One-person exhibition, Shado Gallery, Portland, Oregon.

SELECTED BIBLIOGRAPHY

BY NELL DORR

Books

In a Blue Moon. New York: G. P. Putnam & Sons, 1939.
Mother and Child. Oakland, Cal.: The Scrimshaw Press, 1972. Originally published by Harper & Brothers, New York, 1954.
The Bare Feet. Greenwich, Conn.: New York Graphic Society, 1962.
Night and Day. Greenwich, Conn.: New York Graphic Society, 1968.
Life Dance. Text by Covington Hardee. Allendale, N.J.: Alleluia Press, 1975.

ABOUT NELL DORR

Articles

Grace Mayer. "Interview with Nell Dorr." *Infinity*, 1963.
Margaretta Mitchell. "Nell Dorr." *Popular Photography*, March 1975.

16-mm. films (in the collection of the Museum of Modern Art, New York)

The Singing Earth. Dance film with Kurtgraff Ballet.
Through the Dorr Way. Documentary made with Erica Anderson on the Dorr-Oliver Company World Wide.
The Golden Key. A story about a doll's wedding, using Tasha Tudor's dollhouse and collection of antique dolls.

TONI FRISSELL

BIOGRAPHICAL NOTES

1907	Born in New York City, March 10.
1925	Graduated from Miss Porter's School, Farmington, Connecticut.
1930	Joined staff of *Vogue* magazine as caption writer.
1931	First experiments at fashion photography published in *Town and Country* magazine.

1931–42	Worked for *Vogue* as fashion photographer.
1932	Married Francis McNeill Bacon III.
1933	Son, Varick, born.
1935	Daughter, Sidney, born.
1941	Worked as official photographer for the Red Cross in England and Scotland.
1942	Worked for *Harper's Bazaar.*
1944	Toured Europe as guest photographer of the American 15th Air Force Squadron. Official photographer of the Women's Army Corps. Photographed for the Office of War Information. Published illustrated version of Robert Lewis Stevenson's *A Child's Garden of Verses.*
1946	Published *The Happy Island,* based on a trip to Bermuda.
1947	Award of distinctive merit for fashion photograph "The Floating Boat" taken in Jamaica.
1953	Invited to photograph Sir Winston Churchill. Began working for *Sports Illustrated.*
1955	Participated in "The Family of Man" exhibition, the Museum of Modern Art, New York.
1961	Traveling exhibition "A Number of Things through the Eyes of Toni Frissell," sponsored by the IBM Corporation.
1967	One-person exhibition, "View from My Camera," sponsored by Hallmark.
1968	Participated in "Man in Sport" exhibition, Baltimore Museum of Art (only woman in a long list of photographers).
1970	Gave collection of negatives and prints to the Library of Congress.
1975	Participated in traveling exhibition and book of the King Ranch, sponsored by the Amon Carter Museum. Permanent exhibit installed at King Ranch.
1975–76	Photographs in traveling exhibition "Fashion Photography: Six Decades," sponsored by the Emily Lowe Gallery, Hofstra University.
1976–77	Participated in "Women Look at Women," a Library of Congress traveling exhibition.
1977–78	Participated in traveling exhibition "History of Fashion Photography," International Museum of Photography, George Eastman House.

SELECTED BIBLIOGRAPHY

BY TONI FRISSELL

Books

Robert Louis Stevenson. *A Child's Garden of Verses,* New York: U.S. Camera, 1944.
The Happy Island. New York: T. J. Maloney, 1946.
Toni Frissell's Mother Goose. New York: Harper, 1948.
The King Ranch. Fort Worth, Tex.: Amon Carter Museum of Western Art; and Dobbs Ferry, N.Y.: Morgan and Morgan, 1975.

ABOUT TONI FRISSELL

Articles

"When the Cameraman Is a Woman." *Chicago Sunday American Magazine,* October 25, 1964, p. 5.
"Toni Frissell, Portfolio." *Infinity* (cover story), December 1967, pp. 4–11.
"Tony Frissell Bacon: 'I'm Sixty-Six and I Love It.' " *Vogue,* June 1973, pp. 140–45.

LAURA GILPIN

BIOGRAPHICAL NOTES

1891	Born in Colorado Springs, April 22.
1908	Made first autochrome color transparencies.
1911	Moved to western slope of Colorado and fixed up a darkroom.
1915	Visited San Diego and San Francisco. Photographed painting and sculpture at San Francisco Fair.
1916	Managed trio of musicians in Colorado during the summer.
1916–17	Studied at the Clarence White School in New York; friendship with Gertrude Käsebier.
1918	Struck with influenza. Took the year to recover in Colorado.
1920	First saw New Mexico with her father on a spring trip from Colorado Springs to Durango.
1922	Trip to Europe with Brenda Putnam. Studied books by William Blake in British Museum print room.
1930	Trip with Elizabeth Forster to photograph ruins of Betatakin and Keet Seel and Mesa Verde. Navaho pictures published in guidebook to New Mexico by WPA writers project.
1931	Became interested in the Navaho people and their landscape.
1932	Visited the Yucatán to photograph Mayan ruins.
1933	Met landscape photographer William Henry Jackson in Colorado.
1942–46	Worked as plant photographer for Boeing Airplane Company in Wichita, Kansas.
1946	Second trip to the Yucatán.
1948	Published book on the Mayan ruins; worked on the Rio Grande book.
1950	Returned to Navaho reservation and began fifteen-year study of the Navaho people.
1968	Published *The Enduring Navaho.*
1974	Retrospective exhibition at Museum of New Mexico, circulated by Western Association of Art Museums.
1975	Received Guggenheim Fellowship to make hand-coated platinum prints. Participated in "Women of Photography: An Historical Survey" exhibition, San Francisco Museum of Art.
1978	Retrospective exhibition at Amon Carter Museum, Fort Worth, Texas; announced gift of her entire photographic collection to the museum.

SELECTED BIBLIOGRAPHY

BY LAURA GILPIN

Books

The Pueblos: A Camera Chronicle. New York: Hastings House, 1941.
Temples in Yucatán. New York: Hastings House, 1947.
The Rio Grande: River of Destiny. New York: Duell, Sloan, and Pearce, 1947.
The Enduring Navaho. Austin and London: University of Texas Press, 1968.

ABOUT LAURA GILPIN

Articles

David Vestal. "Laura Gilpin, Photographer of the Southwest." *Popular Photography,* February 1977.

LOTTE JACOBI

BIOGRAPHICAL NOTES

1896	Born in Thorn, West Prussia, August 17.
1898	Family moved to Posen, then part of Germany.
1908–09	Made first picture with pinhole camera.
1912–16	Studied history of art and literature at Academy of Posen.
1916	Married Fritz Honig.
1917	Son, John Frank, born.
1920	Moved to Berlin.
1924	Divorced Fritz Honig.
1925–27	Formal study of photography and film technique in Munich at the Bavarian State Academy of Photography; also studied history of art at the University of Munich.
1927	Assumed responsibility for father's photographic portrait studio in Berlin.
1930	Began showing work in exhibitions in Berlin, Paris, London, Tokyo.
1932–33	Traveled in central Asia, Russia.
1935	In September left Germany with son for England; in October arrived in New York. Set up portrait studio with sister, Ruth, also a photographer. Sold photographs to *Herald Tribune, Life, Look,* and others.
1937	First one-person show at Directions Gallery, New York. (Succeeding years included one-person shows every two or three years.)
1940	Married Erich Reiss, publisher.
1942	Participated in "20th Century Portraits" exhibition at the Museum of Modern Art, New York.
1946	Began experiments in light abstractions called "photogenics."
1951	Participated in "Abstraction in Photography" exhibition at the Museum of Modern Art. Husband died after long illness.
1955	Moved to New Hampshire.
1959	One-person show at Currier Gallery of Art, Manchester, New Hampshire.
1961–62	Enrolled as student at University of New Hampshire to study horticulture, graphic arts, art history, French, and educational television.
1962–63	Traveled to Europe. Studied etching and engraving with William Stanley Hayter at Atelier 17 in Paris.
1963	Opened gallery in Deering, New Hampshire, for exhibition of photographs and other works of art.
1972–73	One-person exhibition, Hamburg, Germany.
1973–74	One-person exhibition, Museum Folkwang, Essen, Germany.
1974	Awarded honorary Doctorate of fine Arts, University of New Hampshire.
1975	Participated in "Women of Photography: An Historical Survey" exhibition, San Francisco Museum of Art.
1976	Trip to Caribbean island of Grenada.
1977	Trip to Peru. Received grant from National Endowment for the Arts for project of photographing photographers.
1978	Awarded Honorary Doctorate of Humane Letters, New England College, Henniker, New Hampshire. Participated in "Fourteen New England Photographers" exhibition, Museum of Fine Arts, Boston.

SELECTED BIBLIOGRAPHY

ABOUT LOTTE JACOBI

Books

Lotte Jacobi, Photographer. New York: Addison House, 1978.

Articles

"Lotte Jacobi: Photogenics." *Aperture* 10:1, 1962.
Jacob Deschin. "Viewpoint: Lotte Jacobi Photographic Psychedelics." *Popular Photography,* July 1970.
Richard M. Bacon. "Lotte Jacobi." *Yankee,* August 1976.

CONSUELO KANAGA

BIOGRAPHICAL NOTES

1894	Born in Astoria, Oregon, May 25.
1915	Worked as reporter and feature writer for the *San Francisco Chronicle.* Did portrait work.
1926	Divorced first husband and moved to New York. Became news photographer for *New York American.*
1927	Traveled in Europe with Louise Dahl-Wolfe; moved back to San Francisco.
1932	Participated in exhibition of the f/64 group.
1934	Moved to New York. Did photographs and covers for *Daily Worker* and *New Masses.*
1936	Worked on assignment for the Arts Program of the Works Progress Administration.
1940s	Worked for *Woman's Day* magazine and did freelance photography. Married painter Wallace Putnam.
1950	Moved to Yorktown Heights, New York. Trip to Florida.
1955	Participated in "The Family of Man" exhibition, the Museum of Modern Art, New York.
1963	Went to Albany, Georgia, to photograph civil rights demonstrators.
1974	One-person exhibition, Lerner-Heller Gallery, New York.
1976	Retrospective exhibition at the Brooklyn Museum.
1977	Exhibition of photographs and paintings at Ware Hill, Riverdale, New York.
1978	Participated in historical exhibition of the original f/64 group of photographers at the University of Missouri in St. Louis.
1978	Died February 28.

SELECTED BIBLIOGRAPHY

BY CONSUELO KANAGA

Books

Photographs: A Retrospective. New York: Lerner-Heller Gallery, Catalogue for exhibition May 14–31, 1974.

ABOUT CONSUELO KANAGA

Articles

Judith Kalina. "From the Icehouse: A Visit with Consuelo Kanaga." *Camera 35* 16:10, December 1972.

BARBARA MORGAN

BIOGRAPHICAL NOTES

1900	Born in Buffalo, Kansas, July 8.
1919–23	Studied at University of California at Los Angeles as art major. Began exhibiting paintings and woodcuts in junior year in West Coast art societies. Informally studied theatrical lighting and puppetry.
1923–24	Taught art in San Fernando High School.
1925	Married Willard D. Morgan.
1925–30	Joined art faculty at UCLA. Taught design, landscape, and woodcut; painted and photographed in Southwest during summers.
1930	Moved to New York City. Traveled for Willard Morgan's Leica lectures. Photographed Barnes Foundation collection, Merion, Pennsylvania.
1931	Established studio in New York for painting and lithography. Exhibited graphics at Weyhe Gallery, New York.
1932	Son, Douglas, born.
1934	One-person painting and graphics exhibition at Mellon Gallery, Philadelphia.
1935	Son, Lloyd, born. Turned to photography.
1935–41	Photographed and exhibited pictures of city themes, dance, children, light drawings, and photomontages.
1941	Published *Martha Graham: Sixteen Dances in Photographs*. Awarded American Institute of Graphic Arts Trade Book Clinic award. Moved to Scarsdale, New York.
1952	Published *Summer's Children: A Photographic Cycle of Life at Camp*.
1955	Did picture editing and design of book by Erica Anderson and Eugene Exman: *The World of Albert Schweitzer*.
1959	Archeological trip to Crete, Greece, Spain, Italy, France, and England.
1961	One-person exhibition at Sherman Gallery, New York.
1967	Willard Morgan died.
1970	Elected a Fellow of the Philadelphia Museum of Art.
1973	One-person exhibition at Pasadena Art Museum.
1974	One-person exhibition at Institute of American Indian Art, Santa Fe, New Mexico. Participated in exhibition at Whitney Museum of American Art, New York.
1975	Received grant from National Endowment for the Arts. Participated in "Women of Photography: An Historical Survey" exhibition, San Francisco Museum of Art.
1976	Participated in "200 Years—America on Stage" exhibition, J. F. Kennedy Center, Washington, D.C.
1977	One-person exhibitions at Gallery at Hastings-on-Hudson, New York, Marquette University, and University of Nebraska.
1978	Received honorary Doctorate of Fine Arts from Marquette University.
1979	One-person exhibition at Ohio University College of Fine Arts.

SELECTED BIBLIOGRAPHY

BY BARBARA MORGAN

Books

Martha Graham: Sixteen Dances in Photographs. New York: Duell, Sloan, and Pearce, 1941.
Prestini's Art in Wood. Text by Edgar Kaufmann, Jr. Lake Forest, Ill.: Pocahontas Press, 1950.
Summer's Children. Scarsdale, N.Y.: Morgan and Morgan, 1951.
Barbara Morgan. Dobbs Ferry, N.Y.: Morgan and Morgan, 1972.
Barbara Morgan Dance Portfolio. Dobbs Ferry, N.Y.: Morgan and Morgan, 1977.

Articles

"Photomontage." *Miniature Camera Work*, 1938.
"Photographing the Dance." *Graphic Graflex Photography*, 1940.
"Dance into Photography." *U.S. Camera*, December 1941.
"Dance Photography." *The Complete Photographer* 18:3, March 10, 1942.
"In Focus: Photography, the Youngest Visual Art." *Magazine of Art* 35:7, November 1942.
"The Scope of Action Photography." *The Complete Photographer* 10:4, March 20, 1944.
"Kinetic Design in Photography." *Aperture*, No. 3, 1953.
Essays contributed to *Encyclopedia of Photography*, 1963.
"Aspects of Photographic Interpretation." *General Semantics Bulletin*, 1963–64.

ABOUT BARBARA MORGAN

Articles

Etna M. Kelley. "Barbara Morgan: Painter Turned Photographer." *Photography*, September 1938.
Fritz Neugass. "Great American Photographers: Barbara Morgan." *Camera*, February 1952.
Beaumont Newhall. "Barbara Morgan, Summer's Children." *Magazine of Art*, March 1952.
Harold Lewis. "On Illustrating a Book. *Photography*, April 1952.
Helen Haskell. "Summer's Children: Life at Camp." *Living Wilderness*, Summer 1952.
Jacob Deschin. "Archival Printing—Push for Permanence." *Popular Photography*, August 1969.
Doris Hering. "Barbara Morgan: One of America's Great Photographers Reflects a Decade of Dance 1935–1945." *Dance Magazine*, July 1971.
Clive Lawrence. "An Explosion of Energy." *Christian Science Monitor*, January 13, 1973.
Anna Kisselgoff. "Interview with Barbara Morgan." *The New York Times*, June 19, 1975.
Deborah Papier. "All the Atoms Are Dancing." *Washington Calendar Magazine*, October 1, 1976.
Casey Allen. "The Influential Photographs of Barbara Morgan." *Camera 35*, May 1977.
Diana Loercher. "The Essence of Dance." *Christian Science Monitor*, September 18, 1978.
Suzanne DeChillo. "Barbara Morgan: Photographer of the Dance." *The New York Times*, January 14, 1979.

ACKNOWLEDGMENTS

The publisher, the director of the International Center of Photography, and I extend gratitude to the photographers for their cooperation and generosity in lending photographs for both publication and exhibition, for consenting to interviews and portraits, for their direct involvement (when possible) in the reworking of texts and the selection of prints, and also for their kind hospitality and friendship during the past two years.

I am indebted to the many persons who opened doors to me through their hospitality or help or both; Kathryn Abbe, Ray and Susan Belcher, David and Marcia Bell, Addison and Reed Berkey, Sarah Boasberg, Rodney and Natalie Ferris, Mary Louise Grossman, Sarah von Henneberg, Olivia and Harrison Hoblitzelle, Mrs. D. T. Hood, Erna and Charles Huber, Harry King, Tony and Judy King, Douglas and Liliane Morgan, Anne Bell Robb, Harold and Polly Taylor, Stephen Taylor; particular thanks to my mother and father for exceptional patience and support, and extraordinary thanks to a unique friend and colleague, Frances McLaughlin-Gill, for her repeated generosity and for always asking the right questions; special thanks to my three daughters, Anne, Kate, and Julia, who have participated perhaps more than they expected.

No one deserves more thanks than David Bell, former senior editor at Studio Books, with whom I initiated the book and who has continued to show interest. Gratitude to the late Margery Mann, cocurator of the exhibition "Women of Photography: An Historical Survey," who shared her research with me. Greetings to photographer Lisette Model and regrets that she did not consent to be in the book. I am indebted to Susan Kismaric and her staff at the Photography Library of the Museum of Modern Art, New York, for access to files on some of these photographers; to Deborah Stokes of the Marlborough Gallery; to Harry Lynn of the Lynn Gallery; to Marcuse Pfeifer of the Marcuse Pfeifer Gallery; to Beverly Brannan, curator of the Toni Frissell Collection at the Library of Congress; to Richard Lerner of the Lerner-Heller Gallery; to those associated with several of the photographers, especially Christopher Ashe, Sina Brush, Anne Kennedy; also to the husbands: Meyer Wolfe, Wallace Putnam, and Francis M. Bacon; to Peggy Price for editing the transcriptions; to Peggy Harrison for typing the manuscript again and again; to Elizabeth Fishel, John Blaustein, Georgianna Greenwood, Anita Mozley, Katharine Whiteside Taylor, and Franny Taliaferro for reading portions of the manuscript and offering valuable advice as well as specific editing. With special appreciation for the presence in my life of my husband and in-house editor Frederick Mitchell, who has been a skillful and supportive consultant throughout the preparation of this book.

For the exhibition I have Cornell Capa, director of the International Center of Photography, and his dedicated staff to thank. I particularly want to mention Ann Doherty, the development director, and William Ewing, director of exhibitions, and his associate, Ruth Silverman. This exhibition is sponsored by a museum grant from the National Endowment for the Arts and funds from the Levi Strauss Foundation, which allows the exhibition not only to be shown at the International Center of Photography but also to travel around the United States for two years, beginning in January 1980.

The last and vital measure of gratitude goes to the staff of Studio Books, particularly senior editor Barbara Burn and designer Gael Dillon, both of whom have given this book the special attention it deserves.

Margaretta K. Mitchell

First published in 1979 by The Viking Press
625 Madison Avenue, New York, N.Y. 10022

Published simultaneously in Canada by
Penguin Books Canada Limited

Library of Congress Cataloging in Publication Data
Main entry under title:
Recollections: women of photography.
 (A Studio book)
 1. Women photographers—Biography.
2. Photography, Artistic. I. Abbott, Berenice, 1898—
II. Mitchell, Margaretta.
TR139.R38 770'.92'2 [B] 79-13980
ISBN 0-670-59078-9

Printed in the United States of America
Set in Baskerville.

Margaretta Mitchell's portraits of the photographers appear on pages 12, 30, 48, 66, 84, 102, 120, 140, 158, and 178